FROM THE

SUN KING

TO THE

ROYAL TWILIGHT

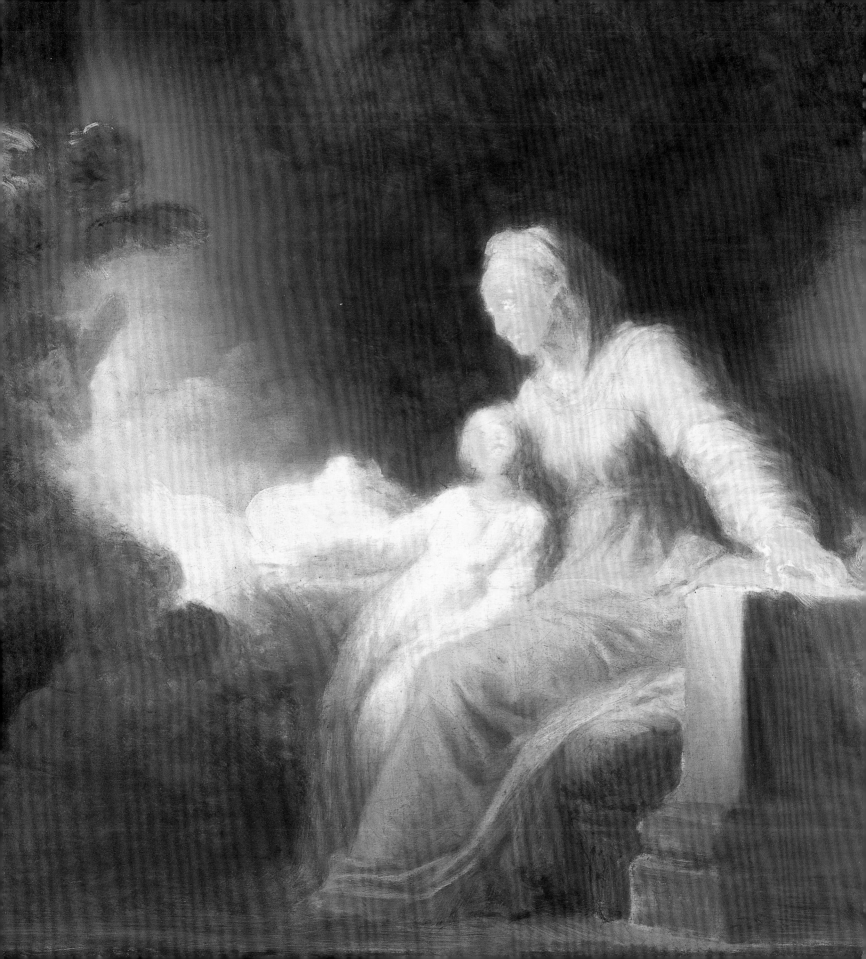

Painting in

Eighteenth-Century France

from the Sun King to the Royal Twilight

from the

Musée de Picardie, Amiens

MATTHIEU PINETTE

Foreword by
PIERRE ROSENBERG

AMERICAN FEDERATION OF ARTS

This catalogue has been published in conjunction with *From the Sun King to the Royal Twilight: Painting in Eighteenth-Century France from the Musée de Picardie, Amiens*, an exhibition organized by the American Federation of Arts.

AMIENS

The American Federation of Arts is a nonprofit art museum service organization that provides traveling art exhibitions and educational, professional, and technical support programs developed in collaboration with the museum community. Through these programs, the AFA seeks to strengthen the ability of museums to enrich the public's experience and understanding of art.

Published in 2000 by the American Federation of Arts, 41 East 65th Street, New York, New York 10021.
www.afaweb.org

The entries for catalogue numbers 16, 17, 18, 19, 20, 21, and 47 are adapted from Xavier Salmon, *Versailles: Les chasses exotiques de Louis XV*. Paris, 1995.

Unless otherwise indicated, photographs are supplied by the owners of the works and are reproduced by their permission.

Library of Congress Cataloguing-in-Publication Data
Musée de Picardie.
 From the Sun King to the royal twilight : painting in eighteenth-century France from the Musée de Picardie, Amiens / Matthieu Pinette ; foreword by Pierre Rosenberg.
 p. cm.
 Includes bibliographical references and index.
 ISBN 1-885444-13-3
 1. Painting, French—Exhibitions. 2. Painting, Modern—17th-18th centuries—France—Exhibitions. 3. Painting—France—Amiens—Exhibitions. 4. Musée de Picardie—Exhibitions. I. Pinette, Matthieu. II. Title.
ND546 .M86 2000
759.4'09'033074442625—dc21 00-029963

EXHIBITION ITINERARY

Columbia Museum of Art
Columbia, South Carolina
August 26–October 29, 2000

The Frick Art and Historical Center
Pittsburgh, Pennsylvania
November 16, 2000–January 14, 2001

Joslyn Art Museum
Omaha, Nebraska
February 3–April 1, 2001

Santa Barbara Museum of Art
Santa Barbara, California
April 20–June 17, 2001

Front cover: Jean-François Donvé, *Wedding Procession Passing Through the Place Périgord in Amiens*, ca. 1785 (no. 73)
Back cover: François Boucher, *The Rape of Europa*, 1732–34 (no. 14)
Frontispiece: Jean-Honoré Fragonard, *Education of the Virgin*, ca. 1775 (no. 66)
Page 12: Detail of Hyacinthe Rigau y Rós, called Rigaud, *The Provost and Aldermen of the City of Paris Deliberating on the Commemoration of the Dinner Given for King Louis XIV at the City Hall After His Recovery in 1687*, 1689 (no. 1)
Page 26: Detail of Studio of Hyacinthe Rigau y Rós, called Rigaud, *Louis XIV in Coronation Dress*, ca. 1704–10 (no. 4)
Page 40: Detail of Aubry, *Louis XV the Beloved*, 1749 (no. 33)
Page 58: Detail of Charles Parrocel, *The Elephant Hunt*, 1736 (no. 19)
Page 148: Detail of Unknown French Artist, after Louis-Michel Vanloo, *Portrait of Louis XVI in Coronation Dress*, 1774(?) (no. 64)

Publication Coordinator: Michaelyn Mitchell
Book Design: Susan E. Kelly, Marquand Books, Inc., Seattle
 www.marquand.com
Editor: Carolyn Vaughan

Printed in Hong Kong

Contents

Acknowledgments 6

Foreword by Pierre Rosenberg 8

France in the Eighteenth Century: An Historical Overview
of the Century of Enlightenment 13

The Collection of Eighteenth-Century French Painting
at the Musée de Picardie 19

CATALOGUE 25

The Reign of Louis XIV 27

The Reign of Louis XV 41

The Reign of Louis XVI 149

Exhibitions Cited 178

Bibliography 183

Index of Artists 191

Acknowledgments

THE HOLDINGS OF THE MUSÉE DE PICARDIE ARE RICH IN MANY AREAS, BUT UN-doubtedly the museum's greatest treasures can be found in its superb collection of eighteenth-century French paintings. Bringing these works to the attention of an American audience for the first time, the AFA is proud to present what Pierre Rosenberg refers to as the "glory" of the museum.

Deepest gratitude goes to our esteemed French partner, Matthieu Pinette, director of the Musée de Picardie and both curator of the exhibition and principal author of this book. I also wish to acknowledge the other distinguished contributors to the book: Eric Moinet, chief curator, Musée des Beaux-Arts, Orléans; Pierre Rosenberg, of the Académie Française, and *président-directeur*, Musée du Louvre; and Xavier Salmon, curator, Musée national des Châteaux de Versailles et de Trianon, who allowed us to adapt text from his book *Versailles: Les chasses exotiques de Louis XV* (1995).

At the AFA, this project has come about through the efforts of numerous staff members, in particular, Thomas Padon, director of exhibitions, who lent his important counsel throughout the development of the project; Robin Kaye Goodman, assistant curator of exhibitions, who oversaw all aspects of the organization of the exhibition; and Michaelyn Mitchell, head of publications, who skillfully coordinated the publication of this book. Working with Ms. Goodman and Ms. Mitchell were Rebecca Friedman, curatorial assistant, and Beth Huseman, editorial assistant, respectively. Kathleen Flynn, head registrar, and Mary Grace Wahl, registrar, coordinated the logistics of traveling the exhibition; Lisbeth Mark, director of communications, guided the promotion and publicity efforts for the project; and Brian Boucher, interim head of education, created the educational materials. Finally, thanks go to Marie-Thérèse Brincard, adjunct curator of exhibitions, who, together with Mr. Pinette, developed the concept for the exhibition and shepherded it in its early stage.

The three royal portraits, which constitute a key component, come from the collection of the Musée des Beaux-Arts, Orléans. We are most appreciative for the generous loan.

Thanks also go to Carolyn Vaughan for her editorial work; to John Tyler Tuttle, Jr., and John Goodman for their translation of the texts; and to Susan E. Kelly at Marquand Books for her elegant design.

Lastly, I wish to recognize the four museums that are participating in the exhibition tour and with which it has been a pleasure to work: the Columbia Museum of Art, The Frick Art and Historical Center, the Joslyn Art Museum, and the Santa Barbara Museum of Art.

—SERENA RATTAZZI
Director, American Federation of Arts

I WOULD LIKE TO EXTEND MY THANKS TO THE FOLLOWING PEOPLE FOR THEIR CON- tributions to the catalogue and exhibition: Pierre Rosenberg, of the Académie Française, and *président-directeur* of the Musée du Louvre, for writing the foreword; Xavier Salmon, curator at the Musée national des Châteaux de Versailles et de Trianon, for allowing us to reprint his entries on the Exotic Hunts of Louis XV and Bachelier's Hunt from his book *Versailles: Les chasses exotiques de Louis XV* (1995); Eric Moinet, chief curator at the Musée des Beaux-Arts, Orléans, for writing the catalogue entries on the portraits of the three French kings; Raphaëlle Delas, an intern at the Musée de Picardie, for preparing the technical notes; and Dominique Brême, Nathalie Coural, Martin Eidelberg, Christine Beauvalot-Gouzi, Laure Hug, Dominique Jacquot, Alastair Laing, Edgar Munhall, and Marie-Catherine Sahut. Additional thanks go to John Tyler Tuttle, Jr., and John Goodman for translating the texts; France Dijoud, Nathalie Volle, David Liot, Guillaume Faroult, and Isabelle Cabillic at the Versailles Restoration Workshop, for their supervision of the restoration work on many of the paintings; at the Musées d'Amiens, Christel Martin-Leverbe, deputy director, Anouk Cateland, registrar, the united technicians, in particular Jimmy Quennchen, Sophie Sanon, secretary to the director, Nadine Bellanger, secretary; Christine Thuiller, temporary employee, Michéle Camus, curatorial assistant, Catherine Renaux, curatorial leader, Jean-François Danquin, communications, and Françoise Lernout, curator. Lastly, I would like to acknowledge the many people who worked on the restoration of the paintings: Jeanne Amoore, Marie-Alice Belcour, Claire Bergeaud, Marie-Thérèse Brunet-Brewer, Laurence Callegari, Albert Chavanon, Cécile Dubruel, Madeleine Fabre, Anne Gerard, Aubert Gerard, Lucia Guirguis, Catherine Haviland, Nathalie Houdelinckx, Jean-François Hulot, Alain Jarry, Daniel Jaunard, Michel Jeanne, Jacques Joyerot, Bertrand Le Dantec, Yves Luttet, Robert Mallet, Nicolas Malpel, Patrick Mandron, Flo- rence Marcille, Frédérique Maurier, Cécile Munerot, Cinzia Pasquali, Marie-France Racine, Alain Roche, Jacqueline Roussel, and Isabelle Wade-Leegenhoek, as well as Marc Jeanneteau and Didier Cry, who photographed many of the paintings.

—MATTHIEU PINETTE
Director, Musée de Picardie

Foreword

THE HISTORY OF PROVINCIAL FRENCH MUSEUMS HAS YET TO BE WRITTEN. THERE certainly are excellent catalogues of their collections, the great majority of them written in the nineteenth century, and some more recently (although few between 1914 and 1970). Local scholars have researched the origins of these museums, their establishment under the Revolution, the construction of new buildings to house them in the nineteenth century, their growing collections, various notable personalities connected with them, and the reasons or chance developments that prompted these people to donate their collections to the local museum. There are also superb scholarly studies, although these are unfortunately less numerous today than they were prior to World War I. Finally, there are fine studies devoted to the extraordinary transformation of our provincial museums over the last generation. Awakening after a half century of hibernation, these museums have been remodeled by the finest French and foreign architects, and they have made splendid purchases and organized magnificent exhibitions, to the great benefit of their friends and visitors.

But no general study has been devoted to their history, to the deep currents affecting their birth, efflorescence, dormancy, and reemergence. How are we to explain this phenomenon, to situate it properly in a national and international context? How are we to distinguish relevant larger trends from purely local factors? What prompted rivalries between cities? Were these always political in nature, and are they still? What portion of its budget did—and does—each city allocate to its museum? And is it justifiable to oppose a hardworking, meticulous northern France to a more creative, casual southern France? Do nineteenth-century circumstances still hold true today? Although much remains to be done (one could draft a list of museums as yet untouched by the magic wand), the renewal process has largely completed its course—from Lille to Quimper, from Cambrai to Lyon, from Nantes to Nancy, from Rouen to Grenoble. It seems therefore that the time has come not only to prepare an inventory but above all to investigate the nature of the phenomenon and its extent, to analyze in depth the past significance of these provincial museums and the raison d'être for their continued existence. What can they, what should they contribute to the life of a city? What is expected of them? What do they expect of their cities, of the state, of their friends and visitors?

Amiens is a good example. Elsewhere in these pages, Matthieu Pinette recounts the history of the city's museum. We saw it all but abandoned, empty of visitors as well as tourists, left to its own devices, ignored by both the city's inhabitants and the municipal authorities. We also saw its re-

awakening. To be sure, the work is not yet completed, but an important threshold has been crossed, a great step forward has been taken.

Two examples will make this clear. Almost all of the paintings in this catalogue entered the Musée de Picardie as gifts, and all, with just few exceptions, entered in the nineteenth century. Of course the Lavalard brothers, given the gentle names Ernest and Olympe, studied in their time by the elder Jacques Foucart (father of the present curator at the Louvre), were crucial, as Matthieu Pinette notes, but it would be unjust to neglect other generous benefactors. The State, which is to say the Louvre, helped to enrich the collection. Then nothing, or very nearly. No gifts, no purchases. Only in 1992 did the city bestir itself with a masterstroke, a brilliant accomplishment: the purchase of an absolute masterpiece by Fragonard, *The Education of the Virgin*, which now complements the Lavalard Fragonards.

The other example is more personal in nature. Between 1960 and 1980, I visited many French provincial museums. At the time they were regarded as virtual balls-and-chains, useless expenditures; at best, they were ignored. Often, it was hoped that one day they would be closed. It was thought the money would be better spent on *maisons de la culture*. Such centers were viewed as oriented toward the future, bursting with vitality, whereas the museums seemed irretrievably, definitively dead. The situation has changed radically since that time: Museums now compete with one another, and their curators again figure prominently among the personalities of the city. Some of them favor contemporary art without limiting their field of vision to France alone; some make a point of selecting the finest architects; some try to outdo Paris by organizing exhibitions that the capital couldn't manage to mount; some strive to make purchases that the Louvre, the Musée d'Orsay, or Beaubourg (the centre Georges Pompidou, our national museum of modern art) were unable to secure for themselves. We should rejoice in this resurgence, but we must not delude ourselves. Fashions change. It is up to the curators to make sure that the energy doesn't simply expend itself.

I alluded above to local circumstances specific to each museum. It is undeniable and irrefutable that Amiens rhymes with *dix-huitième*, with French painting of the eighteenth century. To be sure, it would be grievous to ignore the famous Puys d'Amiens (wells of Amiens)—works by Frans Hals, Kalf, Ribera, and Crespi; the museum's superb mural decorations by Puvis de Chavannes and Sol Le Witt; as well as other marvels that visitors should be allowed to discover for themselves. But it is the museum's French eighteenth-century paintings that are its glory.

Which eighteenth century? A mere half-century ago, one swore by only a few names: Watteau, Chardin, Boucher, Fragonard, sometimes Hubert Robert and, if one was audacious, Greuze. This

was the eighteenth century inherited from the Goncourt brothers and a few collectors (to whom we shall return) who rehabilitated a century that had fallen into neglect in the wake of the Neoclassical assault. But this eighteenth century was not that of the period itself. The eighteenth century loved other painters. Here are a few of them, for the most part either *premier peintres* to the king or directors of the powerful Académie de France in Rome: the Boullogne brothers, Antoine and Charles-Antoine Coypel, François Le Moyne, Jean-François de Troy, Carle Vanloo, Jean Restout, Noël Hallé, Jean-Baptiste Marie Pierre, François-André Vincent, Joseph-Marie Vien. We are indebted to a new generation of art historians, not only French but also English, German, and American, for rediscovering these artists, for devoting to them exhibitions and monographs that have made it possible to determine their proper worth. But there are other artists who, while famous during their lifetimes, were not in the front rank, either because they chose to live far from their country, like Subleyras, or because fortune did not smile on them, for example, Charles Parrocel, Joseph-Benoît Suvée, and Lagrenée *l'aîné*. They, too, merit our attention.

The interesting thing about the Amiens collection is that it affords ample opportunity to study these various eighteenth centuries. It boasts masterpieces by Chardin (three still lifes and a moving *tableau de chasse*, as arrangements of dead game and hunting paraphernalia were called in the eighteenth century); some Bouchers, notably an exceptional design for a theatrical decor (for Favart's *Ecole des amours grivois*, according to Alastair Laing); and several Fragonards, among them, the extraordinary *Head of an Old Man*, whose fleet brushwork strikingly anticipates nineteenth-century stylistic developments. But it also includes works by Carle Vanloo, Restout, and a seductive Noël Hallé (his *Game of Blind Man's Buff* was attributed to Hubert Robert before we restored it to its true author). And it is also rich in works by artists who are unjustly forgotten or accorded scant attention: Louis Aubert, Jean-Jacques Bachelier, Alexis Grimou, Jean-Baptiste Huet, etc.

The Amiens collection represents a truly diverse array of artists and genres: landscapes, still lifes, a splendid series of portraits (Nattier and Trinquesse, Duplessis and Tocqué, Largilliere, and Rigaud), *grand genre* and history painting, and genre scenes, including the exceptional *Punchinello Singers* and *Punchinello Painters* by Hubert Robert. Finally, the collection has both technical variety—from rapidly brushed sketches to highly finished canvases—and stylistic variety—from the last echoes of the art of Louis XIV's day to Neoclassicism, represented by a work of Romantic cast by one of the woman painters now valued so highly, Constance Charpentier.

We cannot fail to mention the admirable royal hunts from the Petite Galerie of Versailles and their splendid frames, among the most beautiful in the entire history of framing. These works came to the museum as the result of a political happenstance, the 1802 treaty of Amiens, which had all Europe hoping and believing, for a brief moment, that Bonaparte—who was not yet Napoleon—

preferred peace to war. Boucher, Carle Vanloo, and Charles Parrocel are here at the peak of their genius.

To be sure, the panorama is not complete—such is the case even at the Louvre—and we can regret the absence, a challenge to future curators and their municipal superiors, of the great Watteau, of Gabriel de Saint-Aubin, of Joseph Vernet (although we can admire his portrait by Subleyras, and the Louvre has quite recently decided to fill this gap by lending Amiens two works from its own collection), as well as of less famous artists to whom scholars have recently drawn our attention: Jean Barbault, Pierre-Jacques Cazes, Nicolas Vleughels, Louis-Joseph Le Lorrain, Michel-François Dandré-Bardon, Robert Tournière, and Charles Natoire. But it must be admitted that few museums in the world can pride themselves on so rich and diversely stimulating an ensemble of French paintings from the period. We are greatly indebted for this to the Lavalard brothers: They were among the first revivers of the eighteenth century. They had their taste, which was not that of the Marcilles, who loved above all Chardin and Prud'hon, nor that of Dr. Lacaze, who loved everything, nor that of Sir Richard Wallace, who loved Watteau and had an eye for quality but forgot Chardin and Fragonard. They assembled two hundred and fifty paintings, some of which were loved from the start and some of which would be loved at some point in the future.

For my part, I am infinitely grateful for their acquisition of *Still Life with Two Rabbits, Game Bag, and Powder Horn* by Chardin. Where did they obtain this masterpiece of intimate poetry? It may have come from the collection of the sculptor Jean-Baptiste Lemoyne (1704–1778), but we cannot be sure. Its condition is far from perfect, but never has any painter, however great, managed to render innocent death with such tenderness, restraint, affection, and compassion.

—PIERRE ROSENBERG, OF THE ACADÉMIE FRANÇAISE
Président-directeur, Musée du Louvre

France in the Eighteenth Century: An Historical Overview of the Century of Enlightenment

MATTHIEU PINETTE

THE EIGHTEENTH CENTURY SAW RADICAL CHANGE IN FRANCE, CULMINATING IN A violent upheaval that established a new order. A brief account of these developments may be useful here, for they shaped the context of contemporary artistic production in important ways.

Louis "the Great," the Sun King (1643–1715)

The reign of Louis XIV was one of the longest in history. Born in 1638, Louis XIV acceded to the throne at age five. His youth was marked by grave difficulties, most notably the civil war known as the Fronde (1648–52), which was fomented by members of the nobility and magistrates in the *parlement* (supreme court) who tried to assert their prerogatives at the expense of royal power. The young king and his first minister, Cardinal Mazarin, vigorously opposed this revolt, and the monarchy emerged with renewed strength. Fortified by this experience, Louis XIV, who began his personal rule in 1661, gradually imposed his notion of divine-right absolutism: The king, as God's representative on earth, should reign unfettered.

All of Louis XIV's actions followed from this postulate. He made Versailles the seat of his power, imposing rituals on life at court designed to increase his authority while neutralizing that of the nobility. He employed great artists to affirm his concept of absolutism, notably the painter Charles Le Brun, the architect Jules Hardouin-Mansart, the playwright Molière, and the composer Marc-Antoine Charpentier, all of whom augmented the king's glory.

The reign of Louis XIV, called the Sun King, coincided with a period of relative prosperity in France. Thanks to the skill of one of his ministers, Jean-Baptiste Colbert, who oversaw its finances, the state's resources grew, as a result of more efficient tax collection as well as of increased trade (especially with the colonies) and mercantile productivity that favored exports. Rigorous domestic policy led to tighter control of French territories and more efficient administration, thanks to resident intendants now accorded authority over their respective provinces.

| 13

The reign of Louis XIV was also marked by significant territorial expansion, spearheaded by such great figures in military and strategic history as Vauban, Condé, and Turenne. The regions of Artois, Alsace, the Franche-Comté, and Roussillon all became part of France in these years.

However, grave problems developed toward the end of the Sun King's reign. The War of Spanish Succession (1701–13) cost the country dearly. The revocation of the Edict of Nantes in 1685 initiated a period of sometimes violent persecution against Protestants, prompting many valuable citizens to emigrate. In 1709, a severe winter led to serious famine. Finally, the king's secret marriage to Madame de Maintenon, shortly after the death of Queen Marie-Thérèse of Austria in 1683, ushered in the reign's final phase, a period characterized by moralizing and conspicuous piety, as opposed to the lavish festivities of earlier years, as well as by an increasingly rigid etiquette. Finally came the blow to the populace of two deaths in close succession, that of the Grand Dauphin, heir to the throne, in 1711, and that of his son in 1712.

The Reign of the "Well-Loved" King (1715–74)

The new sovereign, the great-grandson of Louis XIV, was only five when his predecessor died. Between 1715 and 1723, power was wielded by the late king's nephew, Philippe II, duc d'Orléans. This was the Regency, marked by a laxity of morals at court that was especially striking given the moralistic temper of Louis XIV's final years. This period was followed by the government of the duc de Bourbon (1723–26)—who negotiated the marriage of the young king and Marie Leszcynska—and then that of Cardinal Fleury (1726–43). The latter, Louis XV's tutor, was a gifted administrator who managed to put the State's finances on a firmer footing, but he also engaged France in the risky War of Polish Succession. On Fleury's death in 1743, the king decided that he himself would govern, but he delegated considerable authority to his ministers, with the result that his personal reign was less assertive than that of Louis XIV.

Long and expensive military campaigns (the War of Austrian Succession, the Seven Years War) resulted in France's loss of several provincial territories (India, Canada, and Louisiana), a development that, despite the addition of the region of Lorraine and the island of Corsica, signaled the country's declining power in relation to England and Prussia.

Royal power was increasingly challenged by the magistrates of the *parlement*, by the nobility, and by the bourgeoisie: The political models of England and the United States, shaped by the Enlightenment, created a strong current of dissent that even glorifications of absolutism proved unable to neutralize. The inability of Louis XV to impose his authority and his conspicuous liaisons with Jeanne Antoinette Poisson, later ennobled as the marquise de Pompadour, and then with Madame

du Barry—in short, his politics of unbridled expenditure—discredited royal power and were prejudicial to its restoration.

At the end of the reign, however, thanks in particular to the intervention of the duc de Choiseul in the fields of foreign diplomacy and military administration, and that of Chancellor Maupeou in the struggle with the *parlements*, which he succeeded in reforming, the realm, whose administrative system was well organized, enjoyed a degree of economic prosperity.

Louis XVI and the Fall of the Monarchy (1774–92)

The new sovereign, Louis XV's grandson, acceded to the throne at a moment when royal finances were in a difficult situation, although the country as a whole was enjoying relative prosperity. The ministers Turgot and Necker tried in vain to control the deficit by making the upper classes pay more taxes, but the nobles and the magistrates opposed these reforms, and Louis XVI ceded to their pressure, thereby weakening royal authority as well as endangering the government's fiscal solvency. The threat of bankruptcy was rendered all the more serious by the government's tender of financial support to insurgent Americans fighting for their independence; furthermore, although this aid brought the monarchy a certain prestige, it also won a larger audience for the new ideas.

The State's fiscal crisis, the *parlementaire* opposition, and the unpopularity of the extravagant Queen Marie-Antoinette all came to a head in 1788–89. An especially harsh winter resulted in food shortages in a country whose population had been growing rapidly. The high price of certain staples (especially bread), popular discontent in the face of taxes and seignorial privilege, and increasing unemployment in the cities led to riots that exacerbated an already volatile situation.

In May 1789, Louis XVI was obliged to convoke the Estates General, composed of representatives of the three orders: the nobility, the clergy, and the Third Estate. When efforts to secure truly proportional representation for their constituency failed, the deputies of the Third Estate proclaimed a National Assembly. On June 20, joined by the deputies of the lower clergy, they swore to draft a constitution; this was the so-called Tennis Court Oath, which led to the creation of the Constituent Assembly. Eventually the two privileged orders also joined—on instructions from the king, who had ceded to pressure from the Third Estate. Louis XVI, who had not yet grasped the gravity of the situation, tried to subdue the Assembly by deploying an army around Versailles, but the people of Paris rose to the Assembly's defense and seized the Bastille on July 14, 1789. This symbolically powerful act sparked uprisings in the provinces.

In the countryside reigned the Great Fear, as peasants attacked châteaux that they regarded as dens of conspirators. Alarmed by these uprisings, which were becoming so pervasive as to threaten

their own authority, the deputies voted to abolish privilege on August 4 and to endorse the Declaration of the Rights of Man and of Citizens on August 26, which effectively brought the ancien régime to a close. The king resisted, but in the end he was forced to acknowledge the Declaration's legitimacy.

For a time, it appeared that a compromise might be possible between the king, who had been brought to Paris by the people, and the Assembly, which was trying to establish a constitutional monarchy. The civil constitution of the clergy (July 1790), which decreed the confiscation of church property—an action designed to enrich the State's coffers—and reduced the clergy to a body of bureaucrats, was vigorously opposed by many Catholics. The nobles, most of whom had emigrated, tried to plot against the Revolution from outside the country; the king attempted to flee the country but was arrested at Varennes in the northeast of France. His treasonous act intensified the hostility of the people, prompting the Assembly, in the interest of prudence, to enact a constitution excluding the poorest Frenchmen—designated "passive citizens"—from power.

In April 1792, France declared war against Prussia and Austria. This martial action was supported by the revolutionaries, who hoped it would reenergize the dynamic of change; the moderates, who sought to strengthen their own position; and the king, who hoped that a defeat might lead to reestablishment of his power. But exposure of the king's collaboration with the enemy, whose representatives had promised justice for those guilty of violence against Louis XVI, prompted the extremist *sans-culottes* to invade the Palace of the Tuileries and to overthrow the king on August 10, 1792.

The First Republic (1792–99)

The king having been removed, a new assembly, called the Convention, was created. Fortified by military victories, it proclaimed the Republic on September 22, 1792. But the Convention was divided among the Montagnards, led by Danton and Robespierre, who wanted democracy; and the Girondins, who favored a more moderate regime. Soon the Montagnards spearheaded a vote condemning the king to death, and he was duly executed on January 21, 1793. After masterminding the arrest of the Girondins, whom they judged insufficiently radical, the Montagnards became the unchallenged masters of the Convention.

However, there were counter-revolutionary uprisings in some parts of the country, and all of Europe joined forces against France. In the face of this threat, the Convention established a Committee of Public Safety, placing at its head Robespierre, who effectively ruled as dictator, mobilizing the brutal repression of "counter-revolutionaries" and other suspects: This period was referred to as the Reign of Terror. Despite military victories, Robespierre refused to relent, continuing to

order arrests and executions, including among his victims Danton and his supporters, who were deemed too moderate. Increasingly uneasy, the Convention finally brought down Robespierre: Arrested on July 27, 1794, he was executed the next day.

Upon gaining power, the Thermidorians, adversaries of Robespierre, put an end to the Reign of Terror, emptying the prisons and crushing the *sans-culottes*, who continued to clamor for democratic representation. To preclude the return of a dictatorship, the Directory was established, under which executive power was shared by five *directeurs*. In this way the Thermidorian reaction managed to limit democracy and safeguard the interests of the prosperous bourgeoisie. The Directory was widely contested, however, from the left and the right, where the clergy and the nobility had regained some of their former influence. Recourse to the army seemed increasingly inevitable.

In the face of mounting social unrest, a faltering economy, equivocal results on the battlefield, and increasing poverty, the Directory became totally discredited. Only a strong regime, one that could win the war and safeguard the accomplishments of the Revolution, seemed capable of reestablishing order. On November 8, 1799, a coup d'état ended the Directory and brought to power the most popular of the French generals: Napoleon Bonaparte.

Social Transformation and Changing Ideas

The political evolution of eighteenth-century France coincided with significant social transformation. Until the end of Louis XIV's reign, the court played a crucial role, functioning among other things as a center of intellectual reflection. Immensely wealthy, guarantor of the legitimacy of royal power, and possessed of enormous prestige, the nobility continued to exert considerable control over public opinion.

After the death of the Sun King, the severity of his reign's final years gave way to a permissiveness, warranted by the behavior of the Regent himself, that opened a new phase. Thanks to the proliferation of salons—informal gatherings, in private homes, of the social and intellectual elite—as well as of clubs and cafés frequented by members of the urban middle class, the intellectual and social order was gradually transformed. New ideas could be disseminated in relatively open environments, a development that undermined the supremacy long enjoyed by members of the court. In these venues, the most advanced political ideas were discussed, and the most innovative philosophical conceptions were debated in ways that anticipated the emergence of new fields of reflection. This unprecedented freedom of thought fostered a moral laxity, an unfettered pursuit of pleasure, and a kind of libertine cynicism that spawned, eventually, a reactive movement vaunting morality and virtue. The eighteenth century was, of course, the century of the Enlightenment, which sought a means of escaping from this facile opposition of pleasure versus virtue. With a view to effecting a

radical transformation of society, Enlightenment philosophers, notably Montesquieu, Voltaire, Rousseau, and Diderot, denigrated traditional models and their dependence on religion, exalting instead human reason, which they deemed the engine of progress. Their views were expressed in the *Encyclopédie*, a vast enterprise whose primary aim was to combat intolerance, authority, and despotism using knowledge in the hope of attaining happiness. Science was accorded a privileged role in this context, replacing that formerly accorded the church. Toward the middle of the century, there arose a tendency to moderate this rational, progressivist program by adding a touch of sensibility, a development that made it possible for Romanticism to blossom early in the next century.

This fecund period was also marked by the emergence of new social classes. The Third Estate, formerly dominated by the nobility and the clergy, assumed a new importance in French society; the bourgeoisie, the urban working class, and the peasantry now became key actors in the profound transformation of the country.

Eighteenth-century France, simultaneously the victim and the beneficiary of upheavals as violent as they were rapid, generated a brilliant civilization that, paradoxically, was appreciated and imitated by its own enemies. The king of Prussia admired and played host to Voltaire; Catherine the Great of Russia did likewise with Diderot. Eventually, the spirit of the Enlightenment led to the triumph of universalistic ideals over specific interests and blundered nationalism.

Such is the context within which we should consider the works of art on view here. This fecund century, in which the king, the nobility, and the church continued to dominate the production of knowledge, saw a series of artistic trends, from the last echoes of Classicism, the Baroque, and the Rococo to Neoclassicism and the early manifestations of Romanticism. These developments are presented here, in paintings that reflect the century.

The Collection of Eighteenth-Century French Painting at the Musée de Picardie

MATTHIEU PINETTE

LIKE A NUMBER OF OTHER FRENCH PROVINCIAL MUSEUMS, the Musée de Picardie (fig. 1) was conceived during the nineteenth century in a post-revolutionary spirit that was both ambitious and generous. It originally strove to be an encyclopedic institution, collecting vestiges of the local patrimony but also encompassing broader areas of European and even world culture.

Today, the museum is made up of four main departments—archaeology, the middle ages, fine arts, and decorative art—with the painting collection on display upstairs. The aim of this collection is to present an approach to the evolution of painting in Europe since the fifteenth century. It features works of the sixteenth, seventeenth, and eighteenth centuries by southern—Italian and Spanish—artists such as El Greco, Ribera, Giordano, Tiepolo, and Guardi and northern—Dutch and Flemish—painters such as Hals, Van Dyck, Jordaens, Ruysdael, Snyders, and Teniers. The collection of French painting includes notable works from the nineteenth century—Corot and Courbet—and twentieth century—Picasso and Balthus. It is especially distinguished, however, for the eighteenth-century section, which is doubtless one of the finest outside of Paris.

Inaugurated in 1867 in an exemplary building constructed specially for the purpose (see Vieville 1995), the Musée de Picardie constitutes one of the very first establishments of a new type built in France after the Revolution. But the origin of the Amiens museum goes back further still, to the very beginning of the nineteenth century. In 1801, preparations were underway for the Congress of 1802, which was being organized to sign the Peace of Amiens, the treaty between France and England. In order to properly acknowledge this exceptional event, the State decided to turn over a series of works to be hung in the Hôtel de Ville of Amiens, where the signing of this significant act

Fig. 1
Façade of the Musée de Picardie, 1864–67
Musée de Picardie, Amiens
Photo Marc Jeanneteau

Fig. 2 (left)
Jean-François Bernard
Portrait of Olympe Lavalard, 1858
Oil on canvas
31⅛ × 23⅜ in. (79 × 59.3 cm)
Musée de Picardie, Amiens
Photo Marc Jeanneteau

Fig. 3 (right)
Madame Jean-Baptiste Lavalard,
née Berthelot
Portrait of Ernest Lavalard, ca. 1860
Oil on canvas
28⅞ × 23¼ in. (73.3 × 59.2 cm)
Musée de Picardie, Amiens
Photo Marc Jeanneteau

was to take place. The chosen paintings, often large-scale, all date from the preceding century and were primarily decorative. Among this group were four of the nine Hunts in Foreign Lands of Louis XV, which were used as overdoors! Remaining in the Hôtel de Ville after the treaty's ratification, the paintings soon constituted the Napoleon Museum, which moved to the Musée de Picardie shortly after its opening.

Above all, however, it was the donation of the Lavalard brothers' collection in 1890 that was decisive in creating a significant picture collection and, especially, the eighteenth-century French collection. This precious group, which has been thoroughly analyzed and described by the elder Jacques Foucart (1977), was assembled by two brothers, Olympe and Ernest Lavalard (figs. 2 and 3), who were born in the region of Picardie, and who, thanks to a flourishing textile business, were able to amass a comfortable fortune. Not averse to picking up a paint brush themselves, the Lavalards lived in Paris and benefited from the friendly and enlightened advice of the famous Doctor Lacaze, a benefactor of the Louvre. They assiduously attended art sales and progressively put together a collection particularly rich in seventeenth-century northern and eighteenth-century French works. Between the 1850s and the 1870s, eighteenth-century French art, which was gradually being "rediscovered," thanks in particular to the Goncourt brothers, Edmond and Jules, was

still not appreciated at its full worth. The Lavalards succeeded, for a relatively small investment, in assembling a collection the reputation of which gradually spread. As can be seen in the current exhibition, it includes canvases by top-flight artists such as Boucher, Fragonard, and Hubert Robert, as well as those by painters less famous but of great interest, such as Aubert and Trinquesse. This extraordinary gift was followed in 1894 by an additional gift from Adolphe Lavalard, the patrons' younger brother.

Of course, the generosity of other donors has, throughout the nineteenth and twentieth centuries, enabled important canvases to enter the museum, further supplementing the collection. Noteworthy are Baroness de Fourment, Madame Gaudefroy du Roisel, the descendants of the Amiens-born poet Jean-Baptiste Gresset, Doctor Demarquay, and Messrs. Edmond Soyer and Dupont. In a policy aimed at allowing the provinces to benefit from the national heritage, the Louvre made long-term loans of a number of choice works in 1864—shortly before the museum's inauguration—and again in 1872. This perspicacious attitude was seen again recently, with the Louvre's loan of two fine landscapes by Joseph Vernet (1714–1789). Additionally, the City of Amiens has periodically purchased works from this period such as, not long ago, a prestigious Fragonard (no. 66) and an interesting panel by Jacques Gamelin (1738–1803), which is not in the current exhibition. Finally, the generous patronage of the Société des Amis des Musées is responsible for the arrival, in 1998, of an interesting "portrait" of Amiens in the eighteenth century, attributed to Donvé (no. 73).

Of course, it was not possible for the present exhibition to transport all the museum's eighteenth-century works: In certain cases, their size or fragility prevented such an undertaking. Among the monumental paintings, a vast tapestry cartoon by Jean-Jacques Bachelier, *Childhood Amusements* (1761), two matching works by Carle Vanloo and Joseph-Marie Vien (1716–1809)—*Augustus Ordering the Closing of the Doors of the Temple of Janus* (1763; fig. 9, p. 27) and *Marcus Aurelius Helping the People* (1765)—intended for the Château de Choisy, were unable to join this selection, as were *The Death of Priam* (1785) by Jean-Baptiste Regnault (1754–1829), *Arie and Poetus* (1785; fig. 19, p. 149) by François-André Vincent, and the *Greek Rider Fighting a Lion* (1789) by Carle Vernet (1758–1836), which would have accentuated the emergence from Neoclassicism at the end of the century. Finally, two works by Antoine-François Callet (1741–1823), *The Fetes of Ceres* and *Homage to Juno* (1789 and 1791, respectively); a Lagrenée, *Ulysses and Circe;* as well as a Charles Lemonnier (1743–1824), *Cléombrote and Chelonis* (1787), are currently awaiting restoration.

Also regrettable is the absence of more modest sized works that are too fragile to be moved, such as five of the Hunts in Foreign Lands of Louis XV, as well as the famous *Washerwomen* (fig. 4) now determined as being by Hubert Robert (and no longer by Fragonard), Fragonard's *Resistance,*

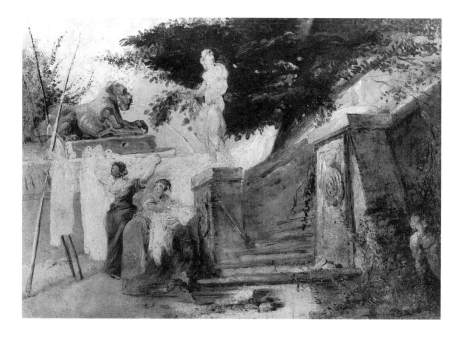

Fig. 4
Hubert Robert
The Washerwomen, ca. 1758
Oil on canvas
18¼ × 25⅝ in. (46.5 × 65.2 cm)
Musée de Picardie, Amiens
Photo Marc Jeanneteau

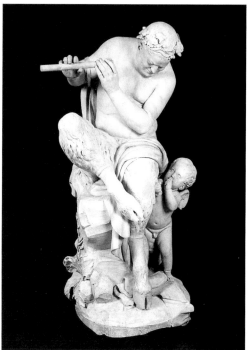

Fig. 5 (left)
Attributed to Aleksander Kucharski
Portrait of Choderlos de Laclos, ca. 1785
Pastel on paper mounted on canvas
23¼ × 19⅛ in. (59 × 48.5 cm)
Musée de Picardie, Amiens
Photo Marc Jeanneteau

Fig. 6 (right)
Auguste Pajou
Faun, 1758
Stone
52⅜ × 23⅝ in. (133 × 60 cm)
Musée de Picardie, Amiens
Photo Didier Cry

and two precious tondos by Robert, as well as a picturesque Jacques-Philippe Loutherbourg (1740–1812) and the spectacular Gamelin depicting *The Death of Cato of Utica*.

Similarly, the Drawings Department of the Musée de Picardie would have been able to complete this survey in a fine way with, in particular, a masterpiece of pastel, the famous self-portrait of Maurice Quentin de La Tour (ca. 1740; fig. 10, p. 41). This panorama of the eighteenth century at Amiens might have been completed with drawings by Boucher, Michel François Dandré-Bardon (1700–1778), Huet, Gamelin, Greuze, Lancret, Parrocel, Jacques-Louis David (1748–1825), Trinquesse, Vincent, and finally two fine portraits in pastel (see fig. 5), attributed to Aleksander Kucharski (1741–1819), depicting Choderlos de Laclos (the author of *Les Liaisons dangereuses* and, in fact, a native of Amiens) and his wife. But once again, the concern of the curators for preservation precluded such a journey.

Finally, let us point out that the collection of eighteenth-century sculpture, unfortunately rather undeveloped, nonetheless includes two important works by Auguste Pajou (1730–1809), a *Silenus* (with its sketch) and a *Faun* (fig. 6), as well as a *Bust of Gresset* by Pierre-François Berruer (1733–1797).

In conclusion, we must deplore the destruction, during World War I, of an immense masterpiece by Restout, *The Last Supper*, and the 1907 theft of three Bouchers (see fig. 7) and two Fragonards (see fig. 8), which will perhaps return one day to the collection to which they belong. In spite of

these absences, and, admittedly, with certain gaps, this exhibition aims to offer a look at French art of the eighteenth century.

This exhibition and its catalogue propose a series of masterpieces and significant pieces, organized chronologically to elucidate the pictorial evolution over some hundred years of creation: a period marked by profound upheavals, from the end of the reign of Louis "le Grand" to the fall of the monarchy and the Directory, by way of the Regency and the reign of Louis XV. The Musée des Beaux-Arts in Orléans, a royal city, was kind enough to lend its support with the portraits of the three sovereigns who reigned successively over the course of the century.

A number of the paintings have come out of storage for the first time in decades; many for this occasion benefited from a salutary restoration, which in some cases led to clarifications of attributions or iconographies. It is hoped that this process will further the understanding and appreciation of one of the most fruitful and enticing periods in French art.

Catalogue

Unless otherwise noted, catalogue entries are by Matthieu Pinette.

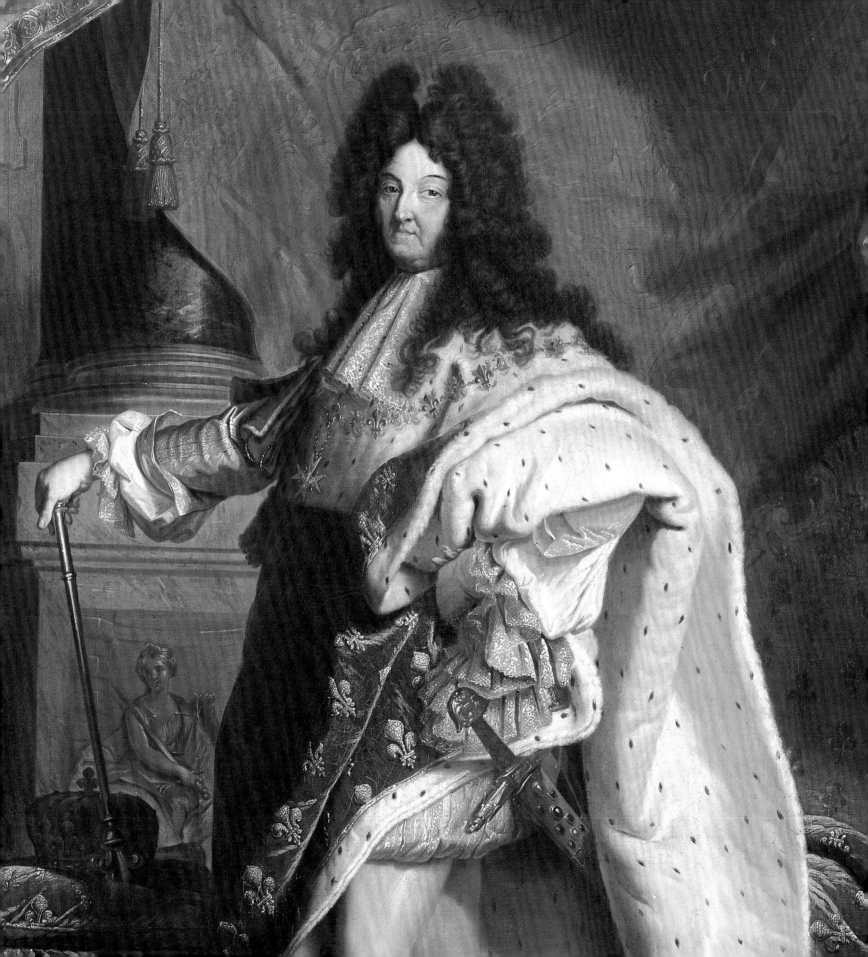

The Reign of Louis XIV

1643–1715

DURING THE REIGN OF LOUIS XIV, FRANCE BECAME THE PRE-eminent artistic power in Europe. Although he inherited a taste for fine objects from his mother, Anne of Austria, Louis XIV was far from being a connoisseur. Instead, he conceived of art as a means of bolstering the glory of the State and himself.

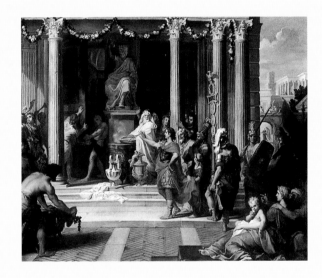

Fig. 9
Louis de Boullogne *le jeune*
Augustus Ordering the Closing of the Doors of the Temple of Janus, 1681
Oil on canvas
69¼ × 84⅞ in. (176 × 215 cm)
Musée de Picardie, Amiens
Photo Marc Jeanneteau

With the aid of his powerful ministers, Louis XIV organized the arts under a complex administrative hierarchy, which effectively subordinated the arts to the state. The body with perhaps the greatest influence on the arts was the *bâtiments du roi*, which initiated and oversaw royal artistic commissions.

The *bâtiments du roi* also supervised the Académie Royale de Peinture et de Sculpture. Founded in 1648, the Académie provided a level of training unparalleled by any other European art school. The Académie's adherence to the traditional hierarchy of painting genres—placing history, religious, and mythological painting above portraiture, decorative works, landscape, genre scenes, and still life—had a pronounced effect on the art of the time.

The leading artistic figure under the Sun King was Charles Le Brun. A founding member of the Académie, Le Brun was also director of the Gobelins factories. As such, he influenced painting, tapestry weaving, furniture making, sculpture, and metalwork, and also shaped prestigious decorative ensembles that employed numerous artists. A skilled administrator, Le Brun established the characteristics of the majestic, heroic imagery created during the first half of Louis XIV's reign (see fig. 9).

Thirty years before the end of Louis XIV's rule, Pierre Mignard came to the forefront in royal art patronage. Mignard's preference for a more graceful and elegant style eventually paved the way for the light, pastel-colored art that developed under the Regency. Still, the art created in the late years of Louis XIV's reign was resolutely lavish, sumptuous, and richly colorful.

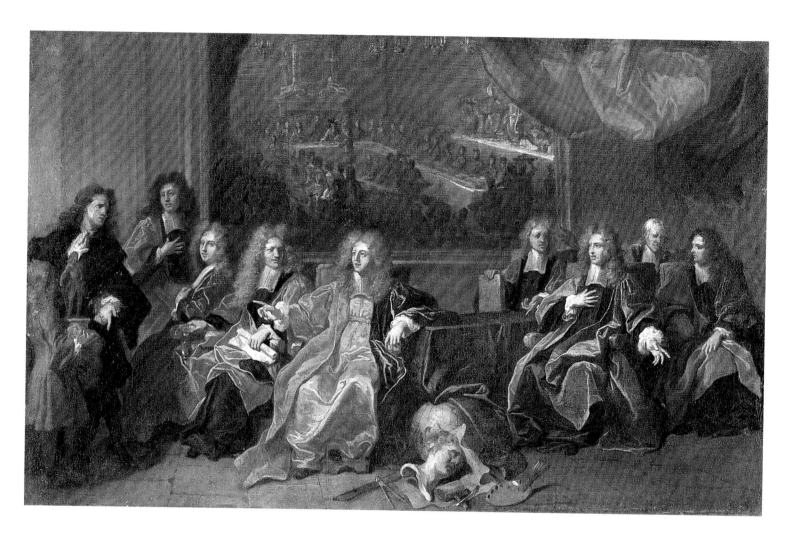

1. Hyacinthe Rigau y Rós, called Rigaud
(Perpignan 1659–Paris 1743)

The Provost and Aldermen of the City of Paris Deliberating on the Commemoration of the Dinner Given for King Louis XIV at the City Hall After His Recovery in 1687, 1689

Oil on canvas, 12¾ × 20⅜ in. (32.5 × 51.7 cm)

Signed and dated, back of canvas (inscription concealed by the lining):
Hyacinthe Rigaud fecit 1689

Musée de Picardie, Amiens; Gift of the Lavalard Brothers, 1890
(M.P.Lav. 1894–162)

With its complex iconography and an attribution that was questioned for quite some time, this painting has been the subject of numerous studies, including the work of Georges de Lastic and Myra Nan Rosenfeld, which definitively reestablished the present attribution. The painting was long considered as being by Largilliere.

The recovery of Louis XIV, following a fistular operation by Guy-Crescent Fagon, was the occasion, at the beginning of 1687, for great festivities in Paris. On January 30 a dinner was given for the king at the Hôtel de Ville. In a symbolic gesture intended to reconcile him with the capital that had proved rebellious at the

beginning of his reign, Louis XIV decided on that occasion to have removed from the courtyard of the Hôtel de Ville the statue of Gilles Guérin, who was represented crushing the Fronde, the uprising of 1648–49 that had set the people of Paris against royal authority. Two years after this act of concord, the city councilors deliberated about how to commemorate this royal banquet: whether to organize a fete or commission works of art. Their debate is the subject of the present painting, executed within the framework of group portraits of the city committee that the councilors had commissioned on a regular basis.

This sketch depicts the most eminent of the men presiding over the city's destiny: In the center, leaning on the table, is seated the provost, Henry de Fourcy; to his right are placed, respectively, the king's prosecutor, Louis-Maximilien Titon, and the city tax collector, Nicolas Boucot; the man standing to the right of Boucot may be the court clerk Jean-Martin Mitantier. Finally, the person standing on the far left who, with the help of an apprentice is presenting the model of a statue, could be the sculptor Antoine Coysevox (1640–1720), from whom the councilors actually commissioned a sculpture of the sovereign to replace that of Guérin. On the right are seated four aldermen in dark robes. The background of the scene is completely filled by a large painting commemorating the 1687 banquet. In the foreground lies an allegorical trophy combining various symbols of the fine arts— a bust and a sculptor's mallet and chisel, a painter's palette, and an architect's ruler and compass—reflecting the purpose of the group's deliberations, which was to commemorate with an artistic commission the king's act of concord.

Rigaud supplied another sketch for this same composition (Château de Parentignat), but the definitive painting was executed by the other great portraitist of the time, Nicolas de Largilliere. Does this mean that the councilors preferred the sketch of his "competitor" (Paris, Musée du Louvre) to Rigaud's? Or, as Lastic has suggested, did Rigaud, attracted by even more prestigious commissions, withdraw his proposal or recommend his colleague? Whatever the case, the work constitutes a fine testimony to the splendors that marked the reign of Louis XIV.

Rigaud is considered the great court portraitist of the second half of the Sun King's reign. Arriving in Paris in 1681, he won the Prix de Rome the following year and entered the Académie Royale in 1700. Rigaud painted his first portrait of Louis XIV, which was followed by numerous portraits of members of the royal family: Among the most famous paintings are his *Portrait of Louis XIV in Coronation Dress* (1701; Paris, Musée du Louvre) and *Portrait of Louis XV in Coronation Dress* (1730; Versailles, Musée National des Châteaux de Versailles et de Trianon). The head of a very large studio, which generated numerous replicas, Rigaud was also the author of many portraits of foreign dignitaries and eminent men of the church.

Musée de Picardie Catalogues: 1894, p. 42, no. 162 (Largilliere); 1899, p. 219, no. 164 (Largilliere); 1911, p. 135, no. 161 (Largilliere).
Bibliography: Horsin-Déon 1862, p. 144 (Largilliere); Champeaux 1898, p. 206; Gonse 1900, p. 13 (Largilliere); Bellemère 1908, p. 43 (Largilliere); Brière 1918–19, p. 239; Boinet 1928, pp. 12, 13; Pascal 1928, pp. 17–19, 76, no. 200; Gronkowski 1928, p. 334; Maumené and d'Harcourt 1932, p. 129; Brière, Dumoulin, and Jarry 1937, p. 31; Parker 1938, vol. I, p. 226; Florisoone 1948, p. 19; Blunt 1953, p. 278; Smith 1964, pp. 134–36, fig. 42, pl. 11; exhib. cat., Paris 1965–66, p. 67; exhib. cat., Paris 1975, no. 38; Lastic 1976, pp. 147–56, fig. 2; Foucart 1977, pp. 18, 29, 43, 49; Rosenfeld 1984, p. 69; Brême 1996, p. 56; Brême 1998, p. 14.
Exhibitions: Paris 1874, no. 284; Paris 1928, p. 20, no. 3; Paris 1933, no. 124; Amiens 1951; London 1954–55; Sceaux and Brussels 1962, no. 230, pl. 43; Lille 1968, p. 57, no. 77, p. 89, pl. 77; Montreal 1981, pp. 150–54, no. 24; Dijon 1982–83, pp. 262, 263, fig. 465, p. 284, no. 105; Lille 1985, p. 143, no. 103; Nantes and Toulouse 1997–98, pp. 238, 239, no. 79, p. 146, fig. 79.
Related Work: Rigaud, *The Provost and Aldermen of the City of Paris*, ca. 1689, oil on canvas, private collection, Paris.

$\mathcal{2}$ · Nicolas de Largilliere
(Paris 1656–Paris 1746)

Still Life with Fruit, ca. 1695–1700

Oil on canvas, 30⅜ × 38⅜ in. (77 × 97.5 cm)
Musée de Picardie, Amiens; Gift of the Lavalard Brothers, 1890
(M.P.Lav. 1894–165)

Largilliere is generally associated with the art of the portrait. A peerless practitioner of that genre from the end of the reign of the Sun King, through the Regency, and up to the beginning of the reign of Louis XV, he also distinguished himself in other pictorial forms: religious painting, landscape, and still life.

As a child in Antwerp, Largilliere studied with the painter Antoon Goubau (1616–1698), then during a stay in London, with Sir Peter Lely (1618–1680). He thus had the opportunity to become familiar with the art of the still life in its rich northern tradition, and then to practice it.

Georges de Lastic has identified several datable works from Largilliere's London period and from the early years after his return to Paris. In the paintings, mixed fruits, flowers, and dead game appear in arrangements reminiscent of Dutch and Flemish painting. Lastic also has shown how Largilliere's inclination toward still life gradually evolved to a style closer to that of the Italians, and became, at the beginning of the eighteenth century, more sporadic, as he produced virtuoso works that seem to have been reserved for a few close friends or for himself.

The present canvas, which originally would have been mounted above a door, and whose proportions have been modified (the canvas was originally more elongated, and curiously, fragments from the side have been cut out and added to the top and bottom), might possibly have come from the painter's own residence, in the rue Geoffroy-l'Angevin in Paris, where his decorative works abounded. Dominique Brême has dated it to around 1695–1700.

On a marble table in front of a vast purple drapery, a watermelon, an open pomegranate, pears, grapes, and peaches are arranged. Agile brushwork enlivens this colorful painting with a sure and allusive swiftness and nimbly disposes the mound of fruit into a skillful and calculated disorder.

Musée de Picardie Catalogues: 1894, p. 43, no. 165 (Largilliere); 1899, p. 220, no. 167 (Largilliere); 1911, p. 135, no. 164 (Largilliere).
Bibliography: Horsin-Déon 1862, p. 144 ; Pascal 1928; Blunt 1953, p. 288, no. 105; Grate 1961, pp. 26–29, fig. 6; Faré 1962, vol. I, p. 152, vol. II, pl. 289; Lastic 1968, p. 239, no. 24; Faré 1976, p. 52, fig. 69; Foucart 1977, pp. 44, 49.
Exhibitions: Paris 1928, p. 44, no. 137, pl. 14; London 1958, p. 107, no. 251; Paris 1958, no. 61, pl. 47; Washington, D.C., Toledo, and New York 1960–61, pp. 71, 72, no. 130; Tokyo 1966, p. 69, no. 8, pl. 8.

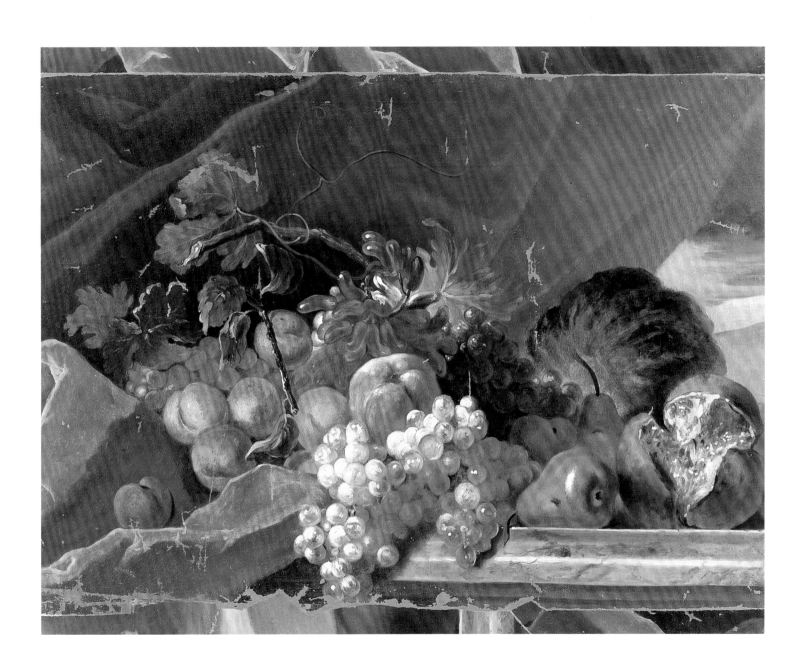

3. PIERRE-ANTOINE PATEL, CALLED PATEL *LE FILS*
(Paris 1648–Paris 1708)

Landscape with Shepherds Playing the Flute Among Ruins,
1702
Oil on canvas, 9½ × 13¾ in. (24 × 34.8 cm)
Signed and dated, bottom right: *P. Patel 1702*
Musée de Picardie, Amiens; Gift of the Lavalard Brothers, 1890
(M.P.Lav. 1894–182)

PIERRE-ANTOINE PATEL WAS THE SON OF PIERRE
Patel (ca. 1605–1676), called *le père,* an artist undoubtedly from
Picardie and one of the finest interpreters of the classical French
landscape. The younger Patel, followed the main pictorial prin-
ciples of his father, to such a degree that works by the two painters
have often been confused. Producing landscapes exclusively, both
artists composed idealized views in which ruined antique architec-
ture is integrated into abundant vegetation. These fantastic
scenes, called *capricci,* are humanized with figures. But where the
elder Patel worked in delicate shades, elaborating an unreal na-
ture, and designed refined architecture to create a poetic atmo-
sphere, his son responded with a more intense and realistic color
scheme and rendering style, which give his work a picturesque
quality. Here, Patel *le fils* invents a conventional pastoral scene
including two shepherds—the seated one playing a flute—their
flock, and nearby ruins. Nathalie Coural has pointed out that one
of these figures, inspired by Claude Gellée (ca. 1602–1682), was
again used by Patel in another work (location unknown). The art-
ist intentionally emphasizes the contrast between the grandiosity
of the ancient architecture and the ordinariness of the rustic scene
that unfolds therein.

The life and career of Pierre-Antoine Patel remain almost
unknown; those of his father, to whom we owe the decoration of
the summer apartments of Anne of Austria in the Louvre (1660)
and the office in the mansion of President Nicolas Lambert de
Thorigny in Paris (ca. 1646–47), are hardly better explored.
Neither artist followed an official academic program, which would
have recorded the development of their careers. However, the
recent work of Coural has, in the case of Patel *le fils,* enabled the
cataloguing of some ninety paintings (including this one) and
more than fifty works in gouache, a medium that Patel seems par-
ticularly to have appreciated.

Musée de Picardie Catalogues: 1894, p. 45, no. 182; 1899, p. 224, no. 183; 1911,
 p. 137, no. 179.
Bibliography: Boinet 1928, p. 15; Vergnet-Ruiz and Laclotte 1962, p. 247; Foucart
 1977, p. 44 ; Lesage 1978, pp. 137–38; Coural (forthcoming).
Exhibition: Lille 1968, pp. 62, 91, no. 92.

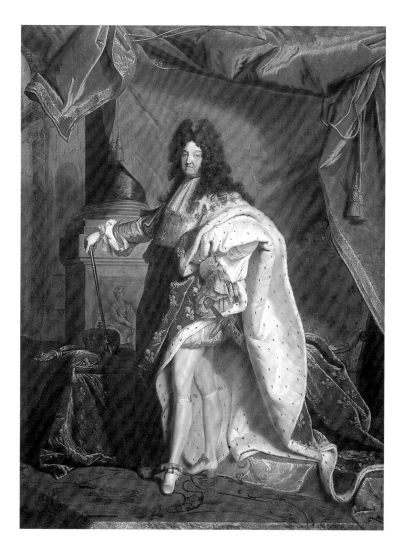

4. STUDIO OF HYACINTHE RIGAU Y RÓS,
CALLED RIGAUD
(Perpignan 1659–Paris 1743)
Louis XIV in Coronation Dress, ca. 1704–10
Oil on canvas, 52 × 38⅝ in. (132 × 98 cm)
Musée des Beaux-Arts, Orléans (769 A)

THIS PAINTING WAS LONG CONSIDERED AMONG THE mediocre copies after the *Portrait of King Louis XIV in Coronation Dress,* painted in 1701 by Rigaud and today in the Louvre (7492). Restoration carried out in 1994 revealed the quality of this canvas, which specialists now consider a fine reduced version executed in the master's studio.

Rigaud and Nicolas de Largilliere, his main rival, have always been viewed as the most important French portraitists of their generation. Rigaud's career, which was exceptionally long for the era, spanned portions of three reigns. Painter to Louis XIV and the court at the end of the great monarch's life, Rigaud continued to be successful under the Regency of the duc d'Orléans and at the beginning of the reign of Louis XV. The ascension of this artist of Catalan origin, trained in the workshop of the Montpellier painter Antoine Ranc (1634–1716), was continuous from the moment of his being accepted into the Académie Royale in 1684. Received into the Académie in 1700, he successively climbed the rungs of its hierarchical ladder, finally becoming director in 1733. His fame was established definitively in 1688 when he painted the portrait of Monsieur, the brother of Louis XIV. In 1694, the sovereign himself asked to pose for Rigaud, resulting in the *Portrait in Armor* now at the Prado. In 1701 Rigaud painted a new portrait of the king in coronation dress. Presented at the Salon of 1704, it met with considerable success. This work, which quickly became the monarch's official image, engendered numerous studio replicas of various sizes, as well as innumerable engraved or painted copies that contributed to the broad distribution of the sovereign's image in France and in the principal European courts. From that time on, Rigaud enjoyed a glorious and fruitful career.

The birth of Louis XIV on October 5, 1638, at the Château of Saint-Germain (the preferred residence of his father, Louis XIII) outside of Paris, marked the end of the long, twenty-three year

wait for an heir to the French throne. This happy event ensured the continuity of the elder branch of the Bourbon dynasty, established by Henri IV, Louis XIV's grandfather, who was assassinated in 1610. Upon the death of his father in 1643, Louis became king at the age of five, but it was his mother, Anne of Austria (1601–1666), who took over the rule of the kingdom. His own reign did not begin until 1661, with the death of Cardinal Mazarin (1620–1661), prime minister and confidant of the Queen Mother. The previous year, the king had married the Infanta Marie-Thérèse, daughter of Philip IV of Spain, and so found himself at the head of one of the main powers of Europe—the Habsburg Dynasty.

The king's youth was profoundly marked by the unhappy memories of the Fronde, the insurrection against Mazarin's government that was supported by a large part of the French aristocracy. He was able to draw his power from the French people's desire to live in peace and security. But he quickly asserted himself as an autocrat by using his absolutism to cut back the privileges of the nobility and those of the parliaments, whose role, beginning in 1673, was reduced to recording royal edicts. As would his successors, he relied on the theory of the divine right of the sovereign, who thus legitimately holds all power. Considering himself the "lieutenant of God," he acted as head of the Church of France toward the pope. More than anything else, he exalted the near-religious character of the monarchic function by personally organizing the cult of his royal majesty. Called the Sun King, he chose the sun as an emblem of his glory, and he installed the court at Versailles, as of 1682, in a palace built to glorify his splendor.

Served by great men of war such as Vauban, Turenne, Duquesne, Tourville, and Jean Bart, the king involved the country in wars of conquest across Europe throughout his reign. The war against the Augsburg League, which became the War of the Grand Alliance (1688–97), marked the end of French domination in Europe, which would be further diminished after the War of Spanish Succession (1701–14).

It was in this particular context that Rigaud was engaged in 1701 to paint the king, then sixty-three years old and at the peak of his glory. The sovereign, particularly attentive to his image and its dissemination, had himself represented in the Throne Room at Versailles, in the ceremonial dress traditionally worn for a sovereign's coronation ceremonies in the Cathedral of Reims. The heavy blue velvet mantle, embroidered with gold fleurs-de-lys and edged in ermine, contributes to asserting the monarch's grandeur. All the regal insignia are shown, attesting to his power: the sword of Charlemagne; the golden crown of the kings of France; the chains of the Order of the Holy Ghost and the Golden Fleece; the gilt silver scepter tipped with a fleur-de-lys evoking royal authority; and the hand, symbol of judicial power.

The luxuriousness of the decor, the colorful play of the sumptuous materials of the curtain and carpet, like the costume worn by the sovereign, all contribute to the exhibition of pomp and glory, to which the sovereign was enamored throughout his life.

—Eric Moinet

Provenance: Seized during the Revolution, between 1791 and 1792; revolutionary départemental storerooms in the custody of the Loiret prefecture until 1800; transferred from there to the museum in 1825.
Bibliography: Demadières-Miron 1843, p. 56, no. 301; Demadières-Miron 1851, p. 104, no. 301; Marcille 1876, p. 126, no. 336; Marcille 1878, p. 33; O'Neill 1981, pp. 125, 126, no. 158.

 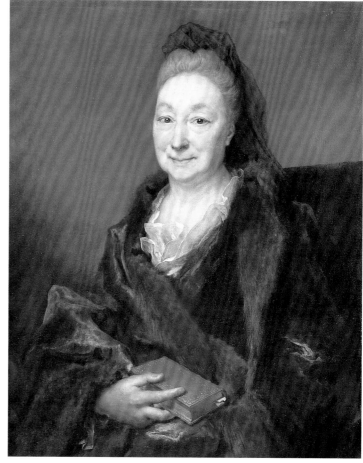

5. NICOLAS DE LARGILLIERE
(Paris 1656–Paris 1746)

Portrait of a Magistrate, ca. 1715

Oil on canvas, 31¹¹⁄₁₆ × 25½ in. (80.5 × 64.7 cm)

Musée de Picardie, Amiens; Bequest of Baroness de Fourment, 1927

(M.P.P. 3054–782)

6. NICOLAS DE LARGILLIERE
(Paris 1656–Paris 1746)

Portrait of a Magistrate's Wife, ca. 1715

Oil on canvas, 31¹¹⁄₁₆ × 25½ in. (80.5 × 64.8 cm)

Musée de Picardie, Amiens; Bequest of Baroness de Fourment, 1927

(M.P.P. 3054–783)

Trained in Antwerp, and then in London, Largilliere returned to Paris in 1682. Entering the Académie in 1686, he gradually gained recognition as one of the most important portraitists at the end of the reign of Louis XIV. Author of a large number of individual as well as group portraits, he was the painter of the upper-middle class, as opposed to his contemporary, colleague, and friend Rigaud, who concentrated on princely families and courtiers.

This pair of paintings depicts a couple as yet unknown, but whose identity will perhaps one day be discovered by way of the donor's genealogy. The man, in a long wig, is dressed in the black robe of a magistrate (is he a lawyer, a councilor at the Paris Parliament or from a provincial court, as Georges de Lastic has suggested?) against which his collar stands out. His wife, her head covered with a veil, wears a dark winter garment edged in fur, from which emerges a delicate blouse. Dominique Brême has maintained that the hairstyles enable us to date the paintings to around 1715. The artist conferred upon his models an attitude that, while giving them a look of composure, underlines their personality: the man points with his index finger in a gesture of eloquence and authority, while his wife holds a book from which bookmarks protrude. Above all, Largilliere knew how to render the features of these figures with realism, depicting their characters with distinction and humanity.

The handsome, dark chromatics of these portraits and their relative lack of ornamentation, which borders on austerity, combine with the vigorous brushwork, particularly perceptible in the draping, to result in two works unusual in the oeuvre of a master painter who was often more demonstrative.

Bibliography: Marcel 1924, pp. 205–13; Lastic 1983, pp. 53, 54.

7. ALEXIS GRIMOU
(Argenteuil 1678–Paris 1733)

Head of a Young Girl, ca. 1720

Oil on canvas, 21¾ × 18⅛ in. (55.3 × 46 cm)
Musée de Picardie, Amiens; Gift of the Lavalard Brothers, 1890
(M.P.Lav. 1894–156)

AN ARTIST WHOSE BRUSH WAS DEVOTED ALMOST EX-
clusively to portraiture, Grimou perfectly exemplifies those *petits maîtres* of the eighteenth century, too often neglected and unrecognized, whose singular talents, although obscured by modest careers, nonetheless tell us a great deal about the spirit of an era: in this case, the end of the reign of Louis XIV and the Regency.

In a number of his paintings, Grimou reveals himself to be sensitive to the art of Rembrandt (1606–1669) and his followers. In this picture, which seems to be an expression of a generic and idealized type of young girl, rather than an actual portrait, the smooth oval of the youthful face of a child wearing a beret and earrings emerges from the shadowy background. The torso, in dark clothing, is barely distinguishable against the background. Dominique Jacquot, who has identified two other versions of this composition, has emphasized the success of this work. While the spectacularly poetic effect of chiaroscuro underscores the influence of the great Dutch master, the smooth brushwork and the spirit that emanates from the features of the sitter, a well-behaved and ingenuous little girl, move away from the austere meditations of Rembrandt. Grimou's is a more anecdotal approach, evoking the sweetly mischievous charms of childhood, a subject highly popular in the eighteenth century.

Musée de Picardie Catalogues: 1894, p. 41, no. 156; 1899, p. 217, no. 157; 1911, p. 133, no. 154.
Bibliography: Foucart 1977, pp. 22, 43; Lesage 1978, pp. 86, 87.
Exhibition: Lille 1985, p. 109, no. 66.
Related Works: Alexis Grimou, *Head of a Young Girl,* ca. 1720, oil on wood, 18⅛ × 14¼ in. (46 × 36 cm), replica(?), Musée des Beaux-Arts, Nîmes. Alexis Grimou, *Head of a Young Girl,* ca. 1720, replica(?), location unknown.

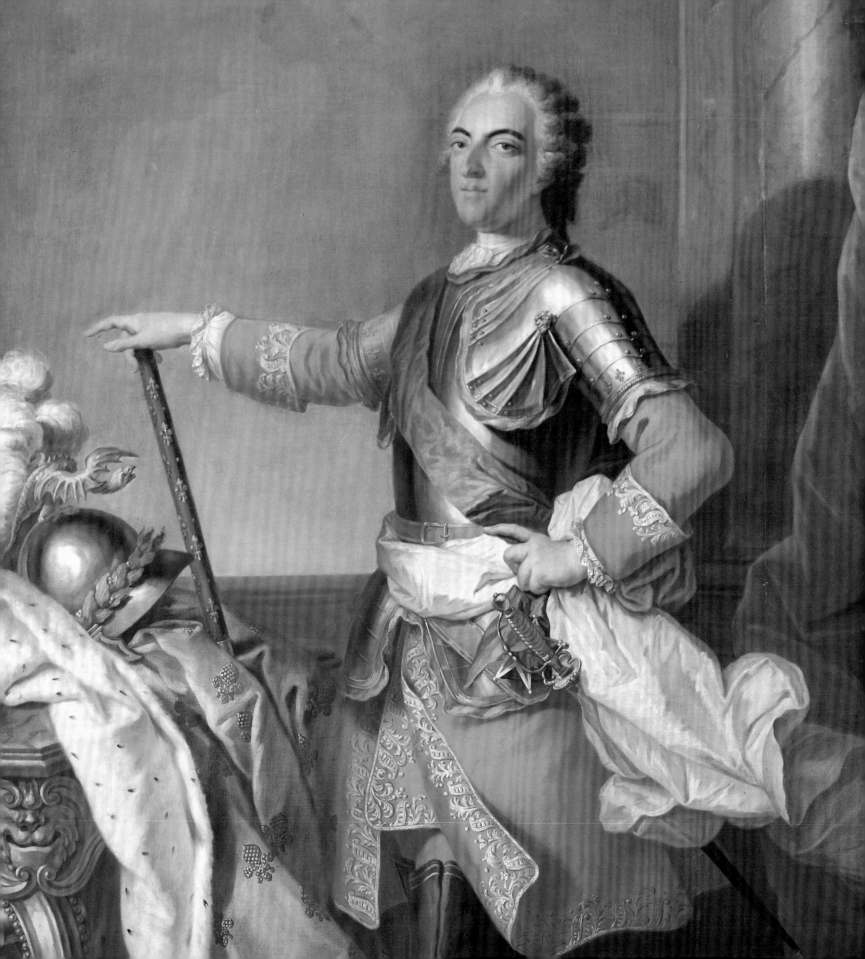

The Reign of Louis XV

1715–1774

DURING THE FIRST HALF OF THE EIGHTEENTH CENTURY, ROYAL PATRON-age was greatly reduced due, in part, to strains on the state's coffers caused by France's participation in numerous wars at the end of Louis XIV's reign. Fortunately, not all artists of the period depended on royal support. Some, including Antoine Watteau and to some extent Jean-Baptiste Greuze and, later in the century, Jean Honoré Fragonard, made a living on orders from private collectors. As a result, an art market outside of royal commissions emerged.

Both the Regency (1715–23) and the reign of Louis XV were characterized by re-laxed morals and a more hedonistic lifestyle, which translated into a taste for pastel-colored, charming, intimate, often erotic, works of art. Painting was still informed by the Académie's elevation of history painting over other subject matter, but artists prac-ticed in all genres. As a result, history paintings, portraits (see fig. 10), and still lifes were widely appreciated by aristocratic and bourgeois patrons alike.

Still, the importance of the Académie should not be underestimated. In 1737 the Académie began to sponsor the exhibition known as the Salon, named after the Salon Carré of the Louvre, where it took place, and designed to augment the prestige of his-tory painting. Each of these official exhibitions brought together paintings, sculptures, and engrav-ings produced by members of the Académie.

The Salon attracted huge audiences, comprised of people who were not necessarily patrons, but spectators. In addition, writings on art, such as those published in the *Mercure de France* and the criticism penned by Denis Diderot grew in popularity, influencing public opinion on the arts and the evolution of the arts themselves.

The directors of the *bâtiments du roi*, whose recommendations were usually approved by the king, sought to maintain the grand manner of history painting against the new Rococo style.

Fig. 10
Maurice Quentin de La Tour
Self-Portrait, ca. 1740
Pastel on paper mounted on canvas
25⅜ × 21 in. (64.5 × 53.5 cm)
Musée de Picardie, Amiens
Photo Marc Jeanneteau

8. ATTRIBUTED TO BONAVENTURE DE BAR
(Paris 1700–Paris 1729)

Military Camp Scene, ca. 1720

Oil on canvas, 16⅜ × 24⅞ in. (41.5 × 63.2 cm)
Musée de Picardie, Amiens; Gift of the Lavalard Brothers, 1890
(M.P.Lav. 1894–205)

ATTRIBUTED AT THE END OF THE NINETEENTH CEN-
tury to Nicolas Lancret (1690–1743), this painting has not been retained in that painter's catalogue. Pierre Rosenberg has recently suggested an attribution to Bonaventure De Bar, an artist about whom we unfortunately have very little information. Martin Eidelberg has entertained this hypothesis as well.

The scene takes us to a military encampment. In front of a tent, soldiers are drinking, conversing, and fondling young women. On the right, an officer advances with a lady on his arm; on the left, guards are lying near a tree. In a vista opening onto the distance, other groups are assembled around smoking bivouacs.

This type of composition, which employs a gallant, military vocabulary, was developed by Antoine Watteau (1684–1721). Watteu's emulators propagated versions that incorporated the same devices: soldiers, friendly beauties, and children in rustic settings. A festive, joyous impression emerges from these scenes that celebrate the charms of the wandering life.

Jean-Baptiste Pater—particularly his *Vivandières of Brest* (London, Wallace Collection)—Nicolas Lancret, and even François Octavien (1682–1740) and Pierre Antoine Quillard (ca. 1704–1733) readily developed this appealing repertoire, but curiously, the work of these disciples of Watteau, and especially that of the last two, remains relatively little studied. As a result, it is not yet possible to confirm the attribution of this attractive work.

Musée de Picardie Catalogues: 1894, p. 50, no. 205 (French School, eighteenth century); 1899, p. 218, no. 162 (attributed to Nicolas Lancret); 1911, p. 134, no. 159 (Lancret).
Bibliography: Boinet 1928, p. 15, pl. 42 (Jean-Baptiste Pater); Wildenstein 1924, p. 104, no. 552; Foucart 1977, p. 45; Lesage 1978, pp. 141, 142 (Pater).
Exhibition: Amiens and Dortmund 1960, no. 9.

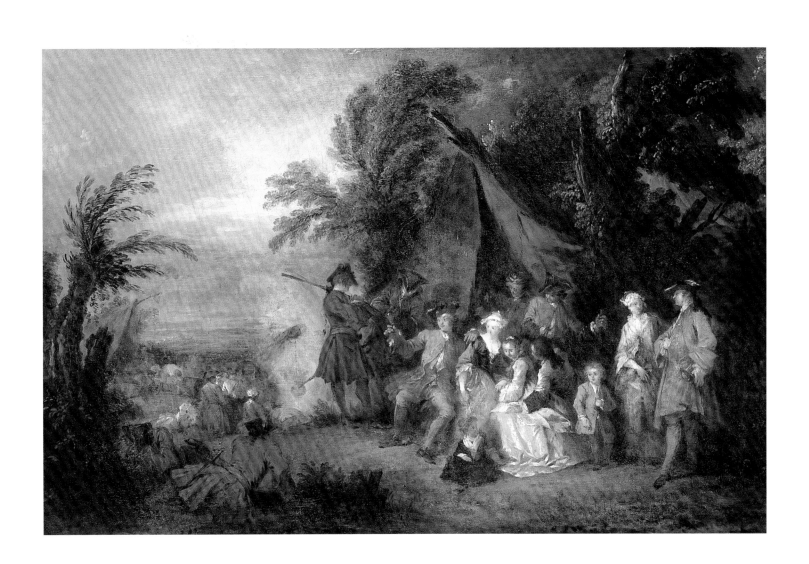

9. ATTRIBUTED TO BONAVENTURE DE BAR
(Paris 1700–Paris 1729)

Village Fete, ca. 1720

Oil on canvas, 25½ × 32⅜ in. (64.7 × 82.3 cm)
Musée de Picardie, Amiens; Bequest of Madame Gaudefroy du Roisel,
in memory of M. Lemerchier, former mayor of Amiens, 1929 (M.P.P.
3096–814)

IT IS POSSIBLE—ALTHOUGH NOT WITHOUT SOME
reservation—to suggest the name of Bonaventure De Bar as
the painter of this *Village Fete*. Martin Eidelberg has stated that it
is the type of painting that can be attributed to this painter. Little
information has come down to us about this artist who died young.

The figures placed around the central area—elegant young
women as well as pretty peasant girls, and handsome lords as
well as dashing valets—recall the spirit of the presumed painter's
teacher, Antoine Watteau. One can even make out, to the left
under the foliage, the traditional carnival figure of Gilles and, to
the right, a hurdy-gurdy player, both of whom seem to have come
from Watteau's cast of characters. In the center, a group of three
figures stands out: A gentleman advances in front of a valet to ap-
proach a young woman. Perhaps this trio conceals a curious story
(that of some Don Juan?).

In a light, precise, and porcelainlike style, this painting empha-
sizes the distinction of the artists who committed themselves to
Watteau's legacy, but who, like Lancret or Pater, developed their
own style dedicated to a gallantly rustic repertoire, the delicate
effects of which can be admired here.

Bibliography: Darcel 1860, p. 43; Lesage 1978, pp. 32, 33.

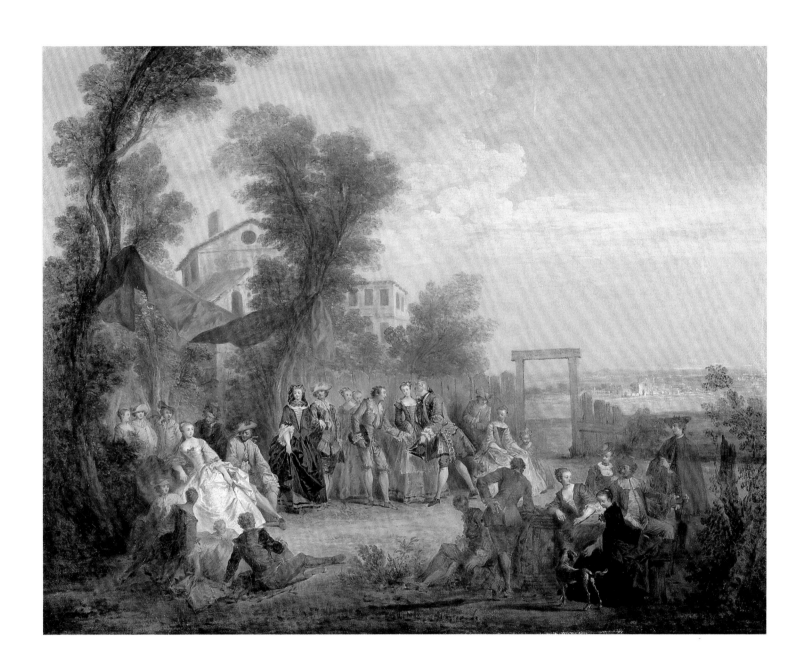

10. CHARLES PARROCEL
(Paris 1688–Paris 1752)

Cavalry Charging Foot Soldiers, 1721
Oil on canvas, 51⅝ × 77³⁄₁₆ in. (131 × 196 cm)
Musée de Picardie, Amiens; On deposit from the Musée du Louvre, 1872 (M.P.P. 330; Louvre 7122)

THIS CANVAS CAPTURES A MOMENT IN THE THICK OF a battle between riders and infantrymen. On the right, an officer wearing a breastplate and mounted on a white charger gallops into the fray. In front of him, a soldier jumps to the side to avoid being trampled, and on his flank, other soldiers charge with bayonets raised. Behind them, a rider fires his pistol at an officer, who collapses. In the foreground, a wounded rider falls backward onto the cadavers of men and horses, and to the left, a soldier attempts to flee the mêlée. In the background, in the smoke, the battle rages.

This violent cavalry charge is the work of Charles Parrocel, son of the painter Joseph Parrocel (1646–1704). Charles specialized in battle scenes, continuing a tradition exemplified in the previous century by certain Italian and Northern masters. His own enlistment in the cavalry in 1705 supported his vocation as a battle painter, and he entered the Académie with this reception piece in 1721. His talent for rendering the mêlées of men and animals led to commissions in 1736 and 1738 for two of Louis XV's exotic hunts.

Provenance: The artist's piece upon being received to the Académie, 1721.
Musée de Picardie Catalogues: 1873, p. 41, no. 89; 1875, p. 53, no. 115; 1878, p. 90, no. 115; 1899, p. 90, no. 222; 1911, p. 62, no. 270.
Bibliography: Bellemère 1908, p. 28; Demont 1913, pp. 80, nos. 88, 147; Boinet 1928, p. 13; Vergnet-Ruiz and Laclotte 1962, p. 247; *Catalogue sommaire illustré des peintures du Musée du Louvre et du Musée d'Orsay, Ecole française*, V, 1986, p. 316; Boyer and Champion 1993, pp. 294, 295, fig. 456.

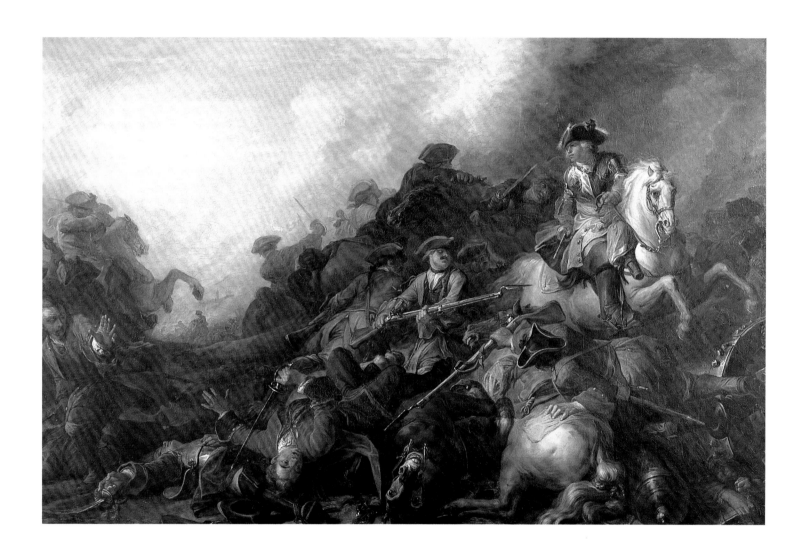

11. ATTRIBUTED TO JEAN-BAPTISTE VANLOO

(Aix-en-Provence 1684–Aix-en-Provence 1745)

Allegory of the Birth of the Dauphin Louis de France,
Son of Louis XV, in 1729, ca. 1729

Oil on canvas, 17⅞ × 21⅝ in. (45.5 × 55 cm)
Musée de Picardie, Amiens; Gift of the Lavalard Brothers, 1890
(M.P.Lav. 1894–166)

THIS SMALL CANVAS MAY BE THE SKETCH FOR THE large painting commissioned on October 19, 1729, by representatives of the City of Paris, which hung in the Great Hall of the Hôtel de Ville until 1746. In 1795 it was recorded as being in the Petits-Augustins storerooms (Colette Gilles-Mouton has written that it was described at the time as being quite mutilated), after which all trace of it was lost. The work celebrates, in an allegorical mode, the birth on September 4, 1729, of the dauphin, Louis de France (1729–1765), son of Louis XV.

The young Louis XV is seated on a throne, under a dais. Behind him are grouped members of the royal family and courtiers, among whom can be identified, in front, Cardinal Fleury, a minister of state, who would direct the kingdom's affairs from 1726 until 1743. Magistrates of the city kneel before the sovereign: the provost (Turgot), four aldermen (Remy, Le Roy, Mesnil, and Besnier), the king's prosecutor (Moriau), the court clerk (Taibout), and the tax collector (Boucot) distinguish themselves with gestures of deference. In the center stands France (or the City of Paris), personified by a crowned woman holding out her arms to receive the newborn from the hands of a winged figure with a flame on its forehead (Charity or Piety). Accompanying this figure are Religion, brandishing a chalice surmounted by the host, and Abundance, who spreads the contents of a horn filled with coins.

Elder brother of Carle Vanloo and father of Louis-Michel (1707–1771) and Charles Amédée (1719–1795), Jean-Baptiste Vanloo belongs to that famous dynasty of painters so active in France in the eighteenth century. He devoted himself to history painting and especially to portraiture. His career followed an impressive itinerary that took him, in his youth, from the south of France (Aix, Toulon) as far as Italy (Genoa, Turin, and Rome). Settling in Paris from 1720 to 1737, he was admitted into the Académie and established his reputation as a portraitist with a likeness of Louis XV. From 1737 to 1742, he lived in London, where he met with brilliant success. Ill health finally obliged him to return to his birthplace.

In this painting, executed within the framework of regular commissions from the Council of the City of Paris, which sought to perpetuate the memory of the municipal administration in large group portraits, Vanloo utilized his dual expertise as portraitist and history painter.

Gilles-Mouton has noted the existence of two preparatory, yet quite different compositions on the same theme, also attributed with reservation to Vanloo (Paris, Musée Carnavalet).

Musée de Picardie Catalogues: 1894, p. 43, no. 166 (attributed to Nicolas de Largilliere); 1899, p. 220, no. 168 (attributed to Largilliere); 1911, p. 135, no. 165 (Largilliere).
Bibliography: Babeau 1899, p. 219; Boinet 1928, pp. 13, 31; Florisoone 1948, pl. 48; Gilles-Mouton 1970, pp. 270–72, no. 5; Foucart 1977, p. 43.
Exhibitions: Paris 1933, no. 102; London 1954–55, no. 463
Related Work: Jean-Baptiste Vanloo, *Allegory on the Birth of the Dauphin*, ca. 1729, definitive painting, location unknown.

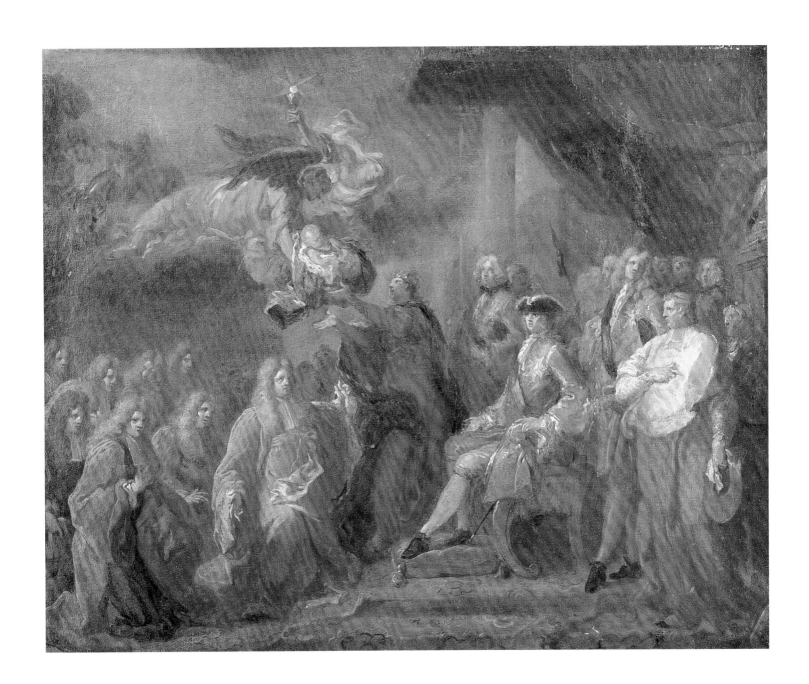

12. ATTRIBUTED TO FRANÇOIS LE MOYNE
(Paris 1688–Paris 1737)

Mountain Landscape Along the Seashore with a Bridge,
ca. 1720–30
Oil on canvas, 15½ × 26⅛ in. (39.5 × 66.5 cm)
Musée de Picardie, Amiens; Sent by the State (M.P.P. récol. 90.2.3)

THIS PAINTING SEEMS TO CORRESPOND TO ONE OF A
pair of paintings that were attributed to François Le Moyne in
the Musée de Picardie catalogue *Notice des tableaux qui décorent
les salles de la Mairie, à Amiens* (1820). If this is indeed the case,
the pendant has unfortunately been lost. Pierre Rosenberg, who
has recently studied this painting, has attributed it to Le Moyne
and dated it to the period when the artist is known to have been
in Italy.

A student of Louis Galloche (1670–1761), Le Moyne won the
Grand Prix de Rome in 1711 and was received into the Académie
in 1718. Above all a history painter, this ambitious artist was most
interested in carrying out extensive decorative ensembles. Appro-
bation came to him with the commission for the ceiling of the
Hercules Salon at Versailles (1733–36), earning him the title of
premier peintre du roi. Soon after, however, he committed suicide.

In this natural panorama, enlivened by a few structures
(bridge, citadel, ruins) and figures (fisherman, peasant leading his
mule), can be seen the energetic technique, free, thick brushwork,
and chromatic quality characteristic of Le Moyne's oeuvre. The
artist's interest in landscape is evident in a number of his works,
particularly in such canvases as the *Narcissus* in the Louvre, al-
though it is somewhat unexpected on the part of a painter devoted
to the grand genres of religious and mythological scenes.

Musée de Picardie Catalogue: 1820, p. 23, no. 19 or 20.

JEAN-SIMÉON CHARDIN
(Paris 1699–Paris 1779)

Still Life with Three Herring, 1731–33
Oil on canvas, 16⁹/₁₆ × 12⁷/₈ in. (42 × 32.8 cm)
Signed, bottom left, on the edge of the stone table: *J.B. Chardin*.
(the *S* was transformed into a *B* at a later date)
Musée de Picardie, Amiens; Gift of the Lavalard Brothers, 1890
(M.P.Lav. 1894–139)

IT WAS IN 1728 THAT CHARDIN, DESPITE NOT HAVING won a prize or received appropriate training, was admitted into the Académie. His career would be exclusively Parisian, and he would not question the hierarchy of genres, even though, as a painter of still lifes, he was ranked fairly low. A relatively discreet and conscientious artist, he exhibited regularly at the Salon and, in general, was warmly received by critics, including Diderot, who held the painter in high esteem.

In this painting, Chardin arranges everyday kitchen utensils and foodstuffs on a stone coping: a copper pot whose inside is tin-plated, a glazed terra-cotta casserole and an earthenware oven, a dishcloth, and provisions—two eggs, a thin leek, a loaf of bread, and a cabbage with three herring hanging from a hook. Many of these objects can be found in other compositions by the artist, who made variations on a theme by using the same elements over and over again.

As was his habit, Chardin made a replica of this work, currently in Williamstown along with its pendant, *Still Life with Two Onions*. It can be assumed that the Amiens painting was also part of a pair.

Chardin's untiring use of the same domestic elements throughout the period, from 1730 to 1735, does not indicate a lack of imagination. On the contrary, it was precisely this formula that enabled him to work exclusively on composition, form, and color —the very essence of painting. In these harmonious, stripped-down arrangements, with limited staging but always a large variety (even if the "actors" are always the same), Chardin invites us to appreciate the calm poetry of the commonplace accessories of everyday human life, revealing a heretofore unsuspected beauty.

Provenance: Barroilhet sale, March 10, 1856, no. 12, or Camille Marcille sale, January 12–13, 1857, no. 18; collection of the Lavalard Brothers as of 1862.

Musée de Picardie Catalogues: 1894, p. 38, no. 139; 1899, p. 213, no. 140; 1911, p. 131, no. 138 (dimensions reversed).

Bibliography: Horsin-Déon 1862, p. 145; Bocher 1876, p. 95; Goncourt 1880, p. 130; Gonse 1900, p. 15; Bellemère 1908, p. 43; Guiffrey 1908, p. 62, no. 34 (dimensions reversed); Goncourt 1909, p. 192; Furst 1911, p. 119; Boinet 1928, p. 15; Ridder 1932, pl. 42; Wildenstein 1933, no. 894, fig. 148; Vergnet-Ruiz and Laclotte 1962, pp. 84, 230; Wildenstein 1963, pp. 145, 146, no. 57, fig. 28; Foucart 1977, pp. 18, 22, 43, 50; Rosenberg 1983, pp. 82, 83, no. 65.

Exhibitions: San Francisco 1949, no. 5; Montreal, Quebec, Ottawa, and Toronto 1961–62, no. 15; Paris 1979, pp. 169, 170, no. 41; Lille 1985, pp. 64, 65, no. 13; Paris 1999–2000, p. 156, no. 57.

Related Work: Jean-Siméon Chardin, *Still Life with Three Herring*, ca. 1732, oil on canvas, 15³/₈ × 12¼ in. (39 × 31 cm), replica, Sterling and Francine Clark Art Institute, Williamstown.

14 · FRANÇOIS BOUCHER
(Paris 1703–Paris 1770)

The Rape of Europa, 1732–34
Oil on canvas, 19⅞ × 23⅞ in. (50.5 × 60.5 cm)
Musée de Picardie, Amiens; Gift of the Lavalard Brothers, 1890
(M.P.Lav. 1894–125)

BETWEEN 1732 AND 1734 BOUCHER EXECUTED FOR François Derbais, a lawyer at the parliament (d. 1743), a series of paintings (examined by Alastair Laing in exhib. cat., New York, Detroit, Paris 1986–87) intended to form a décor for his residence in the rue Poissonnière in Paris. The young Boucher, recently back from Italy, put even more energy than necessary into this commission to draw attention to his talent. He produced eight large-scale paintings that impressed his contemporaries: *The Rape of Europa* and *Mercury Entrusting the Young Bacchus to the Nymphs* (both in London, The Wallace Collection), *Venus Asking Vulcan for Weapons for Aeneas* (Paris, Musée du Louvre), *Aurora and Cephalus* (Nancy, Musée des Beaux-Arts), *The Birth of Venus,* and four canvases featuring cupids that were to be mounted over the doors (current locations unknown). This sketch is the study for *The Rape of Europa.*

Here, Boucher illustrates a subject frequently treated by artists since the Renaissance, drawn from Ovid's *Metamorphoses* (II, 835–875). Jupiter is enamoured of the beautiful Europa, daughter of Agenor, king of Sidon (Phoenicia). In order to approach the princess, who is surrounded by her followers, he decides to transform himself into a superb, peaceful bull and to blend in with the royal herd. Europa, intrigued and then charmed by this splendid beast, finally sits on its back. The deceitful god gradually makes his way toward the sea, eventually carrying off his prey over the waves.

In his treatment of the subject, the painter has remained faithful to the ancient text: The calm bull, lying in the center, receives the ingenuous princess on its flank. Europa's young companions, including a putto, who is disappearing between the animal's hooves, crowd around. Small waves signifying the shore are seen in the left foreground, and the oxen of Agenor's herd are gathered on the right. In the sky, Jupiter's eagle, accompanied by three putti, alludes to the divine stratagem.

As a youth, trained first in engraving, then in painting by François Le Moyne (1688–1737), Boucher won first prize in painting from the Académie in 1723. He spent several years in Italy (from 1728 to 1731) and upon returning to Paris, was first accepted (1731), then received (1734) into the Académie. It was therefore an exceptionally talented young man of barely thirty who painted this powerful grisaille. The words of the collector Pierre Jean Mariette (1694–1774) might be applied to this painting: Judging the décor painted for Derbais, Mariette commented, "Herein, all is admirable, and especially a brush that is as firm as it is graceful."

Provenance: Sale of the M. Vallet (or Vallat) Collection, Grands-Augustins, Paris, April 7, 1774, no. 40; Marcille sale, after death, 1857.

Musée de Picardie Catalogues: 1894, p. 35, no. 125; 1899, p. 209, no. 126; 1911, p. 129, no. 126.

Bibliography: Horsin-Déon 1862, p. 145; Bellemère 1908, p. 42; Boinet 1928, p. 14; Foucart 1977, pp. 22, 42, 50; Huchard, Lernout, Mahéo, and Couderc 1995, p. 103.

Exhibitions: Rotterdam and Braunschweig 1983, no. 57; New York, Detroit, and Paris 1986–87, pp. 161–64, no. 25; Amiens 1992, p. 11 (no. 15).

Related Works: François Boucher, *The Rape of Europa,* ca. 1734, oil on canvas, 90⅞ × 107⅝ in. (230.8 × 273.5 cm), definitive painting, The Wallace Collection, London. For the preliminary drawings for the definitive composition, see exhib. cat., New York, Detroit, and Paris 1986–87, pp. 163, 164.

15. JEAN-SIMÉON CHARDIN
(Paris 1699–Paris 1779)

Still Life with Two Heads of Celery, ca. 1733

Oil on canvas, 12⅞ × 15⅞ in. (32.8 × 40.2 cm)

Signed, bottom right: *c d*

Musée de Picardie, Amiens; Gift of the Lavalard Brothers, 1890

(M.P.Lav. 1894–140)

CHARDIN HAS ARRANGED ON A STONE TRAY TWO heads of celery, a dishcloth, a wooden spice box, a copper skimmer, a glazed terra-cotta dish, and a tureen; a large piece of meat hangs from a hook. Following his customary procedure, the artist executed several versions of this same composition. One of these is now in Wanás, Sweden, with its pendant dated 1734: *Still Life with Casserole*. The Amiens canvas, which originally must have been part of a pair, most probably dates from the same period.

The painting's subject and sense of harmony recall still lifes Chardin painted just before he turned to genre scenes. Indeed, beginning in 1733, the painter devoted himself—if not exclusively, at least for the most part—to subjects he had rarely explored until then. He became interested in bringing to life women, children, and servants of the lower-middle and middle classes engaged in their domestic chores, their daily rituals. *Le Bénédicité* (*The Blessing*), *La Mère laborieuse* (*The Hard-Working Mother*), and *La Pourvoyeuse* (*The Purveyor*) (Paris, Musée du Louvre) are perhaps the most famous examples of this new creative vein.

This painting, though small, nonetheless possesses a certain monumentality. Again the painter quietly expressed the simple beauty of kitchen utensils, the poetry of the accouterments of domestic life.

Provenance: Collection of the Lavalard Brothers before 1862.

Musée de Picardie Catalogues: 1894, p. 38, no. 140; 1899, p. 213, no. 141; 1911, p. 131, no. 139 (dimensions reversed).

Bibliography: Horsin-Déon 1862, p. 145; Bocher 1876, p. 95; Gonse 1900, p. 15; Bellemère 1908, p. 43; Guiffrey 1908, p. 62, no. 35 (dimensions reversed); Furst 1911, p. 119; Boinet 1928, p. 15; Wildenstein 1933, no. 955; Vergnet-Ruiz and Laclotte 1962, pp. 84, 230; Wildenstein 1963, pp. 157, 159, no. 118, fig. 52; Foucart 1977, pp. 18, 22, 43, 50; Rosenberg 1983, p. 84, no. 73.

Exhibitions: Paris 1931, no. 6; Sarrebrück and Rouen 1954, no. 79; Paris 1979, pp. 172, 173, no. 43; Caen 1993, p. 45.

Related Works: Jean-Siméon Chardin, *Still Life with Two Heads of Celery*, ca. 1733, oil on canvas, 13 × 16⅜ in. (33 × 41.5 cm), replica, private collection, Wanás, Sweden. Jean-Siméon Chardin, *Still Life with Two Heads of Celery*, ca. 1733, oil on canvas, 12⅝ × 15⅝ in. (32.1 × 39.7 cm), replica, location unknown.

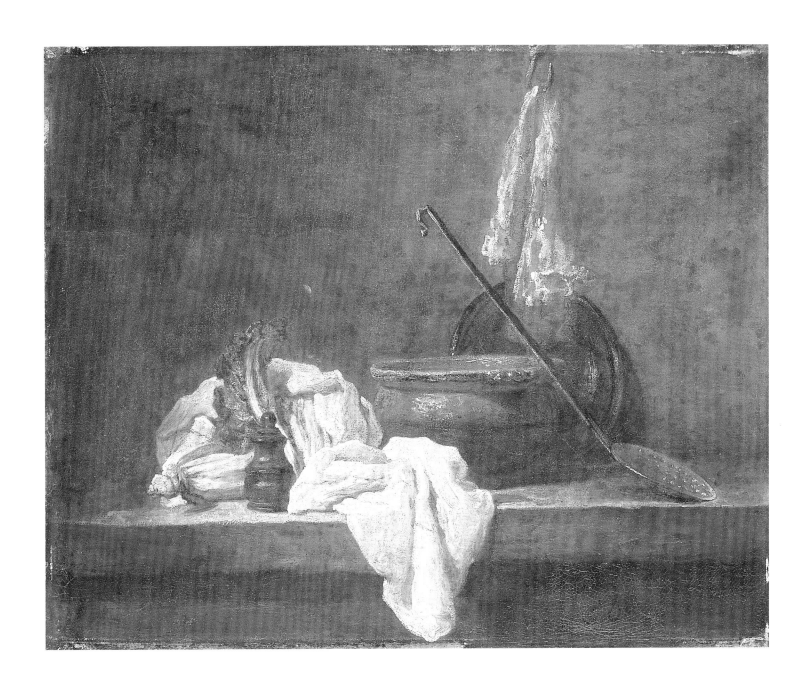

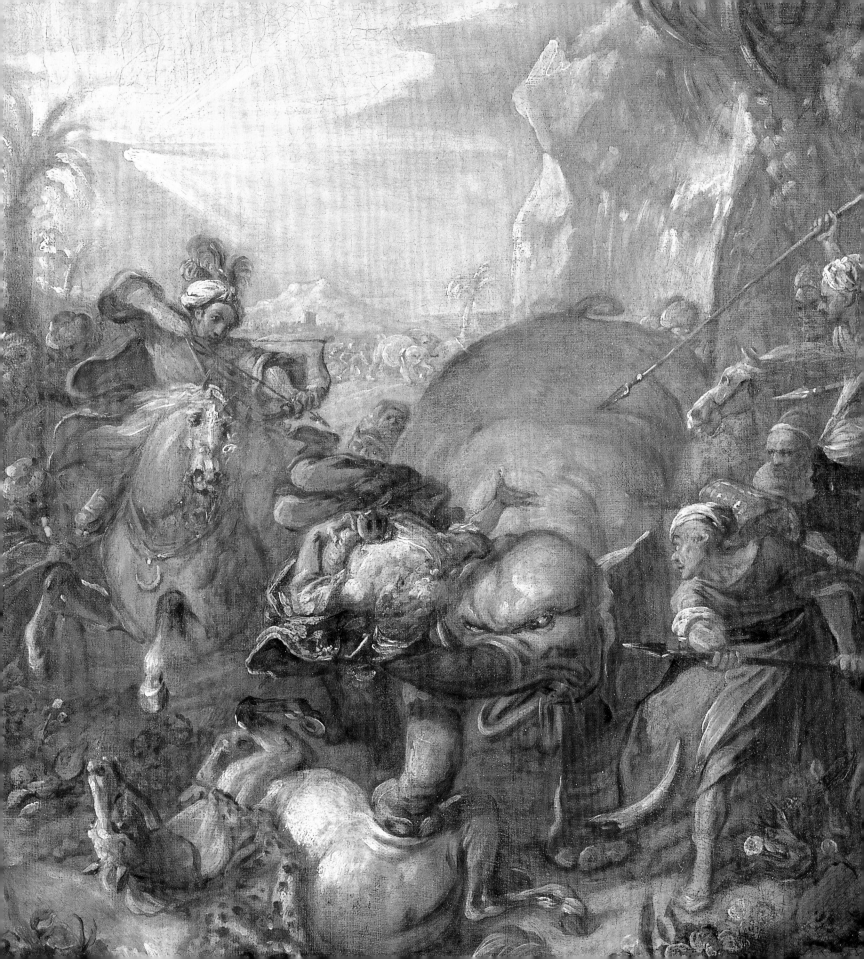

FROM THE TIME HE TOOK THE THRONE, LOUIS XV WANTED TO CREATE AT Versailles, alongside the vast official rooms conceived at the time of Louis XIV, small, comfortable, attractively decorated private apartments suitable for allowing the young sovereign to retire in private for friendly get-togethers far from the constraints, formalities, and etiquette of court life. Among numerous projects, the Petite Galerie du Roi, also called the Gallery of Hunts in Foreign Lands, is one of the most spectacular, by virtue of the singularity of its conception as well as its longevity (many of these apartments would, in fact, undergo thorough upheavals, according to the evolution of fashion). In the exhibition catalogue devoted to this cycle (1995), Xavier Salmon has related the history of the gallery and the paintings that decorated it.

In 1735, on the third floor of the north wing of the Marble Court, work began on the decoration of the king's Petite Galerie. This space under the eaves has four windows on the south side looking onto the Marble Court and two on the north opening onto the Stag Court.

Louis XV was a great hunting enthusiast, and the hunt is a theme that appears frequently in the decoration of his apartments. Two masters of animal painting, François Desportes (1661–1743) and Jean-Baptiste Oudry (1686–1755), regularly supplied paintings featuring hunts with hounds. When it came time to decorate the Petite Galerie, however, it was decided to propose a more exotic repertoire and a style closer to history painting, while still indulging the royal passion for scenes of the hunt. Artists known for this genre were called upon, though Pater and Lancret, who specialized in *fêtes galantes*, were also designated.

As of the end of 1735, six paintings had been commissioned and the painters immediately set to work. In 1736, *The Lion Hunt* by Jean-François de Troy (fig. 11); Parrocel's *Elephant Hunt* (no. 19), Lancret's *Tiger Hunt* (no. 17), Pater's *Chinese Hunt* (no. 18), Boucher's *Leopard Hunt* (no. 16),

Fig. 11
Jean-François de Troy
The Lion Hunt, 1735
Oil on canvas
72¼ × 50⅝ in. (183.5 × 128.5 cm)
Musée de Picardie, Amiens
Photo Marc Jeanneteau

Fig. 12
Carle Vanloo
The Bear Hunt, 1736
Oil on canvas
72¼ × 50⅝ in. (183.5 × 128.5 cm)
Musée de Picardie, Amiens
Photo Marc Jeanneteau

and Vanloo's *Bear Hunt* (fig. 12) took their places on the walls of the gallery (fig. 13, top).

Beginning in 1738, work being carried out on the lower level necessitated the reorganization of the Galerie, and it was enlarged to the east by an additional bay. This modification resulted in the commissioning of two new canvases: Parrocel's *Wild Bull Hunt* (no. 20) and Vanloo's *Ostrich Hunt* (no. 21). According to Salmon, Pater's canvas, which included a variety of animals rather than just one, did not fit in with the other paintings: it was put into storage and replaced by a *Crocodile Hunt* (fig. 14) commissioned from Boucher and delivered in 1739.

In its final form, the Petite Galerie was a wide corridor some twenty meters long, with five deep-set windows opening to the south (the two north windows were blocked by recent construction). Facing these openings were large mirrors set in shallow recesses that reflected the daylight. The eight paintings were set in the paneling between the windows or the mirrors, according to an arrangement that Salmon has been able to re-establish (fig. 13, bottom). A fireplace, decorated with palm trees, occupied the center of the north wall, with another on the short, west wall. The paintings provided the main decoration of the room: Placed very low, they were integrated into the paneling, in which moldings and sculpted gilt ornaments stood out against a white background.

Salmon attributes part of this paneling to Jacques Verberckt (1704–1771) and, in particular, the part that formed the frames that still surround the four hunts by Boucher and Vanloo. The paneling integrates elements that correspond to the spirit of the painted decor—lion and bear heads—especially around the canvases themselves: At the top of each of them, "indigenous" heads seem to symbolize the four continents.

The Petite Galerie du Roi was used for games, and it remained unchanged until 1767 at which time its décor—which survives today only in the recesses of the windows—was completely dismantled to allow for the installation of the apartments of Madame du Barry, who began living there in 1770.

Relegated to the court storerooms, a few of the paintings were occasionally used to decorate certain spaces. Four of them—the hunts by Boucher and Vanloo—were finally sent by the State to Amiens in 1801, part of the preparations for the signing of the Peace of Amiens in 1802. They were soon converted into panels mounted above the doors in the courtroom of the Hôtel de Ville. Sent to the new museum in 1874, the four paintings were eventually joined by the five others in 1923. Since that time, the reassembled series has allowed us to conjure up this exceptional ensemble, one of the most original décors created for Louis XV at Versailles.

Fig. 13
Plans showing the locations of the paintings in the Petite Galerie du Roi (Gallery of Hunts in Foreign Lands) at Versailles before 1738 (top) and after 1738 (bottom). Reprinted from Xavier Salmon, *Versailles: Les chasses exotiques de Louis XV.* Paris, 1995.

1. Carl Vanloo, *The Bear Hunt*
2. Jean-François de Troy, *The Lion Hunt*
3. Nicolas Lancret, *The Tiger Hunt*
4. Charles Parrocel, *The Elephant Hunt*
5. François Boucher, *The Leopard Hunt*
6. Jean Baptiste Pater, *The Chinese Hunt*
7. Charles Parrocel, *The Wild Bull Hunt*
8. Carle Vanloo, *The Ostrich Hunt*
9. François Boucher, *The Crocodile Hunt*

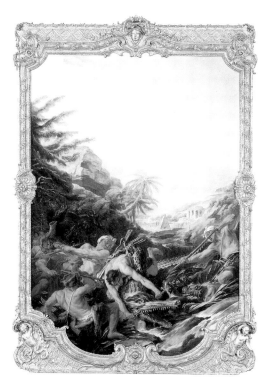

Fig. 14
François Boucher
The Crocodile Hunt, 1739
Oil on canvas
72½ × 50⅝ in. (184 × 128.5 cm)
Musée de Picardie, Amiens
Photo Marc Jeanneteau

16. François Boucher

(Paris 1703–Paris 1770)

The Leopard Hunt, 1736

Oil on canvas, 72 × 50⅝ in. (183 × 128.5 cm)
Signed and dated, bottom right: *f. Boucher f. 1736*
Border forming frame attributed to Jacques Verberckt (1704–1771)
Musée de Picardie, Amiens (M.P.P. 40)

The hunt takes place in a landscape with a hilly gorge, constructed in successive planes whose diagonals accentuate the effect of depth and add dynamism to the action. The hunters appear and disappear behind the rocky irregularities of the terrain, which sometimes reveal only the head of the animal being pursued. In accordance with the requirements of the commission for all the hunts in the Petite Galerie, the main action takes place in the foreground of the composition. Unlike his colleagues, Boucher did not want a numerical imbalance between the wild animals and their hunters: It is not certain that the three Turks in the front will prevail over the leopards, even though there is a clear contrast between the humans' expressions of determination or terror, and the relative docility of the animals.

It is clear that Boucher drew inspiration from two prints that Louis Desplaces (1682–1739) executed in 1731 after the *Lion and Tiger Hunts* painted by Charles Parrocel for the duc de Mortemart. The prints present similar physical actions, establish a relationship in the same spirit between the figures and the landscape, and treat the vegetation in the same manner. Above all, they also include the curious detail of glass balls. The explanation for these is found in the caption on the tiger hunt print by Jean-Jacques Flipart (1719–1782): "The hunter normally strews glass balls intended to amuse the Tigress whose young he carries off; the tigress then believing she recognizes her young when seeing herself reflected in the balls; but as soon as she discovers the fraud, she goes into a rage, pursues the hunter and wreaks carnage on

everything she can reach." This curious hunting technique was not the product of a fertile imagination: Illustrated and described since antiquity, it is mentioned in the *Treatise on Animals* (1651) by Albert le Grand (ca. 1193–1280), a medieval theologian.

Also remarkable is the striking contrast between the naturalism of the wounded leopard, lying to the right, and the humanization of the one to the left pouncing on the downed hunter. The former seems to attest to the artist's familiarity with the animal, whereas the other seems to belie such knowledge. Pontus Grate offered an explanation for this apparent contradiction in 1987: Boucher used a drawing by Jean-Baptiste Oudry, which Oudry himself had used when, in 1739, he painted the caged leopard teased by two ferocious hounds, now in the Nationalmuseum of Stockholm. The wounded cat in that drawing adopts a pose identical to the one seen in Boucher's hunt.

—Xavier Salmon

Provenance: Château de Versailles, Petite Galerie, 1736; Versailles, court storerooms, 1767; Versailles, Musée national, 1794; sent to Amiens by the State as part of the preparations for the Amiens Congress of 1802, 1801 (Courtroom of the Hôtel de Ville).

Musée de Picardie Catalogues: 1820, p. 4, no. 2; 1875, p. 19, no. 23; 1878, p. 33, no. 23; 1899, p. 16, no. 40; 1911, p. 11, no. 47.

Bibliography: Michel 1889, p. 38; Gonse 1900, p. 12; Engerand 1901, pp. 40, 41; Michel, Soulié, and Masson 1906, pp. 30, 94, no. 1728; Nolhac 1907, p. 32; Bellemère 1908, pp. 15–16; Boinet 1928, pp. 14, 36; Racinais 1950, vol. I, pp. 38, 39; Vergnet-Ruiz and Laclotte 1962, p. 74; Ananoff and Wildenstein 1976, vol. I, pp. 250, 251, no. 125; Ananoff and Wildenstein 1980, pp. 94, 95, no. 126; Hazlehurst 1984, pp. 227–29, fig. 10; Grate 1987, pp. 73, 74; Baratte 1990, pp. 119–22; Grate 1994, p. 237; Huchard, Lernout, Mahéo, and Couderc 1995, pp. 96, 97, 100; Salmon 1995, pp. 37, 49, 51; Scott 1996, p. 92; Gaillemin 1996.

Exhibitions: Amiens 1860, no. 3; Paris 1932, pp. 59, 60, no. 125; San Francisco 1949, p. 14, pl. no. 1; Vienna 1966, pp. 50, 60, no. 3; Amiens and Dunkerque 1969, p. 10, no. 5; New York, Detroit, and Paris 1986–87, pp. 173–76, no. 29; Amiens 1992, p. 12, no. 17; Amiens and Versailles 1995–96, pp. 68–71, no. 18.

Related Works: See exhib. cat., New York, Detroit, and Paris 1986–87, pp. 173, 174, and exhib. cat., Amiens and Versailles 1995–96, p. 68.

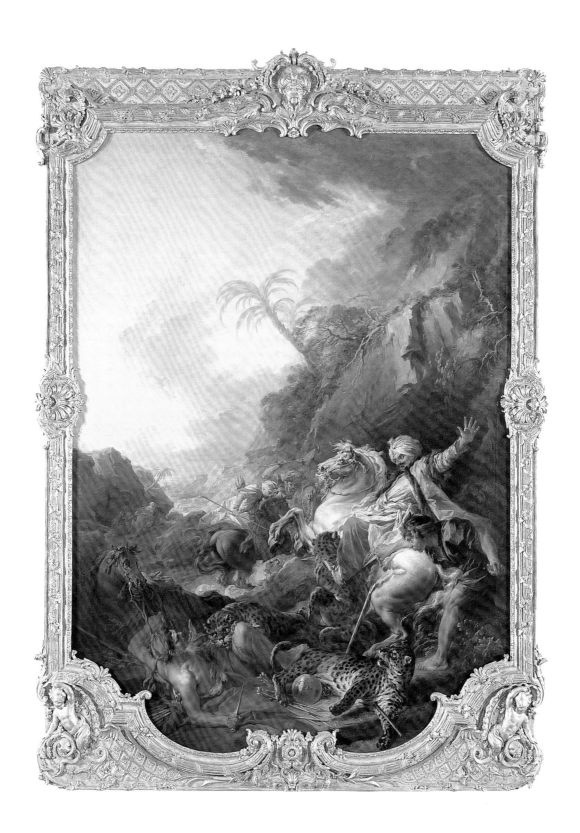

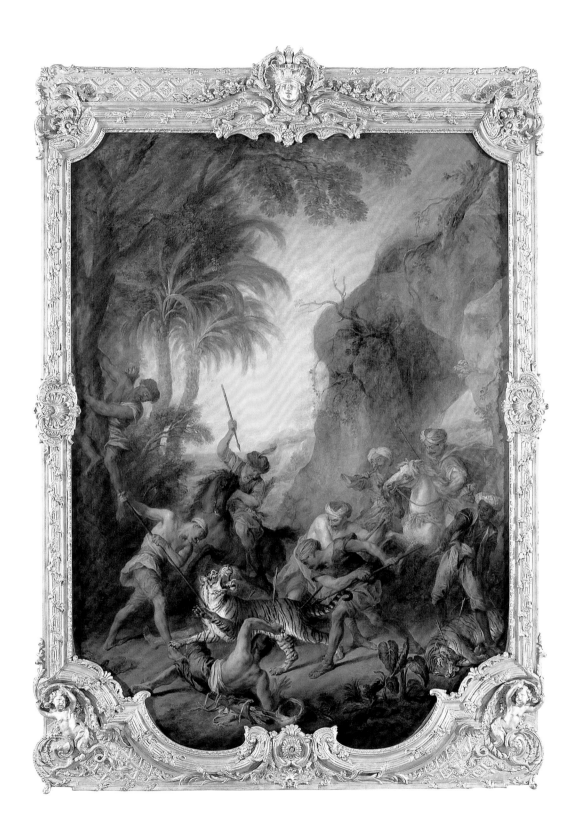

17. NICOLAS LANCRET
(Paris 1690–Paris 1743)

The Tiger Hunt, 1736

Oil on canvas, 69½ × 50⅝ in. (176.5 × 128.5 cm)
Signed and dated, bottom left: *Lancret 1736*
Musée de Picardie, Amiens; On deposit from the Musée du Louvre,
1932 (M.P.P. 2088–688; Louvre 5596)

ACCORDING TO HIS BIOGRAPHER, BALLOT DE SOVOT, Lancret's sole ambition was to create works for the king. By 1735, the year of his appointment as advisor to the Académie Royale, his ambition had been rewarded: He had become one of the regular painters for the sovereign's private apartments. Indeed, in the space of three years, between 1735 and 1737, he delivered no fewer than ten paintings for these extremely private rooms whose decoration was supposed to be a faithful reflection of the inhabitants' tastes. For Versailles, in particular, he painted *Le Déjeuner de jambon* (Chantilly, Musée Condé) in 1735, which hung in the dining room of the king's small apartments.

Among these multiple commissions, usually on pastoral subjects, *The Tiger Hunt* of 1736 stands out as an exception. When the exotic hunt paintings for the Petite Galerie were commissioned, it must have been quite difficult for the *bâtiments du roi* not to solicit a painter who was enjoying such favor with the king. However, the resulting painting must not have been a complete success, or else Lancret refused to continue in this vein, for he was not one of the three painters engaged in 1738 to paint the new hunting scenes destined for the Petite Galerie. He was appreciated primarily for his pastoral scenes.

Nonetheless, Lancret's efforts at precision in depicting the two tigers are undeniable. He must certainly have observed a living specimen both awake and at rest. Positioned at the center of the composition, Lancret's great cat is depicted in a defensive stance, growling as if in response to wounds the hunters have inflicted. The realism is further accentuated by the extreme precision of the brushstroke, which gives the fur a tactile aspect. Lancret's use of the prints of Antonio Tempesta (1555–1630) is also evident; in the opinion of Hazlehurst, they furnished him with a repertoire of varied poses from which he drew inspiration. Judging by his drawing and preparatory sketch, Lancret seems to have had some difficulty in arranging his composition. The X-ray of the final painting even shows that he continued to modify the positions of the participants in the hunt, attesting to his hesitations. Unaccustomed to this sort of subject, he clearly needed to think about it at greater length. The detail of the plant at bottom left, its leaves suggesting a cyclamen, also indicates that he gathered information out of concern for the greatest exotic credibility.

—XAVIER SALMON

Provenance: Château de Versailles, Petite Galerie, 1736; Versailles, court storerooms, 1767; Versailles, Musée national, 1794; Paris, Musée centrale des Arts, late eighteenth-early nineteenth century; Fontainebleau, Château, 1832–1922.

Bibliography: Dezallier d'Argenville, 1762, vol. 4, p. 438; Dezallier d'Argenville, 1779, p. 102; Guiffrey 1874, p. 32; Chennevières 1881, no. 102; Engerand 1901, pp. 263, 264; Gabillot 1907, pp. 52, 54; Boinet 1921, pp. 3, 4; Wildenstein 1924, pp. 31, 57, 58, 99, no. 400, fig. 107; Verlet 1926, S 549; Boinet 1928, p. 14; Lécuyer 1932, p. 18; Racinais 1950, vol. 1, pp. 38–39; Hazlehurst 1984, pp. 230, 231, fig. 16; Holmes, 1985, pp. 27, 31, fig. 12; exhib. cat., New York and Fort Worth 1991–92, pp. 80, 91; Salmon 1995, p. 41; Gaillemain 1996.

Exhibitions: Copenhagen 1935, p. 34, no. 110; Geneva 1949, p. 53, no. 94; Hamburg and Munich 1952–53, no. 36; Vienna 1966, p. 65, no. 39; Moscow and Leningrad 1978, no. 61; Amiens and Versailles 1995–96, pp. 52–54, no. 9.

Related Works: Nicolas Lancret, *Tiger Hunt*, 1735–36, oil on canvas, 19⅜ × 15¾ in. (49 × 40 cm), preparatory sketch, private collection. Nicolas Lancret, *Tiger Hunt*, 1735–36, black and white chalks on paper, 16⅛ × 12¼ in. (41 × 31 cm), preparatory drawing, Musée de Picardie, Amiens.

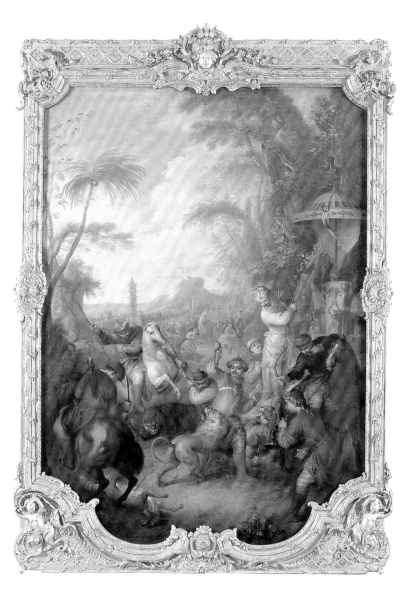

18. JEAN-BAPTISTE PATER
(Valenciennes 1695–Paris 1736)

The Chinese Hunt, 1736

Oil on canvas, 67¾ × 50 in. (172 × 127 cm)
Signed, bottom left: *Pater pinccit*
Musée de Picardie, Amiens; On deposit from the Musée du Louvre,
1923 (M.P.P. 2088–689; Louvre 7144)

PATER PAINTED *THE CHINESE HUNT* IN THE EARLY
months of 1736, most certainly before June 28, the date on which
he bequeathed to his servant Catherine-Perrette Castel in his will
"the sum of five hundred *livres* to be taken and received on the
first payment which will be made for the painting I had the honor
to execute for the King." This was his first official commission,
and the work was his most ambitious painting. Nothing in his ear-
lier career presaged that Pater would be one of those called upon
for the works in the Petite Galerie. Unlike his colleagues, he had
neglected his career at the Académie, attending none of that pow-
erful institution's sessions after he was admitted in 1728. He had
thus denied himself access to commissions from the *bâtiments du
roi.* Thanks to his talents as a painter of *fêtes galantes,* he enjoyed
an estimable reputation, but his tastes hardly attracted him to ex-
otic subjects. The few Turkish-inspired fantasies he painted were
exceptions, and even then, they stemmed from an exoticism of
costumes and accessories most often borrowed from the theatrical
world. He had even less experience as an animal painter.

This is no doubt the reason he executed so many preparatory
works before attacking his large canvas. However, the final paint-
ing was not a success with either the king or the *bâtiments du roi;*
it was shown in the Petite Galerie only from 1736 to 1739. When
François Boucher's *Crocodile Hunt* was finished in 1739, *The Chi-
nese Hunt* was relegated to the court storerooms. This decision
was not unjustified: The painting's weakness lies in the fact that
the artist represented several animals whose appearance in the
same scene is realistically impossible: He placed a striped tiger

from Asia and a spotted leopard from Africa in the middle of his composition. In the foreground, an African hyena is expiring while in the background, a European boar vainly attempts to escape its pursuers. Though perhaps amusing today, this disregard for accuracy is a far cry from the concern for zoological realism sought by Boucher or even, more surprisingly, by Lancret, the other painter of *fêtes galantes*. Pater does not seem to have spent much time in menageries.

However, the composition itself is not lacking in brilliance. It shows us a China made up of inventions and borrowings from both European and Oriental sources. A pagoda and the curved roofs of a city stand out on the horizon. The motif was conceived in imitation of numerous manufactured objects imported from the Far East, which were all the rage in Europe at the time. In execution, however, the scheme became a general exoticism rather than a strictly Chinese one. The few accessories Pater introduced into the foreground of his hunt—fur-covered helmets and a horn looking like a still—may give an impression of China. They are, however, the product of the painter's imagination.

Unquestionably more astonishing is the king's palanquin with parasol. With its delicate colors, it recalls the precious aspect of Pater's work in porcelain. The chromatic palette, with its unreal character, also contributes to the work's exoticism. Particularly poetic is the hazy, hilly landscape in the distance, tinted graded shades of blue, its softness and atmospheric value accentuated by the few splashes of pink, red, green, and yellow in the hunters' costumes in the foreground. Perhaps nowhere else in the Hunts in

Foreign Lands cycle does color play so important a role. In this way Pater made up for his lack of experience in the exotic and animal fields. His China was less concerned with archeology than with fantasy. In keeping with a magical vein, his invention prefigures the realm that Boucher would describe in 1742 in his famous series of sketches that were destined to be woven at the royal Gobelins workshops (Besançon, Musée des Beaux-Arts et d'Archéologie). To borrow the phrase of the Goncourt brothers, China was "one of the provinces of the Rococo."

—Xavier Salmon

Provenance: Château de Versailles, Petite Galerie, 1736; Versailles, court store-rooms, 1739; Versailles, Musée national, 1794; Paris, Musée centrale des Arts, late eighteenth–early nineteenth century; Fontainebleau, Château, 1832–1922.

Bibliography: Chennevières 1881, p. 59, no. 116; Engerand 1901, pp. 40, 389; Gabillot 1907, p. 36; Boinet 1921, pp. 2–4; Boinet 1928, pp. 14, 39; Ingersoll-Smouse 1928, pp. 29, 34, 35, 67, no. 376, p. 189, no. 160; Lesage 1978, pp. 143–45, no. 36; Hazlehurst 1984, pp. 231, 232, fig. 18; Barthélemy 1990, pp. 18, 19; Huchard, Lernout, Mahéo, and Couderc 1995, pp. 97, 98; Levêque 1995; Fernandez 1995, p. 108; Salmon 1995, pp. 34–36; Salmon 1997, pp. 101–108; Gaillemain 1996.

Exhibitions: Berlin 1973, p. 285, no. N 33; Amiens and Versailles 1995–96, pp. 58–60, no. 12.

Related Works: Jean-Baptiste Pater, *The Chinese Hunt*, 1735–36, oil on canvas, 21 5/6 × 17¾ in. (55 × 45 cm), preparatory sketch, Musée du Louvre, Paris. Jean-Baptiste Pater, *The Chinese Hunt*, 1735–36, oil on canvas, 21⅞ × 17¾ in. (55 × 45 cm), preparatory sketch, private collection, Switzerland. For the preparatory drawings, see exhib. cat., Amiens and Versailles 1995–96, pp. 64–67, nos. 15–17; and Salmon 1997, p. 107, fig. 7, p. 108.

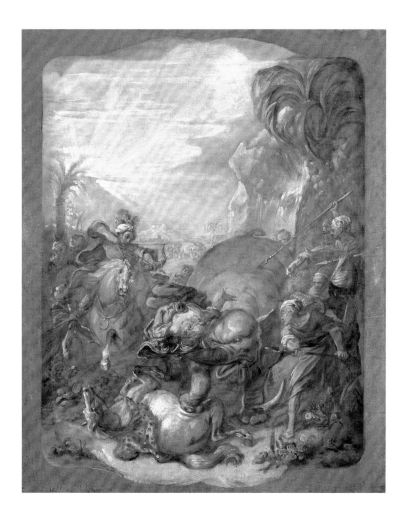

19. CHARLES PARROCEL
(Paris 1688–Paris 1752)

The Elephant Hunt, 1736
Oil on canvas, 25⅝ × 21³⁄₁₆ in. (65.2 × 53.5 cm)
Musée de Picardie, Amiens; On deposit from the Musée du Louvre, 1960 (M.P.P. 4391; Louvre R.F.1959–14)

FOLLOWING HIS ADMISSION INTO THE ACADÉMIE ON February 3, 1721, Charles Parrocel acquired a reputation as a painter of battles, the genre in which his father, Joseph, had also distinguished himself. Unanimously recognized by the critics of his time for his fiery imagination, the vigor of his color, the fluency of his brush, and his generous application of paint, Charles won renown especially for his depictions of horses and barrack-room physiognomies.

According to Mariette, the presentation of *L'Entrée équestre aux Tuileries de l'ambassadeur turc Mehemet Effendi le 21 mars 1721* (*The Entrance on Horseback of the Turkish Ambassador Mehemet Effendi into the Tuileries*, March 21, *1721;* Château de Versailles) at the 1727 painting competition was universally applauded. In 1731, Louis Desplaces put *The Tiger Hunt* and *The Lion Hunt*, his prints after paintings done by Parrocel for the duc de Mortemart, up for sale. Everything marked Parrocel as one of the artists who would be asked to provide an exotic hunt for Versailles, and indeed, he was commissioned to paint *The Elephant Hunt*.

The elephant was rarely depicted in this period, and there was little first-hand information about it. The *Book of Animals*, published by Jollain in Paris, with the captions of the plates engraved after Tempesta (1555–1639), reinforced the animal's mysterious and extraordinary character. It was believed that the elephant lived for three hundred years, was extremely chaste and highly reasonable, drank wine, ate dirt and stones, and had huge body parts except for its eyes and tongue. And was it not depicted this way by Parrocel? An enormous mass accentuated by the bold foreshortened perspective, the animal is endowed with a head punctuated by two miniscule eyes reddened by the fever of combat, and it reveals a tongue foaming with anger.

According to Parrocel's biographer, Charles-Nicolas Cochin, the artist had difficulty in limiting himself to a single idea. Thus he continually erased and started over. But nothing of the sort was necessary for *The Elephant Hunt* of the Petite Galerie; its X-ray reveals very few pentimenti.

Although the arrangement of the main protagonists of the hunt and the distribution of the large masses were not modified from the sketch to the final work, certain elements that escalate the violence of the action do not appear in the painting. The tusk falling to the ground was borrowed from a print by Philippe Galle (1537–1612), after *The Elephant Hunt* by Van der Straet (1523–1605). Broken, it symbolized the extraordinary strength demonstrated by the animal in its fight. With the entire weight of its enormous foot, the pachyderm is crushing the horse it has knocked down. Mortally gripped by his adversary's trunk, the rider is lifted off the ground in a bold foreshortening. Parrocel also aimed for a greater exoticism in the sketch, with its palm trees, its arid soil dotted with flowering cactuses, its panther-skin saddle, and especially, its sun. With its radiating beams enflaming the sky, the sun, like the animal and the costumes of its assailants, indicated to connoisseurs of the eighteenth century that the hunt took place in a hot country.

—XAVIER SALMON

Provenance: Sale, Paris, Hôtel Drouot, January 24, 1944, no. 58; sale, Paris, Hôtel Drouot, February 4, 1959, no. 61; pre-empted by the State.
Bibliography: Schuman 1979, p. 102, no. P.14, fig. 11; Hazlehurst 1984, pp. 225, 226, fig. 2.
Exhibition: Amiens and Versailles 1995–96, pp. 46, 47, no. 5.
Related Work: Charles Parrocel, *The Elephant Hunt*, 1736, oil on canvas, 72 × 50⅝ in. (183 × 128.5 cm), definitive painting, Musée de Picardie, Amiens.

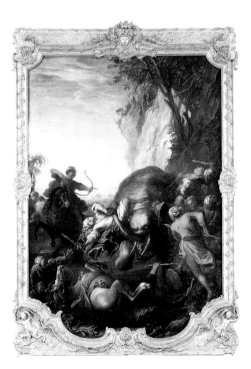

Fig. 15
Charles Parrocel
The Elephant Hunt, 1736
Oil on canvas
72 × 50⅝ in. (183 × 128.5 cm)
Musée de Picardie, Amiens
Photo Marc Jeanneteau

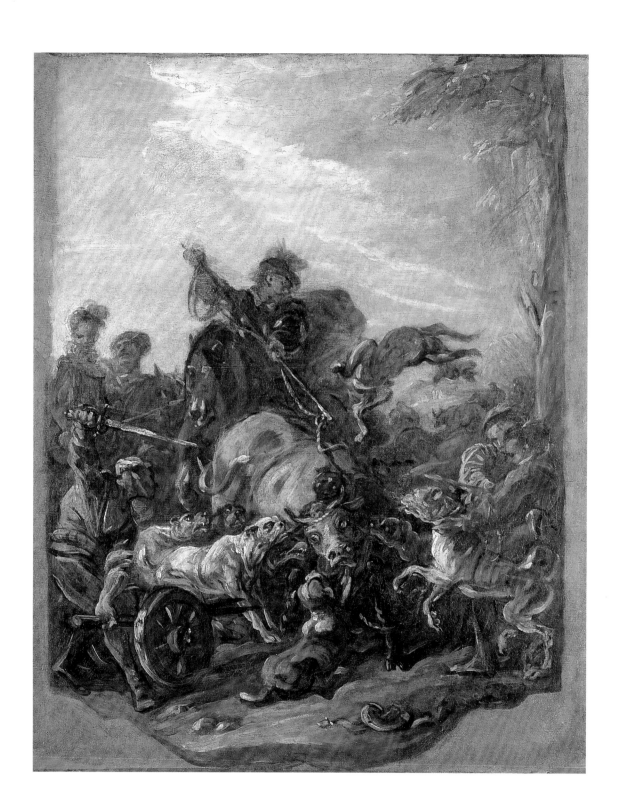

20. CHARLES PARROCEL
(Paris 1688–Paris 1752)

The Wild Bull Hunt, 1738
Oil on canvas, 25⅝ × 21 in. (65.2 × 53.2 cm)
Musée de Picardie, Amiens; On deposit from the Musée du Louvre,
1960 (M.P.P. 4390; Louvre R.F.1959–15)

THE COMPOSITION OF *THE WILD BULL HUNT* DIFFERS
only slightly from that of *The Elephant Hunt*, probably the result
of the artist's following the guidelines that had been set to ensure
the unity of the cycle painted for the Petite Galerie.

In his bold, assertive style with its broad brushwork and emo-
tive forms recognized by Charles-Nicolas Cochin, Parrocel brings
the main participants in the hunt together in a pyramidal arrange-
ment. The rider with a snare dominates the wild bull and tries to
capture it, while the animal fights against the pack, having thrown
one of the dogs over its back. To the right, a hunter holds back his
straining mastiff while, on the left, another brandishes his sword
and pushes before him a curious weapon, borrowed from a print
by Antonio Tempesta (1555–1630). Above is a young female rider,
who does not appear in the final version. Also shown in the pre-
paratory ink drawing, with her frilled lace ruff and décolletage,
this figure helps to mitigate the violence of the combat. With her
silhouette from another age, she evokes the elegant women of
Alexis Grimou.

Departing from this apparent horror *vacui*, with only a narrow
opening onto the mountainous landscape to reveal another bull
pursued by riders, in the final painting Parrocel preferred an airier
image opening broadly onto a vast maritime expanse. Unlike the
other animals selected for the Petite Galerie, the wild bull evokes
neither the Orient nor Africa. However, the artist still demon-
strates a desire to set his hunt in its true geographical context, in
this case, Spain. The mustached faces, the costumes, and the out-
line of the castle on the horizon are intended to be emblematic
of the foreign setting. Familiar to artists at that time, his Hispanic
exoticism was primarily expressed in illustrations for *Don Quixote*,
Filleau de Saint Martin's translation of 1677–78 having been re-
printed in 1730.

Since 1714, Charles-Antoine Coypel (1694–1752) had provided
cartoons for the Gobelins tapestry workshops based on the Cer-
vantes novel. From May 1735 to April 1737, the Beauvais work-
shops wove the first six pieces of a *Don Quixote* hanging based on
cartoons by Charles-Joseph Natoire (1700–1777) for the *fermier-
général* Pierre Grimod Dufort. All these works reveal a fascina-
tion with a Spanish theme. In *The Wild Bull Hunt*, Parrocel was
also following the fashion.

—XAVIER SALMON

Provenance: Sale, Paris, Hôtel Drouot, January 24, 1944, no. 58: sale, Paris,
 Hôtel Drouot, February 4, 1959, no. 60; pre-empted by the State.
Bibliography: Schuman 1979, p. 103, no. P.16, fig. 13; Hazlehurst 1984, pp. 233,
 234, fig. 22.
Exhibition: Paris 1968, no. 90; Amiens and Versailles 1995–96, pp. 88, 89, no. 27.
Related Works: Charles Parrocel, *The Wild Bull Hunt*, 1738, oil on canvas,
 72 × 50¾ in. (183 × 129 cm), definitive painting, Musée de Picardie, Amiens.
 Charles Parrocel, *The Wild Bull Hunt*, 1738, ink, gray wash, and black
 chalk on paper, 21⅞ × 16⅛ in. (55.6 × 41 cm), preparatory drawing, Musée de
 Picardie, Amiens. Charles Parrocel, *The Wild Bull Hunt*, 1738, red chalk on
 paper, 18½ × 13⅞ in. (47 × 35.1 cm), preparatory drawing, Musée des Beaux-
 Arts, Tours.

Fig. 16
Charles Parrocel
The Wild Bull Hunt, 1738
Oil on canvas
72 × 50¾ in. (183 × 129 cm)
Musée de Picardie, Amiens
Photo Marc Jeanneteau

21. Charles-André, called Carle Vanloo
(Nice 1705–Paris 1765)

The Ostrich Hunt, 1738

Oil on canvas, 72⅛ × 50⅜ in. (183.3 × 128 cm)
Signed, bottom right: *Carle Van* [*loo*]
Border forming frame attributed to Jacques Verberckt (1704–1771)
Musée de Picardie, Amiens, 1874 (M.P.P. 39)

CARLE VANLOO WAS INVITED IN 1738 TO PAINT *The Ostrich Hunt* for the Petite Galerie. As in the other hunts, the exotic animal and the men and dogs surrounding it occupy the foreground, and the main diagonals converge upon the bird. Between its powerful claws the hunter, knocked down, tries to defend himself with his weapon, the motif so often repeated in this cycle. All around are straining dogs in dynamic poses. In the background, another scene pitting man against beast stands out against a mountainous horizon located very low so as to emphasize the scene in the foreground. Mindful of the origin of the animals portrayed, Vanloo places the hunt in a site whose exoticism is accentuated by the costumes evoking the countries of the Levant, the two palm trees, and a palette of bright colors punctuated by warm tonalities. As usual in this cycle, a vast, luminous late-afternoon sky bathes the whole scene.

Whereas Vanloo's depiction of a bear in his 1736 painting attested to his concern for naturalism, that of the ostrich here seems rather fantastic. Indeed, how to explain the immaculate whiteness of the imposing bird's plumage? Granted, the artist must have been less familiar with the ostrich than with bears, which were often exhibited in fairs, but it could not have been totally unknown to him. Between 1687 and 1694, Mosnier Gassion had, at the request of Colbert, bought 103 ostriches for the king, and in 1705 he imported 10 more from the Orient. Housed at the menagerie of Versailles in an enclosure that bore their name, they aroused the curiosity of artists from that time on, their image being disseminated especially by way of tapestries.

To the Beauvais workshop, in particular, we owe the *Birds of the Menagerie* hanging, one of whose segments features the ostrich as its principal motif. But it was probably the *Ancient India* hanging, based on works of Eckhout (1621–1674) and Post (ca. 1612–1680), offered to Louis XIV in 1679 by Prince Johann-Moritz of Nassau, that did the most to spread the bird's image. A model of exoticism, the hanging was woven a number of times between 1687 and 1730, and Carle Vanloo doubtless would have had the opportunity to admire it.

In Hazlehurst's opinion, the painter obviously drew inspiration from the plates of Jan van der Straet (1523–1605) and Antonio Tempesta (1555–1630), both of whom illustrated the ostrich hunt, the latter borrowing numerous elements from the former.

—XAVIER SALMON

Provenance: Château de Versailles, Petite Galerie, 1738; Versailles, court storerooms, 1767; Versailles, Musée National, 1794; sent to Amiens by the State as part of preparations for the Congress of Amiens of 1802, 1801 (Courtroom of the Hôtel de Ville).
Musée de Picardie Catalogues: 1820, pp. 8, 9, no. 6; 1875, p. 62, no. 148; 1878, p. 109, no. 148; 1899, p. 120, no. 289; 1911, p. 82, no. 357.
Bibliography: Engerand 1901, p. 473; Bellemère 1908, p. 16; Boinet 1928, pp. 14, 37; Réau 1938, pp. 69, 70, no. 127; Roland Michel 1976, pp. 1448, 1449; Hazlehurst 1984, pp. 233, 235; Salmon 1995, p. 46
Exhibitions: Amiens 1860, no. 43; Amiens 1952; Amiens and Dunkerque 1969, pp. 14, 15, no. 20; Nice, Clermont-Ferrand, and Nancy 1977, p. 39, no. 62; Amiens 1992, p. 13, no. 21; Amiens and Versailles 1995–96, pp. 94–96, no. 31.
Related Work: Blas Amettler, *The Ostrich Hunt*, after Vanloo, ca. 1780–1800, print, Musée du Louvre, Paris.

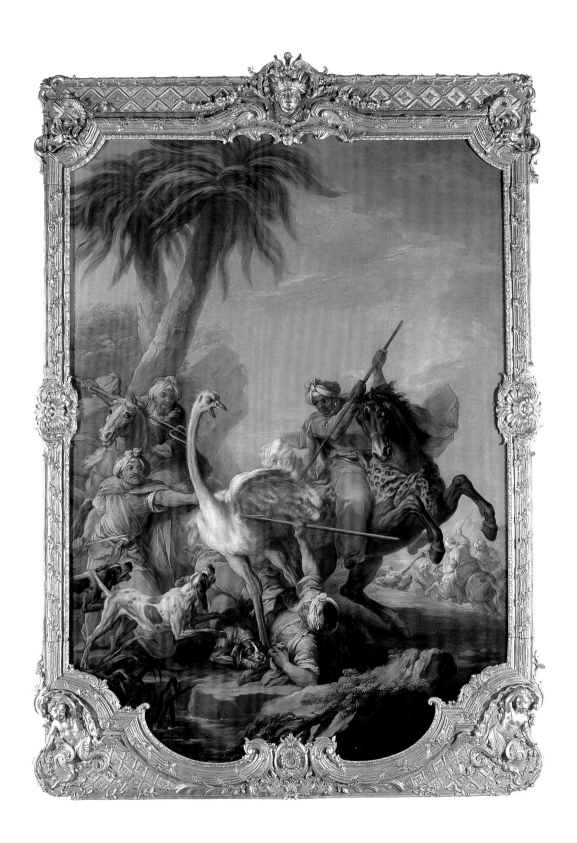

22. Jacques de Lajoue
(Paris 1686–Paris 1761)

After the Hunt, ca. 1738–40
Oil on canvas, 31⅛ × 40¼ in. (79 × 102 cm)
Musée de Picardie, Amiens; Gift of the Lavalard Brothers, 1890
(M.P.Lav. 1894–159)

Traditionally—but curiously—designated *Le Parc de Marly*, this painting, which shows no particular similarity to the gardens of that famous royal château, depicts a hunter's pause in a forest near a fountain. On the right side of the composition rises a monumental structure with twisted forms and a curious three-columned portico sheltering a statue. Extending from the structure is a terrace reached by a broad staircase, which is flanked by two fountains decorated with sculpted groups. One of these groups consists of a large shell surmounted by figures of sea gods holding a flowing urn; on the right, against the colonnade, water pours from the muzzle of a sculpted doe. Hunting dogs are scattered around the basin—several of them resting, while one, to the right, laps energetically from a fountain. Another dog, in the foreground, swims after some ducks, while a third barks, standing in a small boat filled with game, more of which is spread on the steps. Toward the center, a satisfied hunter stands proudly, passing his hand over his horse's hindquarters. Behind him appear a rider and a man loading a rifle. On the left, a coach enters a clearing. As Marianne Roland Michel has shown, Lajoue is a master of rocaille painting, skillfully combining curves and counter-curves in fantasy structures that are matched by occasionally distorted forms of vegetation. He invents unusual monuments in which curves contrast with severity. Furthermore,

Lajoue plays on ambiguity as if to add to the strangeness of his imaginary landscapes. Here, the stone doe looks like a live animal, while the couple leaning over the balustrade could be mistaken for a statuary group.

Next to nothing is known about Lajoue's youth and training. The son of an architect, he was received into the Académie in 1721 and appeared in the 1730s to be one of the finest representatives of Parisian decorative painting of his time. His drawings, popularized by engravings, made him a fashionable artist who enjoyed success with a rich clientele interested in the strange, fanciful settings of this figure who so well embodied the fertile Rococo period.

Musée de Picardie Catalogues: 1894, pp. 41, 42, no. 159; 1899, pp. 217, 218, no. 160; 1911, p. 134, no. 157.
Bibliography: Horsin-Déon 1862, p. 145; Boinet 1928, p. 15; Bataille 1930, no. 18; Cailleux 1957, p. 107; Vergnet-Ruiz and Laclotte 1962, p. 241; Lemagny 1967; Foucart 1977, pp. 18, 25, 43, 50; Lesage 1978, pp. 109–11; Roland Michel 1983, p. 471; Roland Michel 1984, p. 230, P. 236, fig. 176.
Exhibitions: Sceaux 1937, no. 39; Nancy 1960, no. 30; Tokyo 1982, no. CA.12.
Related Works: Jacques de Lajoue, *Rest after the Hunt*, ca. 1742, oil on canvas, 51 × 51 in. (129.5 × 129.5 cm), Pushkin Museum, Moscow. Jacques de Lajoue, *Hunting Break/Pause*, ca. 1740, black chalk, India ink, and watercolor on paper, 15 × 14⅝ in. (38.2 × 37.3 cm), preliminary drawing, Rijksprentenkabinet, Amsterdam.

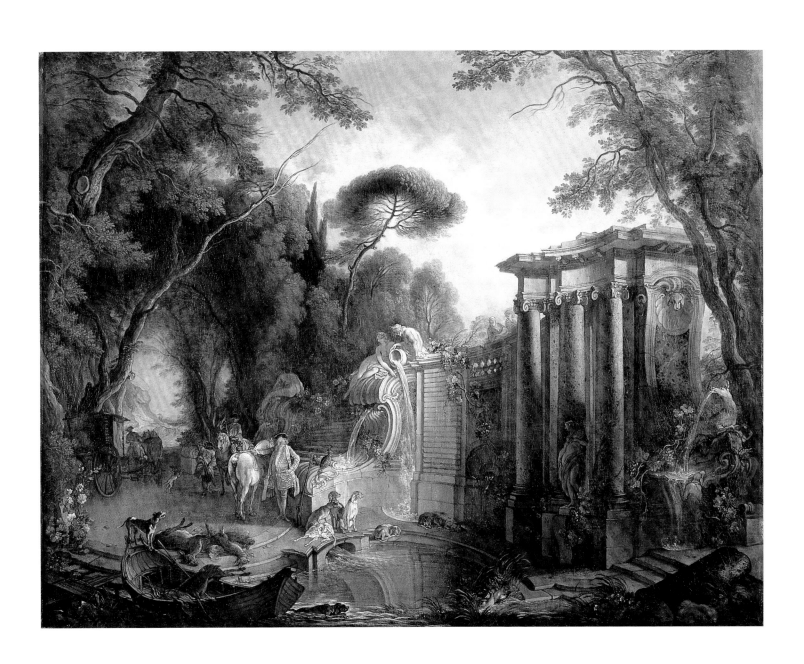

23. JEAN RESTOUT

(Rouen 1692–Paris 1768)

The Prophet Isaiah, 1737

Oil on canvas, 29 × 23⅜ in. (73.8 × 59.3 cm)
Signed and dated, bottom right: *JRestout . 1737*
Musée de Picardie, Amiens; Gift of the Lavalard Brothers, 1890
(M.P.Lav. 1894–183)

THE BEARDED OLD MAN IS SHOWN FROM THE WAIST up, his chest mostly bared. His gaze is turned toward heaven, and he holds a long saw with nasty-looking teeth, the instrument of his martyrdom.

This work has always been read as a representation of Isaiah, the first of the three great biblical prophets (the others being Jeremiah and Ezekiel). The Old Testament book that bears his name denounces the loosening of morals, announces the wrath of God and, in three messianic prophecies, tells of the coming of a savior. Legend has it that, on the orders of Manasseh, the king of Judah, Isaiah was sawed in two, after hiding in a hollow tree to flee persecution.

In 1748 Restout completed a painting showing *The Vision of Isaiah* (location unknown) along with its pendant, *Ezekiel* (Bordeaux, Musée des Beaux-Arts), both intended for the chapel of the Seminary of Saint-Sulpice in Paris. In the preparatory drawing for the first work (Issy-les-Moulineaux, Seminary of the Sulpicians), Restout depicted Isaiah seated in the clouds, holding a book and witnessing the apparition of the Immaculate Conception. The Amiens canvas shows no direct relationship to that composition.

The view that the Amiens painting represents Isaiah is perfectly admissible; however, the canvas might just as well portray the apostle Simon, called either Simon the Zealot (from the name of a Jewish sect to which he belonged) or the Canaanite (from the name of his birthplace, Cana). (Christine Beauvalot-Gouzi has written of a painting on this theme, but its current location is unknown.) According to some accounts, Simon pursued his mission first in Egypt, then with the apostle Jude (also known as Thaddaeus) in Persia, where both were martyred for having overturned idols. Either Simon's throat was cut or he was cut in half with a saw, one of his traditional attributes. This painting could, therefore, be identified as a likeness of Simon, perhaps coming from a cycle bringing together all the apostles, an iconography that was, admittedly, developed more in the previous century.

Orphaned at an early age, Restout entered the studio of Jean Jouvenet (1644–1717) in Paris, by 1707. Received into the Académie in 1720, he devoted himself to often monumental religious painting, at a time when royal commissions were still relatively limited. Even though Restout established himself as an artist linked to the church, he also worked in the area of secular history painting, in spite of a reluctance on behalf of the *bâtiments du roi* to commission works from him. A painter highly respected by his peers, he became director (1760), then chancellor (1761) of the Académie.

Musée de Picardie Catalogues: 1894, p. 46, no. 183; 1899, p. 224, no. 184; 1911, pp. 137, 138, no. 180.
Bibliography: Boinet 1928, p. 13; exhib. cat., Rouen 1970, pp. 86, 194, no. 42; Foucart 1977, p. 44; Beauvalot-Gouzi (forthcoming).

24. PIERRE SUBLEYRAS

(Saint-Gilles-du-Gard 1699–Rome 1749)

Presumed Portrait of Joseph Vernet, ca. 1739

Oil on canvas, 18¼ × 15⅛ in. (46.3 × 38.3 cm)

Inscribed, back (inscription visible before its lining): *Portrait de M. Cochin par M. du Plessis*

Musée de Picardie, Amiens; Bequest of M. Sujol, 1849

(M.P.P. 203—formerly 219)

THE YOUNG MAN, WHOSE AGE CAN BE ESTIMATED AT about twenty-five, is shown from the waist up turning his face toward the viewer. He wears a gray jacket and a bow in his hair. It was in 1987 that the identities of both the model and the painter were restored, thanks to Pierre Rosenberg and Jean-Pierre Cuzin. Before it was lined, the painting bore an inscription on the back indicating that it was a "portrait of Mr. Cochin by Mr. du Plessis." In fact, comparison between the Amiens canvas and a miniature attributed to Maria-Felice Tibaldi (1707–1770), Subleyras's wife, depicting Joseph Vernet (Avignon 1714–Paris 1789) and belonging to Vernet's descendents, led to rejection of the traditional interpretation that this was a portrait of the engraver Charles-Nicolas Cochin (1715–1790). Furthermore, the portrait of Vernet by Louis-Michel Vanloo (1707–1771), dated 1768 (Avignon, Musée Calvet), showing the painter at a later age with an emaciated face, reveals a similarity in the features, also supporting the likelihood of this hypothesis. Finally, the attribution of the work to Duplessis, then to Tocqué, has successively been rejected by specialists on these artists, thus allowing, at last, the rightful attribution to Subleyras.

Joseph Vernet, who would become a famous painter of sea- and landscapes—of which the Musée de Picardie possesses two fine examples—arrived in Rome in 1734, thanks to the support of a few patrons concerned with encouraging young talent. The support of the director of the Académie de France, despite Vernet's not being a king's pensioner, allowed the young man to flourish and perfect his art. He remained in Rome nearly twenty years, gradually acquiring a European reputation, the peak of which was undoubtedly the commission by King Louis XV of the famous series of *Harbors of France* (Paris, Musée du Louvre and Musée de la Marine), for which he would execute fifteen huge canvases. In Rome, Vernet was a close friend of Subleyras, to whom he later lent money, and this fine portrait shows evidence of a friendly sympathy.

A native of southern France, Subleyras carried out his apprenticeship first in Uzès, then in Toulouse in the studio of Antoine Rivalz (1667–1735). Upon arriving in Paris, he obtained the Grand Prix in 1727 and left the following year for Rome. It was in the Eternal City that he pursued his career until his death. One of the most prominent foreign painters there, he obtained the signal honor of seeing, during his lifetime, his painting *The Mass of Saint Basil* copied as a mosaic for the Basilica of Saint Peter.

Musée de Picardie Catalogues: 1875, p. 61, no. 144 (Louis-Lamy Tocqué); 1878, p. 107, no. 144 (Tocqué); 1899, p. 118, no. 284 (Tocqué); 1911, p. 81, no. 352 (Tocqué).

Bibliography: Bellemère 1908, p. 15 (Tocqué); Rocheblave 1927, p. 3 and frontispiece; Boinet, 1928, pp. 15, 46 (attributed to Tocqué); Doria 1929, pp. 99, 100, no. 54; Brunot 1931, p. 155, ill.

Exhibition: Paris 1980, no. 80; Paris and Rome 1987, pp. 235, 236, no. 61.

Related Work: Attributed to Maria-Felice Tibaldi, *Portrait of Joseph Vernet*, ca. 1740, miniature, private collection, Paris.

25. LOUIS AUBERT
(Paris 1720–Paris? ca. 1798)

The Reading Lesson, 1740
Oil on wood, 12¼ × 18¹⁵⁄₁₆ in. (32.5 × 22.7 cm)
Signed and dated, bottom right: *L.Aubert f 1740*
Musée de Picardie, Amiens; Gift of the Lavalard Brothers, 1894
(M.P.Lav. 1894–160)

IN A BOURGEOIS (DOUBTLESS PARISIAN) INTERIOR, IN front of a fireplace surmounted by a pier glass, a woman is seated at a table. She has put her needlework aside to listen to the lesson of a young boy who stands before her, book in hand. The painter has rendered the details of this everyday scene with scrupulous attention, taking a great interest in the rendering of the mother's dress, protected by an apron, and the little boy's suit. The furnishings are described in great detail: the table with the curved legs, the low armchair with a toy drum hanging from the back, the drumsticks lying on the floor, the playing cards that have fallen off the straw chair. On the mantel are the remains of a light meal: a china cup, a silver chocolate pot, and a sugar bowl with its top lying next to it. Finally, on the table, an open birch box reveals a sewing kit intended for use on a piece of white cloth that lies on the tray.

The son of a violinist in the Paris Opéra orchestra, Louis Aubert remains an insufficiently known artist. He did, however, participate in prestigious commissions and executed decorative paintings for the dauphin's apartments in the Château de Fontainebleau and Versailles, for the Château de Choisy, and for Madame de Pompadour at Compiègne. He also left a number of drawings, often colored.

Aubert's art is thoroughly marked by his interest in intimist painting, but his work goes beyond an ethnographic observation of the society around him. His obvious desire is to touch the poetic side of domestic life by observing the daily activities of his peers.

Like Chardin, to whom his works have sometimes mistakenly been attributed, Aubert employed the simplicity of ordinary acts in his pictorial vocabulary. These seemingly insignificant moments of existence are real subjects for him, and the accessories of daily life become the attributes of his "heroes." This lyricism of ordinary life and its simple charms tempted more than one painter from this era, and this painting can be compared not only with similar works by Chardin, like *La Mère laborieuse (The Hard-Working Mother)* or *Le Bénédicité (The Blessing;* both Paris, Musée du Louvre), exhibited at the 1740 Salon, but also with François Boucher's famous *Déjeuner (Luncheon;* Paris, Musée du Louvre), shown at the 1739 Salon, or with *L'Accouchée (The New Mother,* 1744; Saint Petersburg, Hermitage Museum) by Etienne Jeaurat (1699–1789). Such paintings provide a window into domestic life in France around the mid-eighteenth century.

Musée de Picardie Catalogues: 1894, p. 42, no. 160 (Lambert); 1899, p. 218, no. 161 (Lambert); 1911, p. 134, no. 158 (Lambert).
Bibliography: Guiffrey 1915, p. 341; Boinet 1928, pp. 15, 49 (Lambert); Foucart 1977, p. 43; Lesage 1978, pp. 11–16; Roland Michel 1994, p. 249.
Exhibitions: Paris 1933, no. 52 (Lambert); Copenhagen 1935, no. 19 (Lambert); San Francisco 1949, pl. 34, no. 23 (Lambert); Brussels 1953, no. 2, pl. 41; Paris 1959, no. 56; Paris 1964, no. 32; Karlsruhe 1999, pp. 250–52, no. 100.
Related Works: Louis Aubert, *The Reading Lesson,* ca. 1740, drawing in three pencils, 13³⁄₁₆ × 9¹⁄₁₆ in. (33.5 × 23 cm), preliminary drawing(?), Musée Condé, Chantilly. Marguerite Pavoine, *Ce n'est pas cela! d'après Aubert (It's Not That! After Aubert),* 1740–45, engraving.

26. PIERRE SUBLEYRAS

(Saint-Gilles-du-Gard 1699–Rome 1749)

The Martyrdom of Saint Theodora of Antioch and Didymus(?), ca. 1740

Oil on canvas, 25 11/16 × 15 7/8 in. (64.3 × 40.4 cm)

Musée de Picardie, Amiens; Gift of the Lavalard Brothers, 1890

(M.P.Lav. 1894–194)

A YOUNG WOMAN KNEELS, HER HANDS FOLDED ACROSS her breast, while at her side the executioner raises his sword and prepares to cut off her head. Behind them lies the decapitated body of an earlier victim. In the background, on the right, a high priest leans against the base of a statue of a pagan god. Soldiers and other figures witness the scene, which takes place in front of a temple with columns and a pediment. In the sky, an angel bears the martyr's palm and holds out a crown of flowers.

In the catalogue of the 1987 exhibition *Subleyras 1699–1749*, Pierre Rosenberg mentioned the suggestion of Jennifer Montagu, who sees this subject as the martyrdom of Saint Theodora of Antioch: Theodora, saved once from prosecution and conviction by a fellow Christian, Didymus, was finally decapitated with him in 304 in Alexandria, under the reign of Emperor Diocletian. With its delicate tints and strong composition, this work, which seems conceived as a matching piece to *The Crucifixion of Saint Peter,* is characteristic of Subleyras's late style.

Musée de Picardie Catalogues: 1894, p. 48, no. 194; 1899, pp. 227, 228, no. 195; 1911, p. 139, no. 191.

Bibliography: Bellemère 1908, p. 42; Boinet 1928, p. 13; Foucart 1977, pp. 18, 44; Lesage 1978, pp. 154, 155; Huchard, Lernout, Mahéo, and Couderc 1995, p. 103.

Exhibition: Paris and Rome 1987, p. 247, no. 68.

Related Work: Pierre Subleyras, *Martyrdom Scene*, ca. 1740, black chalk heightened with white, on blue paper, 9 5/8 × 6 1/4 in. (24.5 × 16 cm), preliminary drawing, private collection, Paris (in 1987).

27 · Jean-Marc Nattier
(Paris 1685–Paris 1766)

Portrait of Jean-Baptiste Gresset, 1741

Oil on canvas, 24⅜ × 20⅜ in. (61.8 × 51.6 cm)
Signed and dated, left (according to the inventory; signature now illegible): *Nattier 1734*
Musée de Picardie, Amiens; Gift of the nephews of Jean-Baptiste Gresset, 1845 (M.P.P. 28)

Jean-Baptiste Gresset (Amiens 1709–Amiens 1777) was, with Pierre Choderlos de Laclos (1741–1803, author of *Les Liaisons dangereuses*), one of the main figures of the literary pantheon of Amiens in the eighteenth century. He was elected to the Académie Française in 1748, and two years later, upon returning to Amiens, he founded there an Academy of Sciences, Letters, and Arts. A witty and roguish poet, his best-known work is certainly *Ver-Vert* (1734). The text relates the tale of a parrot adopted and raised piously by the Visitandine nuns of Nevers, who admire the bird's religious language. They decide to send their protégé to another of the order's convents, in Nantes, and in the course of the journey, the charming winged creature loses its devout way of speaking and adopts the rougher manner of Loire boatmen, soldiers, and prostitutes encountered on board the boat. Outraged by the bird's vulgarity, the nuns from Nantes send it back to Nevers. Punished and then pardoned, the parrot is finally generously rewarded and dies after gorging itself on sugared almonds. Gresset was also the author of a number of other works including a comedy, *Le Méchant*.

It was his friend Nattier, one of the most refined portraitists of the eighteenth century and a member of the Académie as of 1718, whom Gresset asked to paint the present portrait. In it, the sitter is portrayed soberly within an oval oculus, with hairstyle and dress characteristic of the reign of Louis XV. On his chest he wears the Cross of the Royal and Military Order of Saint-Lazare, and a small scar is visible on his forehead. The painter and the poet knew each other well: Gresset, who greatly admired Nattier's art, went so far as to address him with the flattering sobriquet "Student of the Graces." Xavier Salmon (1999, p. 34, fig. 44) has pointed out that another portrait (location unknown), painted by Nattier in

1755 and sometimes referred to as also being that of our poet, cannot depict him, due to its date and the difference in features as compared with those of the presumed model. In a poem that was perhaps inspired by this portrait, Gresset amusingly evokes the art of portraiture: "My dear Eglé, friendship, to please me, / Draws my portrait on this day. / You, tomorrow, if you wish, could do it better: / The best paintbrush is that of love."

Musée de Picardie Catalogues: 1875, p. 52, no. 111; 1878, p. 88, no. 111; 1899, p. 89, no. 219; 1911, p. 61, no. 266.
Bibliography: Gonse 1900, p. 12; Bellemère 1908, p. 29; Nolhac 1925, pp. 50, 51; Boinet 1928, pp. 15, 45; Dimier 1930, vol. 2, pp. 102, 104, 125, no. 86; Roudier 1998, p. 13; exhib. cat., Versailles 1999, p. 26, fig. 22.
Exhibitions: Paris 1933, no. 63; Paris 1957 (Orangerie), no. 56.
Related Works: Several eighteenth- and nineteenth-century engravings after this portrait are known (by A. Saint-Aubin, Ambroise Tardieu, Landon).

Fig. 17
Pierre-François Berruer
Bust of Jean-Baptiste Gresset, 1786
Marble
32⅝ × 24¾ in. (83 × 63 cm)
Musée de Picardie, Amiens
Photo Marc Jeanneteau

28. PIERRE SUBLEYRAS

(Saint-Gilles-du-Gard 1699–Rome 1749)

The Crucifixion of Saint Peter, 1740–43

Oil on canvas, 25 11/16 × 15 7/8 in. (64.3 × 40.2 cm)

Musée de Picardie, Amiens; Gift of the Lavalard Brothers, 1890

(M.P.Lav. 1894–193)

AS OF 1740, POPE BENEDICT XIV WAS EAGER TO introduce a Subleyras painting into Saint Peter's Basilica in Rome to replace either *The Martyrdom of Saint Peter* by Passignano (1558–1638) or *The Mass of Saint Basil* by Girolamo Muziano (1532–1592). The artist produced sketches for both subjects; it was finally the latter that was chosen, and Subleyras, though more interested in the former, which he considered more rewarding, was obliged to deliver a *Mass of Saint Basil*. It soon became the basis for a mosaic at Saint Peter's and was then sent to the Church of Santa Maria degli Angeli in 1752.

The Amiens picture is a first sketch for *The Crucifixion of Saint Peter*, for which another, very similar, version is known (London, Private collection). In addition, the artist painted a more developed work on this theme, of which three versions are known (at the Louvre, in Leipzig, and in Edinburgh), as well as two partially painted studies (Roanne, Musée Déchelette) and a drawing (Louvre). Jean Barbault (1718–1762) also made an engraving of Subleyras's composition.

The martyrdom of Saint Peter took place on June 29 in the year 64 or 67 (the same day that Saint Paul was beheaded). Legend has it that, considering himself unworthy of being crucified like Christ, Peter asked to be martyred upside down. In the painting, the body nailed to the cross forms the main axis of the composition. A man armed with a shovel, another pulling on a rope, and still others raising the cross busy themselves around their victim. There are several figures, including, to the rear on the left, a seated Roman dignitary (Emperor Nero himself?), who contemplates the apostle's torture. In the sky are two cherubs bearing martyr's palms and crowns of flowers.

One of the great works of Subleyras's career, this painting attests to the painter's growing fame. The clear, and effective image was innovative while at the same time showing the inspiration of the famous prototypes of Caravaggio (ca. 1571–1610) and Guido Reni (1575–1642).

Musée de Picardie Catalogues: 1894, p. 48, no. 193; 1899, p. 227, no. 194; 1911, p. 139, no. 190.

Bibliography: Bellemère 1908, p. 42; Boinet 1928, p. 13; Foucart 1977, pp. 18, 44; Lesage 1978, pp. 155, 156; exhib. cat., Paris and Rome, 1987, pp. 268, 269.

Related Works: Studio of Pierre Subleyras, *The Crucifixion of Saint Peter*, ca. 1740–43, oil on canvas, private collection, London (in 1987). Pierre Subleyras, *The Crucifixion of Saint Peter*, ca. 1740–43, oil on canvas, 53 3/4 × 32 1/8 in. (136.5 × 81.5 cm), Musée du Louvre, Paris. Pierre Subleyras, *The Crucifixion of Saint Peter*, ca. 1740–43, oil on canvas, 53 3/4 × 31 1/2 in. (136.5 × 80 cm), Museum der Bildenden Künste, Leipzig. Pierre Subleyras, *The Crucifixion of Saint Peter*, ca. 1740–43, oil on canvas, 18 3/8 × 12 1/4 in. (46.7 × 31 cm), National Gallery of Scotland, Edinburgh.

29. Unknown French Artist
18th century

The Birth of Venus, ca. 1740–45
Oil on canvas, 14⅜ × 18⅛ in. (36.6 × 46 cm)
Musée de Picardie, Amiens; Gift of the Lavalard Brothers, 1890
(M.P.Lav. 1894–130)

This ravishing study has been seen as the marine triumph of either Venus or Amphitrite, the spouse of Neptune, god of the seas. The youthfulness of the graceful female figure enthroned in the center reinforces an identification as the goddess of beauty and love, and the episode may be her birth.

The goddess is shown seated in a marine chariot drawn by two dolphins. Young and old tritons and naiads accompany her in a procession above which fly two putti unfurling a long veil.

The traditional attribution of this deftly painted work to Boucher has been questioned (by A. Boinet, in 1928, and, more recently, Alastair Laing and Jean-Pierre Cuzin), and the name of Jean-Baptiste Marie Pierre (1714–1789) has been suggested on occasion. Recently Alastair Laing has proposed that this may be a canvas by Joseph-Marie Vien (1716–1809), painted before his departure for Rome in 1743. Whatever the authorship, this work fully embodies the Rococo spirit spearheaded by Boucher beginning between 1735 and 1740. The "Painter of Graces," so named for his inclination to depict the feminine charms, painted several *Births of Venus* that are not unlike this one (Stockholm, Nationalmuseum; London, The Wallace Collection). If not the actual author of this work, Boucher could well have been its inspiration.

Musée de Picardie Catalogues: 1894, p. 36, no. 130; 1899, p. 210, no. 131; 1911, p. 130, no. 129.
Bibliography: Boinet 1928, p. 14 (Boucher?); Foucart 1977, pp. 22, 42.
Exhibitions: Amiens and Dortmund 1960, no. 13; Amiens 1992, p. 11, no. 16.

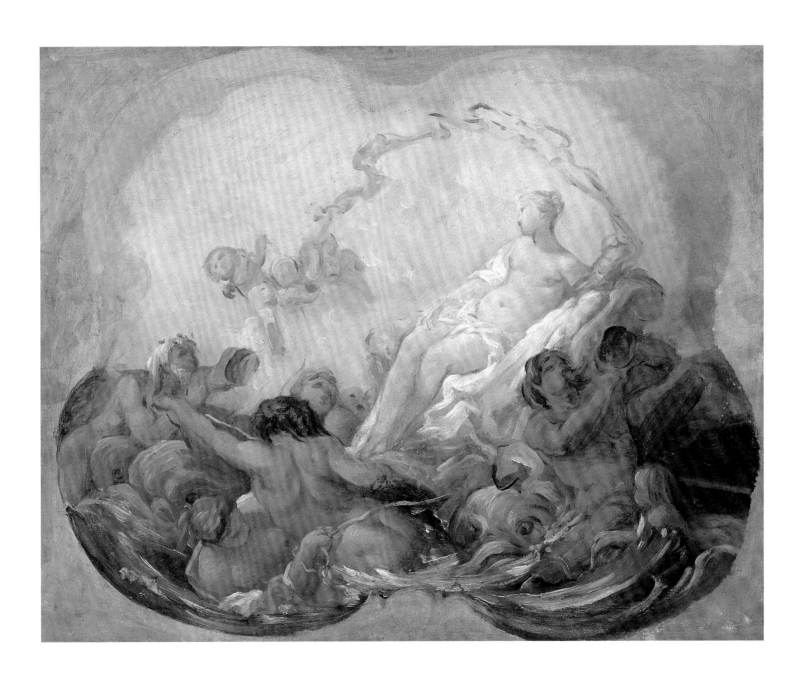

30. LOUIS TOCQUÉ

(Paris 1696–Paris 1772)

Portrait of Louis-Gabriel Bourdon, Age Four, 1745

Oil on canvas, 25 × 19⁷⁄₁₆ in. (63.5 × 49 cm)
Musée de Picardie, Amiens; Bequest of Doctor Demarquay, 1875
(M.P.P. 209—formerly 323)

THE PAINTING ENTERED THE MUSEUM AS A PORTRAIT of the dauphin of France, eldest son of Louis XVI, by François-Hubert Drouais (1727–1775); in 1925 its attribution was restored to its true author. Two years later, the model was accurately identified by Arnauld Doria as Louis-Gabriel Bourdon (1741–1795), son of Thérèse Daumesnil and François-Auguste Bourdon, Lord of Grandmont. This four-year-old child would become a moderately famous writer, the author of *Les Mânes de Flore* (1773), *Les Enfants du pauvre diable* (1776), *Lettre à Emma* (1784), and *Voyage d'Amérique* (1786).

The child is seated on the ground in front of a trellis on which a few roses climb. His hair is powdered; he is dressed in a blue suit with broad lapels and gold buttons and a silk brocade vest with colored floral patterns. On his right shoulder hangs a cascade of ribbons. A snail crawls on the ground in front of him.

Tocqué, the son-in-law of Nattier and an artist who devoted himself exclusively to portraits, was very well received at court (he executed the *Portrait of Marie Leszczynska,* queen of France; Paris, Musée du Louvre) and among a well-to-do clientele. One of the painters of moneyed society of the time, he was sometimes induced to do children's portraits, the most famous being that of the dauphin Louis de France, son of Louis XV (Paris, Musée du Louvre). In that painting, he showed himself to be close to his colleague Drouais, rendering childhood innocence while, at the same time, giving his models the status of small adults.

Musée de Picardie Catalogues: 1878, p. 139, no. 216 (François-Hubert Drouais); 1899, p. 39, no. 98 (Drouais); 1911, p. 30, no. 128 (Drouais).
Bibliography: Bellemère 1908, pp. 29, 52, 53 (Drouais); Dorbec 1909, p. 452, no. 2; Brière 1925, p. 90; Doria 1927, pp. 105–08; Boinet 1928, p. 15, fig. p. 45; Doria 1928, p. 42; Doria 1929, p. 97, no. 32, fig. 48, p. 204; Nicolle 1931, p. 116; Lesage 1978, pp. 163, 164, 167, 168, no. 44.
Exhibition: Paris 1745, no. 77.

31. Pierre Subleyras
(Saint-Gilles-du-Gard 1699–Rome 1749)

The Apotheosis of Saint Camillus de Lellis, 1746
Oil on canvas, 17⅛ × 13¾ in. (43.6 × 34.9 cm)
Musée de Picardie, Amiens; Gift of the Lavalard Brothers, 1890
(M.P.Lav. 1894–195)

Camillus de Lellis (Bucchianico di Chieti 1550–Rome 1614), founder of a monastic order dedicated to serving the sick, was canonized on June 29, 1746, by Pope Benedict XIV. On that occasion, the Camillian fathers, housed in the Magdalene Monastery in Rome, commissioned two paintings from Subleyras.

The first, intended for the pope himself, was *Saint Camillus of Lellis Saving the Ill During the Flooding of the Tiber in 1598* (Rome, Museo di Roma) illustrating an episode that occurred on December 23–24, 1598, in Rome. The waters of the Tiber were rising dangerously and beginning to overrun the Santo Spirito Hospital. Camillus left his monastery to bring help to the sick people threatened by the flood. Despite the opposition of the hospital personnel, who were convinced that the rise of the river would be limited, Camillus, with the help of other monks from his order, carried the paralytics to the upper floor before the Tiber flooded the sick ward.

The second painting was a processional banner that was carried in the canonization ceremonies at Saint Peter's. One side shows *Christ Freeing Himself from the Crucifix to Hold Out His Arms to Saint Camillus* (Rieti, Church of the Crucifix), and the other side, which has disappeared, depicted *The Apotheosis of Saint Camillus de Lellis*. The Amiens sketch is doubtless a pre-liminary study for the second side of the banner. Comparison with one of Gramignani's two engravings, which reproduce both sides of the banner, confirms this theory.

His arms wide open, Saint Camillus is borne by angels and surrounded by cherubim, as he ascends toward heaven in the clouds. Even though the sides have been trimmed, the painting demonstrates Subleyras's subtle, delicate art as a colorist and his easily recognizable style, particularly in the faces of his figures.

Provenance: Collection of the painter Joseph-Marie Vien(?); sold after his death, May 17, 1809, no. 16(?); collection of Chevalier Féréol Bonnemaison(?); sold after his death, April 17–21, 1827, no. 99(?).
Musée de Picardie Catalogues: 1894, p. 48, no. 195; 1899, p. 228, no. 196; 1911, p. 139, no. 192.
Bibliography: Horsin-Déon 1862, p. 144; Bellemère 1908, p. 42; Boinet 1928, p. 13; Vergnet-Ruiz and Laclotte 1962, p. 252; Lehnen 1964, p. 991; Gaehtgens 1974, pp. 68, 69, no. 38 and fig. 12; Foucart 1977, pp. 18, 44, 49; Lesage 1978, pp. 152, 153; no. 38; Gaehtgens and Lugand 1988, p. 62, n. 79, fig. 10.
Exhibition: Paris and Rome 1987, pp. 321, 322, no. 110.
Related Works: Pierre Subleyras, *Saint Camillus de Lellis and an Angel*, 1746, black chalk heightened with white, on blue paper, 11⅞ × 9¼ in. (30.1 × 23.5 cm), preliminary drawing, Musée du Louvre, Paris. Pierre Subleyras, *Saint Camillus de Lellis and an Angel*, 1746, definitive painting, location unknown. Antonio Gramignani, *The Apotheosis of Saint Camillus de Lellis, after Subleyras*, 1749, engraving after the definitive painting, Vatican Library, Rome.

32. JEAN RESTOUT
(Rouen 1692–Paris 1768)

The Ailing Alexander Receives the Potion from His Doctor, Philip, 1747
Oil on canvas, 58¼ × 74 in. (148 × 188 cm)
Signed and dated, right center, on the edge of the console:
"J[fl] 1747"
Musée de Picardie, Amiens; On deposit from the Musée du Louvre, 1864 (M.P.P. 335; Louvre 7455)

IN THE EIGHTEENTH CENTURY, THOSE INVESTED WITH royal authority for overseeing the successful development of art in France were fervently preoccupied with the place of history painting, considered a major genre. In 1747 Lenormant de Tourne-hem, *directeur-général* of the *bâtiments du roi*, and Charles-Antoine Coypel (1694–1752), *premier peintre*, conceived of a competition in which eleven artists, all officers of the Académie, were invited to execute a painting of a specified size on a subject of their choice, it being understood that the topic would be historical. The aim of

the undertaking was to revitalize artistic life by stirring up rivalry among the great painters of the time. François Boucher and Pierre-Jacques Cazes (1676–1754) both painted *The Rape of Europa* (Paris, Musée du Louvre, and location unknown, respectively); Hyacinthe Collin de Vermont (1693–1761), *The Child Pyrrhus Entreating King Glaucias* (Besançon, Musée des Beaux-Arts et d'Archéologie); Jacques Dumont, called *le Romain* (1701–1781), *Mucius Scaevola Before Porsenna* (Besançon, Musée des Beaux-Arts et d'Archéologie); Louis Galloche (1670–1761), *Coriolanus in the Camp of the Volscians* (Orléans, Musée des Beaux-Arts); Etienne Jeaurat (1699–1789), *Diogenes Breaking His Bowl* (Paris, Louvre); Sébastien Le Clerc (1676–1763), *Moses Saved from the Waters* (location unknown); Carle Vanloo, *Silanus, Foster Father and Companion of Bacchus* (Nancy, Musée des Beaux-Arts); Charles-Joseph Natoire (1700–1777), *The Triumph of Bacchus on Returning from India* (Paris, Louvre); Jean-Baptiste Marie Pierre (1714–1789), *Aurora Leaving Thyton* (Poitiers, Musée Sainte-Croix); and Restout, *The Ailing Alexander Receives the Potion from His Doctor, Philip*.

No winner was declared, but each artist received 1,500 *livres* for his work. Although Boucher, Vanloo, and Natoire, treating pleasant groups of divinities and gallants, clearly evaded the constraints imposed upon them, Restout's painting seems to conform more closely to the organizers' objectives: He preferred an episode from the Latin historian Quintus Curcius (first century A.D.) to a more frivolous subject.

The catalogue of the 1747 Salon summarized the scene as follows: "Alexander, after having drunk of the potion that his physician, Philip, had prepared for him, hands him a letter to read. This had been written to Alexander by Parmenion, warning him that Darius had bribed Philip to poison him. This untrue information so infuriated Philip that he threw the letter and his cloak to the ground in front of the king's bed. After three days, the king was fully recovered."

Restout chose this version over that of Plutarch (ca. 50–ca. 125), in which Alexander hands the letter to his physician before drinking. The text of Quintus Crucius allowed him to place more emphasis on the young hero's confidence and determination.

Restout, at the height of his career, brilliantly shows his abilities as a painter: His severe yet clear and balanced composition, usually judged "noble and virile," is in keeping with the firm but free brushwork and dense palette. The dramatic treatment, the attention to the rendering of the expressions, and the decorative richness make this canvas a perfect example of heroic painting, especially as the triumph of virtue was established as a sublime subject.

With this highly moral and edifying subject, Restout develops the venerable theme of the funerary couch, a subject that exalts the emblematic qualities of a noteworthy personage. Previously essayed by Nicolas Poussin (1594–1665), this heroic topic would also be treated by Jacques-Louis David (1748–1825) and his emulators. Thus Restout places himself in the continuum of the French Classical tradition, as he anticipates the Neoclassical current that would triumph at the end of the ancien régime.

Provenance: Acquired by the king following the Competition of 1747; entered the Louvre with the royal collections during the Revolution.

Musée de Picardie Catalogues: 1865, pp. 28, 29, no. 85; 1873, p. 43, no. 95; 1875, p. 56, no. 124; 1878, p. 97, no. 124; 1899, p. 100, no. 244; 1911, p. 69, no. 296.

Bibliography: Leblanc 1747, pp. 313–20; *Galerie Françoise* 1772; Engerand 1896, p. 252; Engerand 1901, p. 424; Locquin 1912, pp. 6, 176, 245; Boinet 1928, pp. 13, 32; Messelet 1938, pp. 129, 130, 167, no. 150; Florisoone 1948, p. 49; Pigler 1956, vol. 2, p. 345; Vergnet-Ruiz and Laclotte 1962, p. 249; Bardon 1963, pp. 232, 237, 239; Beauvalot-Gouzi (forthcoming).

Exhibitions: Paris 1747, no. 2; Mondaye 1956, no. 20; Rouen 1970, pp. 59, 60, no. 31, pl. 37, p. 131; Brussels 1975, p. 100, no. 63, p. 106, fig. a.

Related Works: Jean Restout, *Study for the Figure of Alexander*, 1747, oil on canvas, 18⅞ × 20⅞ in. (48 × 53 cm), private collection, Paris. Copy after Jean Restout, *The Ailing Alexander Receiving the Potion from His Doctor, Philip*, ca. 1750, oil on canvas 31½ × 37⅞ in. (80 × 96 cm), replica, private collection, London, (in 1975); J.-Ch. Levasseur (1734–1816), *The Ailing Alexander Receiving the Potion from His Doctor Philip, after Restout*, ca. 1750, engraving.

33 · AUBRY
(1710–1774)
(active at Versailles in the mid-18th century)

Louis XV the Beloved, 1749
Oil on canvas, 92½ × 52¾ in. (235 × 134 cm)
Musée des Beaux-Arts, Orléans (842 2B)

WE KNOW NOTHING ABOUT AUBRY, WHOSE NAME IS mentioned in the handwritten accounts of the City of Orléans for the year 1749. He could be the father of the painter Etienne Aubry (1745–1781), one of those numerous artists attached to the *bâtiments du roi* at Versailles, in charge of painting official portraits of sovereigns and princes.

The great-grandson of Louis XIV, Louis XV, nicknamed the Beloved, reigned from 1715 to 1774. He became king of France at the age of five, upon the death of his great-grandfather; it was Philippe, duc d'Orléans, however, who controlled the Regency until 1723. In 1725, Louis married Marie Leszczynska, daughter of the dethroned king of Poland, Stanislaw Leszczynska, who became duke of Lorraine by the Treaty of Vienna in 1738, thus permitting the entry of this land into the royal domain when Stanislaw died in 1766.

Unlike his ancestor, Louis XV steered clear of the governing of France, preferring the pleasures of the court. A great lover of the hunt and festivities, he also led a life rich in love affairs. Among his numerous mistresses, the marquise de Pompadour (1721–1764) dominated the king's thoughts for nearly twenty years, from 1744 to 1764, and her influence on artistic and cultural life was considerable. She advised the sovereign by introducing a number of artists she patronized, including Jean-Baptiste Chardin (1699–1779) and Maurice Quentin de La Tour (1704–1788). She also allowed the publication of the works of Diderot and his *Encyclopédistes*. After the death of the marquise de Pompadour, the king's new mistress, Madame du Barry (1743–1793), exerted an important influence as well. The king's passions, his lack of interest in his country's politics, and the court's lavish expenses largely contributed to the decline in the king's popularity toward the end of his life.

This official portrait, commissioned by the aldermen, was intended to decorate the public rooms of the Hôtel de Ville of Orléans, one of the richest cities in France under the ancien régime. It adhered to the requirements of the genre, that of the state portrait intended to spread the sovereign's image, a policy largely initiated by Louis XIV. For this work, the painter drew inspiration from two other portraits of the sovereign: a full-length portrait about 1727 by Jean-Baptiste Vanloo and, for the face, the famous pastel by Maurice Quentin de La Tour, shown at the Salon of 1748.

The monarch is portrayed standing in front of a gilded wooden console, dressed in rich ceremonial armor against which the large blue ribbon of the Order of the Holy Ghost stands out. His hand rests on the baton of the commander of the armies. His heavy mantle, embellished with fleur-de-lys, and his helmet, featuring a crown of laurel leaves, are laid on the sumptuous console, which is decorated with a cupid.

This portrayal of the king as commander-in-chief of the armies probably refers to the victory of Fontenoy when, in 1745, Marshal de Saxe led the French to victory over the English and Dutch. The laurel-leaf crown on the gilt helmet recalls the great military events that made the king popular for a time.

—ERIC MOINET

Provenance: Commissioned in June 1749 by the city's aldermen for the decoration of the Hôtel Commun; remained in the City Hall until around 1791–92; seized by the Revolution; revolutionary storerooms in the custody of the Loiret prefecture until 1800; transferred from there to the museum in 1829.

Bibliography: Demadières-Miron 1843, p. 38, no. 186; Demadières-Miron 1851, p. 76, no. 186; Marcille 1876, pp. 89, 90, no. 229; O'Neill, 1981, no. 187, pp. 142, 143.

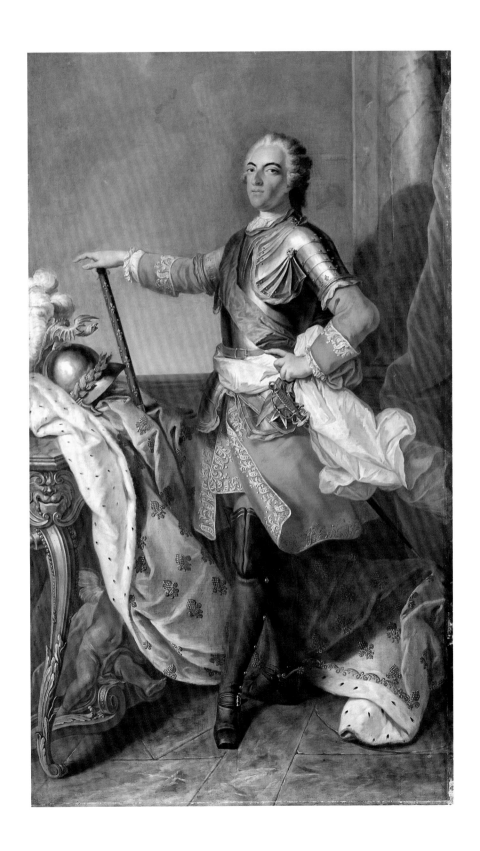

34 · Louis Jean-François Lagrenée, called Lagrenée l'aîné

(Paris 1725–Paris 1805)

Saint Augustine, ca. 1750–70

Oil on canvas, 25⅝ × 31⅞ in. (65 × 81 cm)

Musée de Picardie, Amiens; Bequest of Edmond Soyer, between 1914 and 1918 (M.P.P. 2072–626)

Born in Tagaste in Numidia (present-day Algeria) in 354, Augustine was living in Milan, where he occupied a chair of rhetoric, when he met Saint Ambrose. Soon after, in 387, his conversion took place: One day, lying under a fig tree, a voice suddenly said to him: *"Tolle, lege"* (Take it and read). Upon opening Saint Paul's "Epistle to the Romans," he discovered a verse that advised him to abandon debauchery and impurity and to "array himself" in Christ. After his baptism and the death of his mother, Saint Monica, Augustine returned to Africa where he became first a priest, then bishop of Hippo in 395. It was there that he died in 430, leaving behind him an abundant body of work, including *The Confessions* and *The City of God*.

A key figure in the Catholic Church, a defender of orthodoxy against heresy, Saint Augustine was one of the symbols of the Counter-Reformation. In eighteenth-century France, numerous artists depicted him, including Jean Restout and Carle Vanloo, who devoted a cycle of several large paintings to him (Paris, Church of Notre-Dame-des-Victoires).

This powerful painting—which could be a sketch for the decoration of a pendentive supporting the dome of a church—was recently attributed to Lagrenée *l'aîné* by Pierre Rosenberg. In this canvas, Saint Augustine, dressed in bishop's robes, is seated on clouds. He brandishes a flaming heart, an allusion to the blazing in his own heart upon discovering the love of God and his fellow man. The book he holds on his lap, like the table covered with manuscript pages, refers to the writings of this Doctor of the Church. The angel accompanying him represents inspiration and also recalls a legendary episode: One day Augustine, meditating on the mystery of the Trinity, encountered on the seashore a child, busy emptying the sea with a shell. He realized that the child's undertaking was no more derisory than his own attempt to explain the Trinity. Finally, the shining arrow in the angel's hand symbolizes the indelible and powerful blow Augustine's heart received at the moment of the revelation.

35. Unknown French Artist
18th century

Odysseus Threatening Circe, ca. 1750
Oil on canvas, 40¼ × 31⅛ in. (103.5 × 79 cm)
Musée de Picardie, Amiens; Additional gift of Adolphe Lavalard,
1894 (M.P.Lav. 1894–266)

This painting illustrates fairly exactly an episode from the adventures of Odysseus, as told in Ovid's *Metamorphoses* (XIV, 223–319) after Homer's poem.

After Odysseus and his companions landed on the island of Aeaea (Latium, Italy), Macareus and twenty-one others were sent on a reconnaissance mission. When they arrived at the palace of the sorceress Circe, sovereign of the country, she welcomed them and, with a potion and a magic wand, transformed into swine the soldiers who dared enter this place. The only one not to drink the potion was Euryloch, who managed to escape and warn Odysseus of Circe's plot. That hero rushed to the sorceress's palace to avenge his companions; led before Circe, he was offered the fatal beverage. However, thanks to Hermes, who had given him some *moly*, an herb that protected against evil spells, the magic artifices had no effect on him. He kept his human shape and threatened the sorceress. Surprised by this miracle and admiring of one who could render her spells powerless, Circe became infatuated by Odysseus and turned the Greek warriors back into their original form. The story recounts that, after all the kindness that Circe proceeded to shower upon them, Odysseus and his companions remained on the island for a full year.

The painter followed Ovid's text almost to the letter: Circe is seated "on her raised throne, dressed in a dazzling robe. . . . She is surrounded by Nereids and Nymphs . . . who hold plants and, in baskets, put . . . flowers . . . and colored herbs. . . . Odysseus, invited to accept the perfidious brew, as the goddess tried to stroke his hair with her wand, rejected her and, threatening her with his sword which he had drawn, obliged her, terrified, to give up." The artist has not even omitted the presence of Euryloch, behind the hero, nor the appearance of Hermes on the upper left, easily recognizable by his attributes. The fate of Odysseus's unfortunate companions is delightfully suggested by the outline of a pig on the lower right. To add to the scene's fantastic aspect, the painter placed cupids flitting about, in an atmosphere filled with bewitching scents diffused by smoking incense-burners.

The attribution to Charles-Joseph Natoire (1700–1777) with which the painting entered the museum has now been abandoned, without, however, being replaced by a more convincing name. The clarity of the composition and the elegance and firmness of its technique will doubtless enable us in the near future to redeem this unrecognized work from anonymity.

Musée de Picardie Catalogues: 1894, p. 62, no. 266 (attributed to Charles-Joseph Natoire); 1896, p. 250, no. 266 (attributed to Natoire); 1911, p. 155, no. 262 (attributed to Natoire).

36. CHARLES-ANDRÉ, CALLED CARLE VANLOO
(Nice 1705–Paris 1765)

The Adoration of the Angels, 1750–51
Oil on canvas, 20¾ × 13¾ in. (52.6 × 35 cm)
Signed, bottom toward the right on the first riser: *Carle Vanloo*
Musée de Picardie, Amiens; Gift of the Lavalard Brothers, 1890
(M.P.Lav. 1894–172)

THE CHRIST CHILD LIES SLEEPING IN A MANGER filled with straw. His mother delicately lifts the veil that covers him to look at the Savior. Behind her, Joseph regards the cherubs descending to adore the Holy Child, while in the foreground, three kneeling angels, their hands joined, worship in serene deference. Toward the front, a donkey's packsaddle with a saw leaning against it recalls the humble origins of the newborn, whose father is a carpenter, and the simplicity of the stable in which he was born, further suggested by a straw roof propped up against a column.

This small painting is the preparatory sketch for a large canvas now in the Musée des Beaux-Arts in Brest. The work originally adorned the altar of the Chapel of the Childhood-of-Jesus in the Church of Saint Sulpice in Paris. The decoration of this chapel was commissioned by Monsignor Dulau d'Allemans, curate of Saint Sulpice, in 1748–1749, then carried out in 1750–51. In addition to fine wood paneling and a ceiling painted by Noël Hallé, representing *The Morning Star Guiding the Three Wise Men* (still in the chapel), five canvases initially decorated the chapel's walls. In addition to Vanloo's Nativity (shown at the 1751 Salon), there was a *Presentation in the Temple* (1750 Salon, now lost) by Jean-Baptiste-Marie Pierre (1714–89); a *Flight into Egypt* (1751 Salon,

still in the chapel) by the same painter; a *Jesus Christ Among the Doctors* (Salon of 1751, now lost) by Jean-Charles Frontier (1701–1763); and a *Jesus Calling the Little Children Unto Him* (Salon of 1751, still in the chapel) by Hallé.

Vanloo's final painting shows a few distinctive differences from the preliminary study: The figure of Joseph is moved from the left to the right, freeing up space for the manger's architecture, and some of the cherubs have been suppressed. Vanloo gives us a fairly traditional image of the Nativity, but he plays on the coloration radiated by a golden light to give this rustic scene an exceptional character.

Musée de Picardie Catalogues: 1894, p. 44, no. 172; 1899, p. 221, no. 173; 1911, p. 136, no. 170.
Bibliography: Horsin-Déon 1862, p. 144; Boinet 1928, p. 13 ("mistakenly attributed" to Carle Vanloo); Réau 1938, p. 54, no. 7; Vergnet-Ruiz and Laclotte 1962, pp. 74, 254; Vilain 1970, pp. 373, 376, fig. 2, n. 22; Foucart 1977, pp. 18, 22, 29, 44, 49.
Exhibitions: Paris 1874, no. 909; Amiens 1952; Nice, Clermont-Ferrand, and Nancy 1977, no. 122; Amiens 1992, p. 13, no. 21.
Related Work: Carle Vanloo, *The Adoration of the Angels*, 1751, oil on canvas, 119¹¹⁄₁₆ × 77⅛ in. (304 × 196 cm), definitive painting, Musée des Beaux-Arts, Brest.

37. JEAN-SIMÉON CHARDIN
(Paris 1699–Paris 1779)

Still Life with Two Rabbits, Game Bag, and Powder Horn,
ca. 1750–55
Oil on canvas, 19⁹⁄₁₆ × 22¼ in. (49.7 × 56.5 cm) (enlarged at top and
bottom by ¾ in. [1.8 cm] and on right by⅞ in. [2.2 cm])
Musée de Picardie, Amiens; Gift of the Lavalard Brothers, 1890
(M.P.Lav. 1894–138)

THIS WELL-KNOWN PAINTING WAS PERHAPS ORIGI-
nally paired with *Still Life with Rabbit and Two Dead Thrushes*
(Paris, Musée de la Chasse et de la Nature). The composition is
radical in its simplicity: Two rabbits lie on a stone slab with a
powder horn and a game bag. The horizontal construction is in-
terrupted only by the head of one of the animals, which hangs
over the ledge, as does the ribbon of the powder horn. The min-
imalism of the composition is echoed by that of the palette: a soft
gray-green tonality reigns over the whole canvas, relieved only
by the colored accent of the ribbon.

This work dates from a period when Chardin, having devoted
himself for more than a decade to genre scenes, returned to the art
of the still life. Here, the artist is more concerned with the render-
ing of an ensemble effect rather than of particular elements. The
objects are painted more fluidly than in his youthful work, their
contours more blurred, resulting in a canvas that is less anecdotal.
As Pierre Rosenberg has observed, "An attentive and affectionate
observer, [Chardin] recreates a banal subject *par excellence*, re-
peated by generations of still-life painters, and brings a highly
personal note of restrained emotion to it" (exhib. cat., Paris 1979,
no. 101). Here, the artist discreetly offers a sensitive, moving, and
silent reflection on death.

Provenance: Probably from the sale of sculptor Jean-Baptiste Lemoyne (1704–
 1778), August 10, 1778, no. 28; collection of Madame Geoffrin(?); Didot
 Collection; Didot sale, Paris, December 27–28, 1819, no. 24; anonymous sale,
 March 18, 1829, p. 7, no. 8.
Musée de Picardie Catalogues: 1894, p. 38, no. 138; 1899, p. 212, no. 139; 1911,
 p. 131, no. 137.
Bibliography: Horsin-Déon 1862, p. 145; Bocher 1876, p. 95; Gonse 1900, p. 15;
 Bellemère 1908, p. 43; Guiffrey 1908, p. 62, no. 33; Furst 1911, p. 119; Boinet
 1928, p. 15; Courthion 1932, p. 537; Guiffrey 1933, no. 33; Wildenstein 1933,
 no. 704, fig. 88; Denvir 1950, pl. 35; Wildenstein 1960, p. 2; Vergnet-Ruiz and
 Laclotte 1962, pp. 84, 93, 230; Wildenstein 1963, p. 140, no. 32, fig. 15; Rosen-
 berg 1963, p. 72; Valcanover 1966, pl. 12; Foucart 1977, pp. 18, 22, 25, 30, 43, 50;
 Chefs-d'œuvre de l'art. Grands peintres 1978, pl. 12; Rosenberg 1983, p. 104, 105,
 no. 140; Rosenberg 1991, pp. 72, 73, 119; Roland Michel 1994, p. 258; Huchard,
 Lernout, Mahéo, and Couderc 1995, p. 107, pl. 106.
Exhibitions: Paris 1883–84, no. 25; Paris 1931, no. 5; Paris 1951; Paris 1959, no. 24;
 Vienna 1966, no. 12; Brussels 1975, pp. 127, 131, no. 87; Paris 1979, pp. 303–05,
 no. 101; Karlsruhe 1999, pp. 135–38, no. 25; Paris, Dusseldorf, London, and New
 York 1999–2000, pp. 274–75, no. 73.

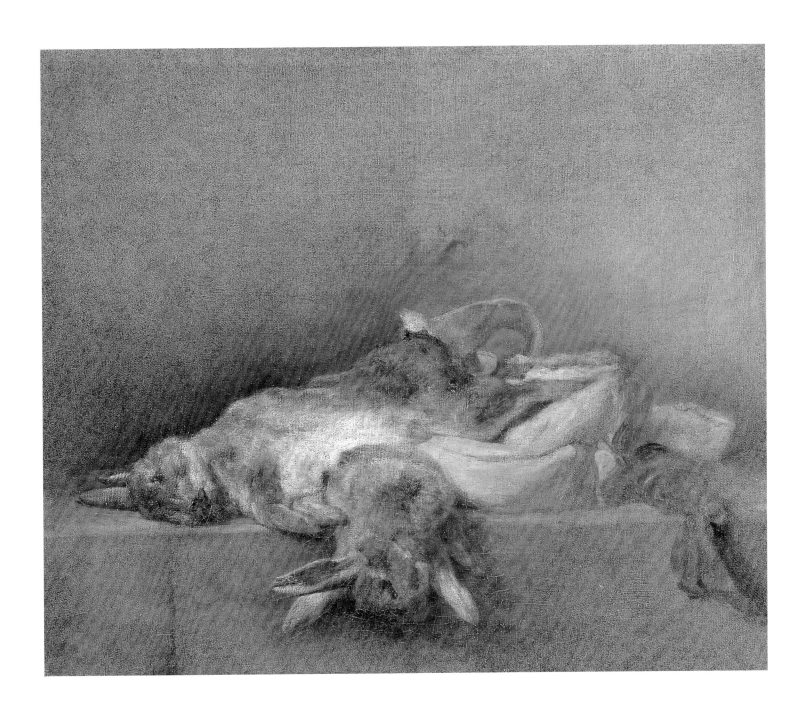

38. François Boucher
(Paris 1703–Paris 1770)

Project for a Stage Set: A Village Square, ca. 1750–60
Oil on canvas, 21⅛ × 25⅝ in. (53.7 × 65 cm)
Musée de Picardie, Amiens; Gift of the Lavalard Brothers, 1890
(M.P.Lav. 1894–128)

THIS LANDSCAPE PROVIDES THE OPPORTUNITY TO broach a lesser-known facet of Boucher's career—that of creator of stage sets. Several aspects of this work support the theory that this is not an ordinary landscape like those Boucher produced in good number. The somewhat exaggerated perspective and the particular centering that leave room for entrances on both sides; the emptiness of the scene, which seems to await the actors; and even the small bush at the bottom center, suitable for hiding the prompt box—all these clues enable us to recognize a project for a stage set.

Boucher ushers us into the square of a rustic hamlet: On the left is an Italian-style villa with a well and, on the right, an inn with a balcony supported by two small columns and a dovecote alongside. In the center, beneath the foliage of a tree, a cask stands on a platform, at the foot of which are a table, a bench, a chair, and a keg, as if awaiting some merry comrades. Only one detail disturbs the peaceful atmosphere. In the landscape in the background, which is dominated by the silhouette of a citadel, the towers of a wall are being devoured by flames.

It was long suggested that this charming painting was a sketch for the set of act II of the opera *Issé*, by André Cardinal Destouches (1672–1749). With a libretto by Houdar de La Motte (1672–1731), based on Ovid's *Metamorphoses* (IV, 124), it recounts the ruses of Apollo who, eager to seduce the nymph Issé, disguises himself as a shepherd and as various animals. The opera was revived at Versailles in 1749. However, the joyfully rustic character of this painting seems unsuitable for a pastoral, heroic mythological fable. A set project created by Boucher for *Issé* was exhibited at the 1742 Salon (no. 20), but its dimensions do not correspond to this canvas at all.

In the catalogue of the 1986–87 Boucher exhibition, Alastair Laing proposed a far more plausible hypothesis: This project would suit a scene from the comic opera and ballet in one act *L'Ecole des Amours grivois,* by Charles-Simon Favart (1710–1792), which was created in 1744 at the Théâtre de la Foire in Paris (it doubtless dates from a re-use of the subject in the 1750s–60s rather than the first of 1744). The description of the set corresponds fairly closely to the painting: "The theater represents a Flemish Hamlet. In the distance one sees a City whose Ramparts are destroyed by Cannon fire; on the other side, a Camp, at the head of which is a Battery of Artillery. The Wings represent Peasant Houses & Taverns. The middle of the Stage is occupied by a large tree [and] several tables . . ."

This brilliant sketch is the work of an artist in full maturity, at the height of his powers. Beginning about 1735, Boucher enjoyed considerable success to which he responded with untiring activity. One royal commission followed another; he created numerous cartoons for the Gobelins and Beauvais tapestry workshops; he was participating in the great projects at Versailles; he created models for the Sèvres porcelain factory; and he designed opera sets. The preferred painter of the marquise de Pompadour and one sought after by the court of France, as well as by certain foreign courts, Boucher embodies the Rococo. His preeminence was confirmed by Louis XV himself, who, in 1765, bestowed on him the title of *premier peintre du roi.*

Musée de Picardie Catalogues: 1894, p. 36, no. 128; 1899, p. 209, no. 129; 1911, p. 129, no. 127.
Bibliography: Horsin-Déon 1862, p. 145; Goncourt 1880, vol. 1, pp. 153, 154; Mantz 1880, p. 100; Michel 1889, pp. 48, 54; Kahn 1905, pp. 30, 35, 80, 83; Michel, Soullié, and Masson 1906, pp. 43, 98, no. 1747, p. 135, no. 2461, p. 148; Nolhac and Pannier 1907, p. 41; Dacier and Hourticq 1926, pp. 47, 48; Magnin 1928, p. 127, pl. 13; Boinet 1928, pp. 14, 33; Tintelnot 1939, p. 185; Lossky 1954, p. 239; Schönberger and Soehner 1960, pl. 168; Ananoff and Wildenstein 1976, vol. 1, p. 335, no. 221; Foucart 1977, pp. 22, 50; Roland Michel 1984, p. 110, fig. 283, p. 370, no. 75.
Exhibitions: Paris 1925, pp. 47, 48, no. 31, pl. 38 I; Paris 1929, no. 10; Paris 1932, p. 69, no. 144; London 1949–50, p. 30, no. 107; Amsterdam 1951, no. 3; Munich 1958, p. 39, no. 12; Paris 1960, p. 79, no. 68, pl. 18; Paris (Cailleux) 1964, no. 21; Bordeaux 1980, pp. 58, 59, no. 5; Lille 1985, p. 57, no. 6; New York, Detroit, and Paris 1986–87, pp. 216–18, no. 47; Amiens 1992, p. 12 (no. 18).

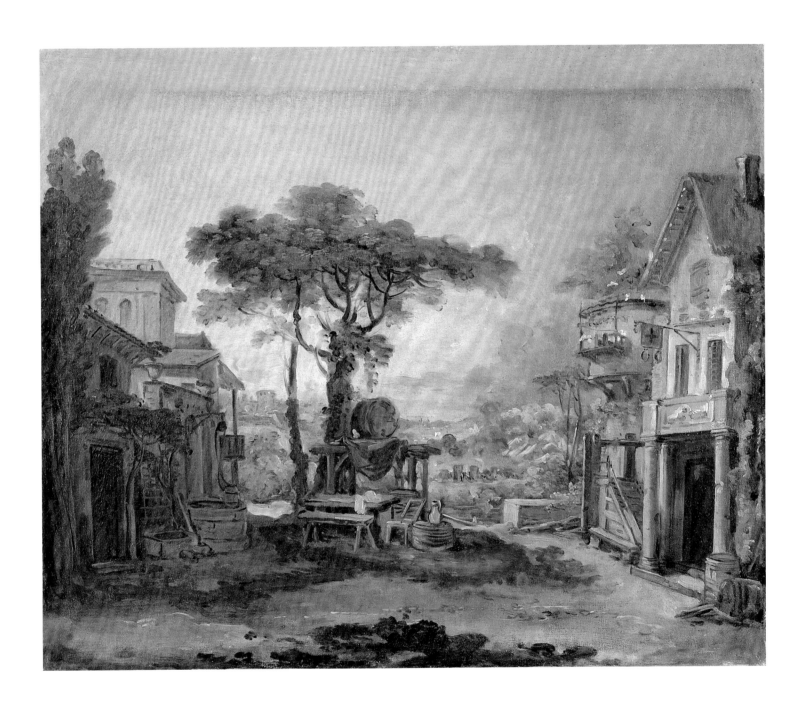

39. ATTRIBUTED TO JEAN-BAPTISTE BÉNARD
(?–before 1764?)

Village Scene, ca. 1750–1760

Oil on wood, 15⅞ × 22⁷⁄₁₆ in. (40.4 × 57 cm)
Musée de Picardie, Amiens; Gift of the Lavalard Brothers, 1890
(M.P.Lav. 1894–122)

JEAN-BAPTISTE BÉNARD IS TYPICAL OF THOSE MINOR masters of eighteenth-century French painting who are at the same time so characteristic of the period and yet so little known. We know practically nothing about this painter who is usually said to be a portraitist, genre painter, and landscape artist. His creative period seems to have been quite brief, according to a reference in the sale catalogue of the La Live de Jully Collection, which notes that the artist "did not live long enough." G. Marcus was able to calculate that his signed works extend over a period from 1745 to 1758.

In this panel, Bénard has created a sort of friezelike composition in which the figures and animals stand out against a background landscape. From left to right, various figures succeed one another: washerwomen at the fountain, peasants conversing or playing, two gentlemen and a lady, two riders, a flock of sheep and a herd of cows with their shepherd and cowherd (one of whom seems to be having a discussion with a buyer), and finally, closing the composition on the right, a woman nursing an infant. The landscape, which features the old walls and tower of a village, opens onto a horizon of pastures and fields. The artist invites us into a pleasant rustic scene with figures of rural life, in which he juxtaposes types without trying to produce a particular subject. The traditional title of this work, *A Market,* has been discarded.

The painting recalls to a certain degree the great Dutch and Flemish rustic traditions of the seventeenth century. With its light and lively touch, it reveals influences that can be detected in other works we are certain Bénard painted: those of Antoine Watteau (1684–1721), from whom he borrows this pleasantly rustic atmosphere, and those of Chardin, which show up in a few intimist details.

Musée de Picardie Catalogues: 1894, p. 35, no. 122; 1899, p. 208, no. 123; 1911, p. 129, no. 123.
Bibliography: Bellemère 1908, p. 42; Boinet 1928, p. 16; Marcus 1965, pp. 4, 5; Foucart 1977, p. 42.

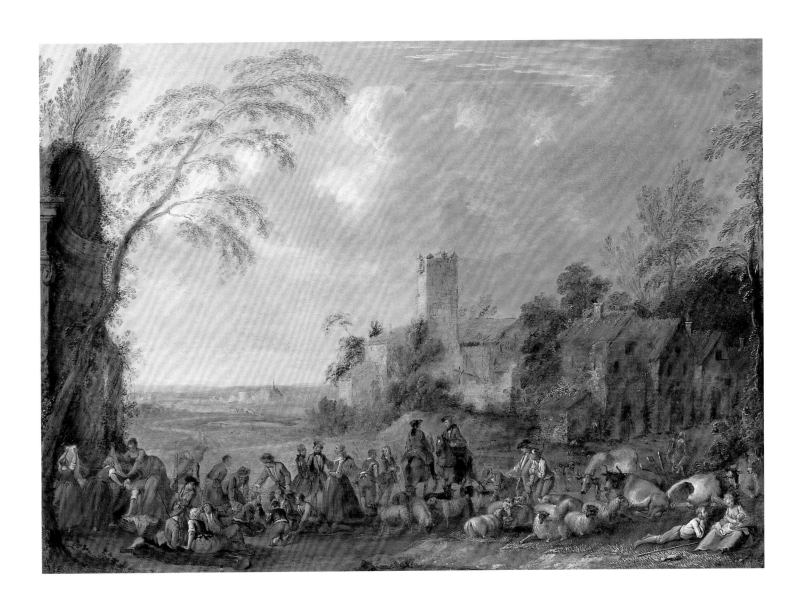

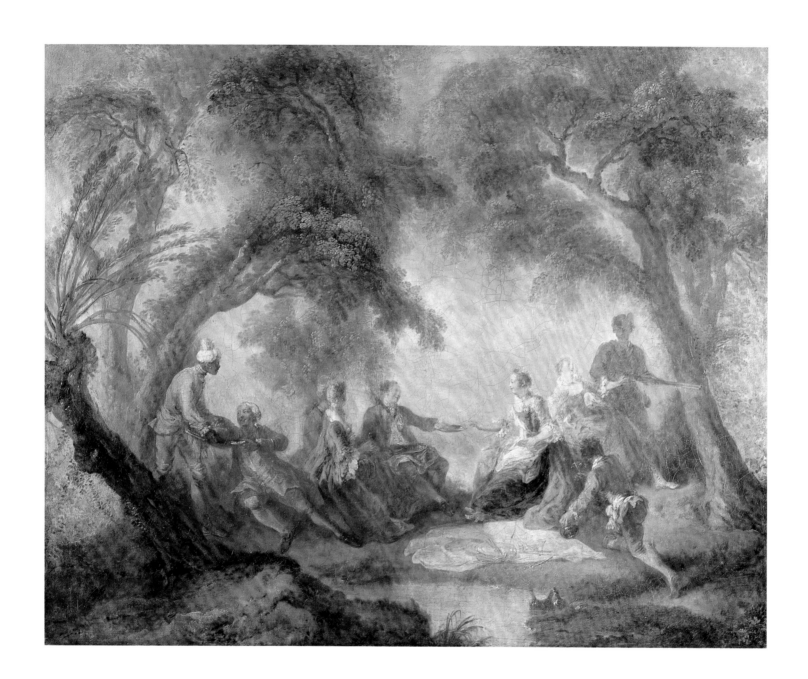

40. UNKNOWN FRENCH ARTIST

18th century

The Country Meal, ca. 1750–1760

Oil on canvas, 31⅞ × 39⁹⁄₁₆ in. (81 × 100.5 cm)

Musée de Picardie, Amiens; Bequest of Dr. Demarquay, 1875

(M.P.P. 208—formerly 322)

NEXT TO A STREAM, BENEATH THE SHADE OF TALL trees, a meal has been set: On a white tablecloth are silverware, plates, glasses, and small loaves of bread; three bottles of wine are cooling in the water. Behind this rustic "table" are seated the guests: two young lords, accompanied by two ladies of quality. To the left, the cook, with a cap on his head, receives a pâté served on a plate by a black servant in a turban. Another servant, kneeling on the right, holds a glass and a carafe. Further back, a lady converses with a man in hunting dress. Rifle in hand he seems ready to depart on a hunt. In the background, under the trees, we can make out a carriage.

Its longstanding attribution to Fragonard having been refuted, this painting continues to resist other attributions and remains classified as anonymous. But rather than belonging to the followers of Fragonard, the work, given its subject as well as its style, seems more closely related, as Martin Eidelberg has argued, to works by imitators of Watteau—and quite inspired by his *Collation* (location unknown)—and his disciples, Pater and Lancret. However, the names of Bonaventure de Bar, François Octavien (1682–1740), Pierre-Antoine Quillard (ca. 1704–1773), like those of Sébastien Leclerc, called des Gobelins (1676–1763), Jérôme-François Chantereau (ca. 1700–1757), or Michel Barthélémy Ollivier (1712–1784) are not wholly convincing.

Someday, someone will doubtless penetrate the mystery of this canvas, unfortunately a bit worn, which treats a theme painted countless times by French artists of the eighteenth century: the *fêtes galantes* much appreciated by a well-to-do society. Such pictures convey the carefree charm of these country diversions.

Musée de Picardie Catalogues: 1878, pp. 140, 141, no. 218 (Jean-Honoré Fragonard); 1899, p. 46, no. 116 (Fragonard); 1911, p. 35, no. 149 (Fragonard?).

Bibliography: Bellemère 1908, pp. 15, 52 (Lancret or Fragonard); Boinet 1928, pp. 15, 44 (attributed to Fragonard); Wildenstein and Mandel 1972, p. 112, no. 577 (attributed to Fragonard).

Exhibition: Paris 1921, no. 6.

Related Work: Mayeur, *Le Déjeuner sur l'herbe, d'après Fragonard,* 1911, etching, printed by the Société septentrionale de gravure in 1911.

41. Attributed to Charles-André, called Carle Vanloo

(Nice 1705–Paris 1765)

The Powers of Earth Pay Tribute to Justice, ca. 1750–1760

Oil on canvas, 27⅞ × 39¼ in. (70.7 × 101 cm)

Musée de Picardie, Amiens; Gift of the Lavalard Brothers, 1890

(M.P.Lav. 1894–174)

In the middle of the composition, with a palatial portico in the background, Justice is enthroned on clouds, displaying the symbols of her power: A double set of scales indicates equilibrium, measure, and equity, and the fascias, replacing the sword of justice that is usually seen, signifies rigor and legitimacy. The personifications of the two earthly powers surround her. On the left, spiritual power is represented by a crowd of prelates, among whom prominence is given to a mitered archbishop, kneeling and bearing a pontifical tiara, with a cardinal wearing a hat behind him. On the right, temporal power is represented by a woman (Monarchy or Aristocracy) placing crowns on a sort of altar covered with a carpet. Behind her, a bearded wise man prepares to do the same, while others show their deference. A trophy of arms lying in the foreground symbolizes the submission of force to Justice.

The painter, most probably Vanloo, demonstrates his talents as a pictorial stage director: Skilled at producing spectacular allegories, he proves himself capable of inventing a scenario couched in the Rococo language typical of his oeuvre.

The attribution of this canvas to Vanloo has been made with caution by Marie-Catherine Sahut, for although some elements recall the master's work (the figure of Justice, for instance), others renounce it fairly clearly.

Musée de Picardie Catalogues: 1894, p. 44, no. 174; 1899, p. 222, no. 175; 1911, p. 136, no. 171.

Bibliography: Horsin-Déon 1862, p. 144; Foucart 1977, pp. 18, 22, 44, 49.

Exhibition: Paris 1966, no. 224.

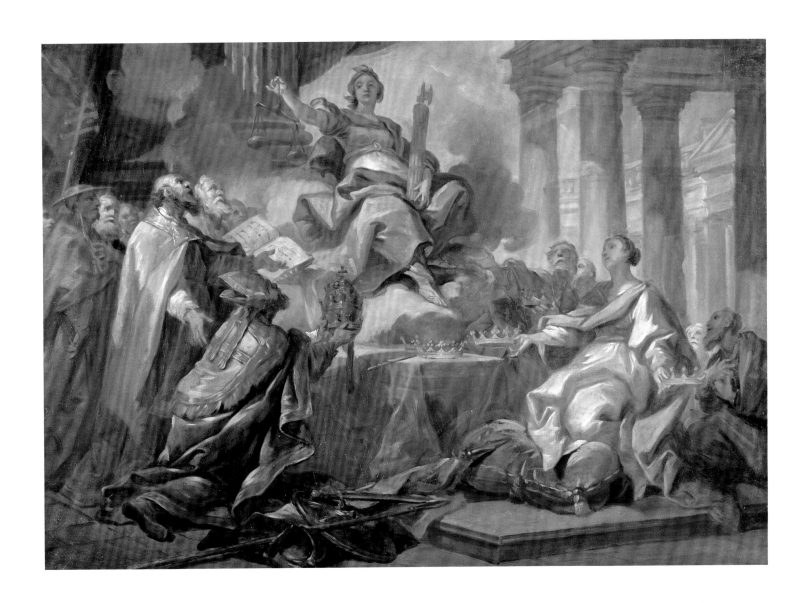

42. CHARLES-ANDRÉ, CALLED CARLE VANLOO
(Nice 1705–Paris 1765)

Venus and Cupid, ca. 1750–60

Oil on canvas, glued to wood, 8⅞ × 12¼ in. (22.6 × 31.2 cm)
Musée de Picardie, Amiens; Gift of the Lavalard Brothers, 1890
(M.P.Lav. 1894–171)

THE GODDESS OF LOVE, WEARING A DRESS SIMILAR to those worn by women of society in the mid-eighteenth century, is seated nonchalantly in a garden. She has confiscated one of Cupid's arrows, and Cupid is trying to retrieve the instrument of his power. Here, Venus, considered to be Cupid's teacher, amuses herself by playing with her pupil who, with a childish gesture, reacts to his "professor's" teasing. In the eighteenth century, other works emphasize even more explicitly Venus's instructional role, in particular *Venus Showing Cupid the Ardor of His Arrows* (1729–30) by François Lemoyne (1688–1737), which was created as an overdoor for the main salon of the Peyrenc de Moras mansion, Hôtel Biron, in Paris (now the Rodin Museum).

Identified by Marie-Catherine Sahut as a preparatory study for a canvas reported in 1955 to be in a private collection, this charming painting is typical of the elegant mythological scenes that were fashionable at the time. Vanloo demonstrated a brilliant, lively style that gives this canvas the spirit of a sort of precious miniature.

Coming from a family of painters who were originally from the Netherlands but settled in France in the seventeenth century, Carle Vanloo enjoyed an exemplary career: After receiving the Prix de Rome in 1724, which enabled him to spend eight years in Italy, he entered the Académie Royale in 1735 as a history painter. Appointed *premier peintre du roi* in 1762, he became the director of the Académie a year later. Unjustly overlooked today, Vanloo was seen in his time as the equal of Boucher and one of the masters of the "great genre," history painting. His mythological and religious scenes attest to a graceful, elegant art that aroused interest at court and earned the good will of Madame de Pompadour.

Musée de Picardie Catalogues: 1894, p. 44, no. 171; 1899, p. 221, no. 172; 1911, p. 136, no. 169.
Bibliography: Vergnet-Ruiz and Laclotte 1962, p. 254; Foucart 1977, pp. 18, 22, 44.
Exhibition: Nice, Clermont-Ferrand, and Nancy 1977, p. 83, no. 172.
Related Works: Carle Vanloo, *Venus and Cupid*, ca. 1743, black chalk on paper, 9 × 11¼ in. (23 × 28.5 cm), preliminary drawing(?), Musée du Louvre, Paris. Carle Vanloo, *Venus and Cupid*, ca. 1750–56, definitive painting, private collection (1995).

43. UNKNOWN FRENCH ARTIST
18th century

The Offering to Cupid, ca. 1750–60
Oil on canvas, 15⅞ × 12½ in. (40.2 × 31.7 cm)
Musée de Picardie, Amiens; Gift of the Lavalard Brothers, 1890
(M.P.Lav. 1894–154)

ATTRIBUTED TO JEAN-BAPTISTE GREUZE WHEN IT
entered the museum, this small painting can no longer support
that attribution.

The subject of *The Offering to Cupid* was popular with certain
eighteenth-century artists, such as Carle Vanloo, Greuze,
Fragonard, Joseph-Marie Vien (1716–1809), and even the sculptor
Clodion (1738–1814). Here, a woman, dressed in classical garb, is
led to an altar by a cupid; the relief of a bow decorating the shaft
of the smoking sacrificial table and the statue of the seated Eros
shooting an arrow indicate that the young woman has come to
solicit the intervention of the "God of Hearts," presumably to
obtain the faith and fidelity of her lover. A putto on the left and
two children with a ewer and a patera on the right witness the
ceremony, which takes place in a vast edifice, the colonnades of
which can be seen in the background.

Imbued with moral and sentimental overtones, such scenes
attest to a widespread taste in the eighteenth century for works
that were amorous and harkened back to antiquity.

Musée de Picardie Catalogues: 1894, p. 41, no. 154 (Jean-Baptiste Greuze); 1899,
p. 216, no. 155 (Greuze); 1911, p. 133, no. 152 (Greuze).

44. ATTRIBUTED TO MARIANNE LOIR
(Paris? ca. 1715–Paris? after 1769)

Portrait of a Woman As a Water Goddess, ca. 1750–60
Oil on canvas, 21½ × 18¼ in. (54.5 × 46.5 cm)
Musée de Picardie, Amiens; Gift of the Lavalard Brothers, 1890
(M.P.Lav. 1894–180)

THIS PORTRAIT OF AN UNKNOWN WOMAN, WHO SEEMS to be in her thirties—once thought to be one of Louis XV's daughters—presents the sitter from the waist up, the head slightly turned toward the left, the eyes staring at the viewer, and a light smile playing on her lips. Small leaves decorate her hair, and a double strand of pearls is wound through her coiffure, falling on her right shoulder in a braid. The knot of her sash is decorated with reed leaves; these same plants constitute the sole decor behind the figure. The use of pearls and reeds suggests that the artist sought to give her subject the appearance of a water goddess. The popularity of portraits in which the model is disguised as a mythological figure is well known: Largilliere, Jean-François Delyen (1684–1761), and especially Nattier practiced this genre to quite an extent. This device was also used by other painters in the eighteenth century, particularly those in the provinces, for example, Louis Dupont (1731–1765), nicknamed "The Norman Nattier," who made several comparable likenesses.

Although the painting was previously attributed to Nattier—an association easily understood, given the theme of the work and its pleasant character—its style excludes it from the oeuvre of that famous portraitist. According to Jean-Pierre Cuzin, it might be the work of Marianne Loir. The "phenomenon" of women painters, perhaps more widespread at the beginning of the eigh-teenth century than is imagined, increased during the second half of the century, and culminated in the figures of Adélaïde Labille Guiard (1749–1803) and Elisabeth Vigée-Le Brun (1755–1842).

Very little information exists concerning Loir. The sister of Alexis Loir (1712–1785), a painter and sculptor, Marianne was the student of Jean-François de Troy (1679–1752). She was in Rome in 1738, then in Pau in 1760, with another brother, Jérôme, a silversmith like their father. Studies on Loir are lacking at the moment, but this portrait bears a convincing resemblance to other canvases attributed to her: *Portrait of a Lady of Quality* (Cholet, Musée d'Art et d'Histoire), *Portrait of Gabrielle Emilie de Tonnelier de Breteuil, marquise du Châtelet* (Bordeaux, Musée des Beaux-Arts), and *Portrait of a Man* (Orléans, Musée des Beaux-Arts).

With its slightly acid colors and appealing iconography so representative of the charms of eighteenth-century French art, this canvas offers the viewer an image of a spirited woman belonging to the society of the time.

Musée de Picardie Catalogues: 1894, p. 45, no. 180 (Jean-Marc Nattier); 1899, p. 223, no. 181 (Nattier); 1911, p. 137, no. 177 (Nattier).
Bibliography: Horsin-Déon 1862, p. 144 (Jean-Marc Nattier); Boinet 1928, p. 15 (attributed to Nattier); Foucart 1977, p. 24, no. 39, pp. 44, 49 (Nattier).

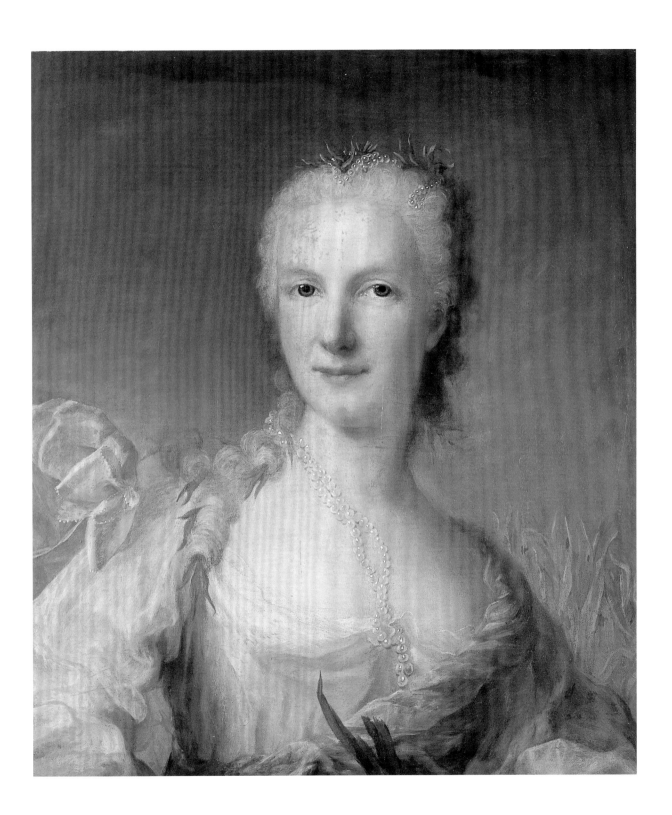

45. CHARLES-ANDRÉ, CALLED CARLE VANLOO
(Nice 1705–Paris 1765)

The Suffering of Artemisia, ca. 1755–60
Oil on canvas, 15⅜ × 12¼ in. (39.2 × 32.3 cm)
Musée de Picardie, Amiens; Gift of the Lavalard Brothers, 1890
(M.P.Lav. 1894–175)

ANCIENT HISTORY RELATES THAT IN THE FOURTH century B.C. Artemesia, the queen of Caria (a region located in southwest Asia Minor), was inconsolable after the death of Mausolos, her brother and husband. She decided to erect a monumental tomb in his memory in the city of Halickarnassos (today Bodrum). The Mausoleum, no longer standing, became one of the Seven Wonders of the World and was celebrated by authors of antiquity. The Latin historian Valerius Maximus even suggested that Artemisia gathered the king's ashes after his cremation and drank them mixed with wine, thus becoming the living sarcophagus of her husband. Naturally, this exemplary act also made the queen the legitimate successor to Mausolos, and she remained on the throne until their son, Lygdamis, came of age.

Here, Vanloo shows the queen giving way to her suffering: Overcome with grief and supported by a servant, she leans on a console on which lies her crown. Her gestures—one hand extended, tense, the other clutching a piece of cloth to dry her tears—attest to the depth and genuineness of her despair.

Considered a paragon of virtue and fidelity, Artemisia was extolled by writers and artists from the Renaissance on. Carle Vanloo places himself within this tradition, but the despondency of his heroine also becomes the pretext for depicting a spectacular posture appropriate to the excesses of the Rococo period.

Musée de Picardie Catalogues: 1894, p. 44, no. 175; 1899, p. 222, no. 176; 1911, p. 136, no. 172.
Bibliography: Vergnet-Ruiz and Laclotte 1962, p. 254; Foucart 1977, pp. 18, 22, 44.
Exhibitions: Nice, Clermont-Ferrand, and Nancy 1977, no. 173; Amiens 1992, p. 13, no 22.

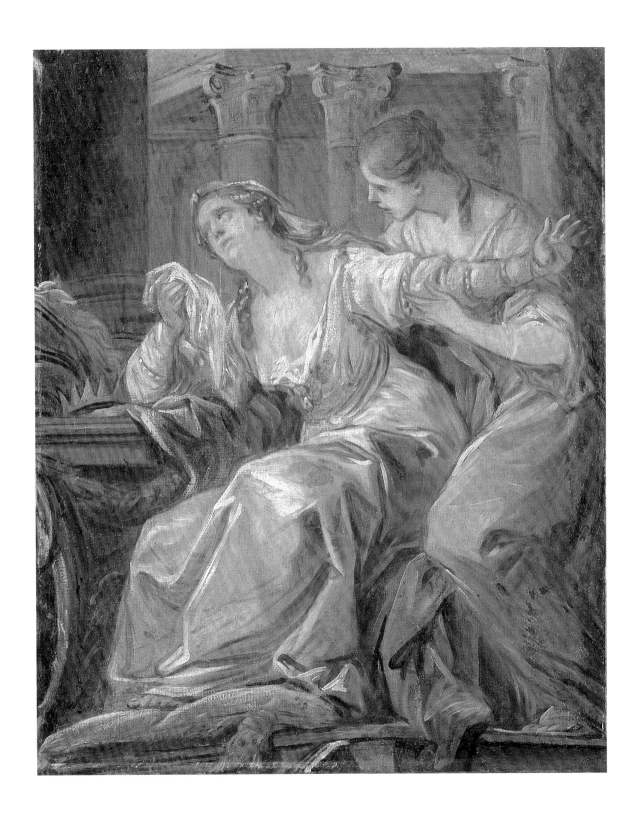

46. JOSEPH SIFFRED (OR SIFFREIN) DUPLESSIS
(Carpentras 1725–Versailles 1802)

Portrait of Abbé Guillot de Montjoye, ca. 1756

Oil on canvas, 36 × 29¼ in. (91.3 × 74.2 cm)
Inscribed left, toward the center on the two books: INVEN[TAIRE]/
DU/TRESOR and BREVIAR/PARISIE.
Inscribed bottom left, on the plan: *Tresor;/Sacristie/Souflot invenit*
Musée de Picardie, Amiens; Gift of the Lavalard Brothers, 1890
(M.P.Lav. 1894–142)

ABBÉ GUILLOT DE MONTJOYE, CANON OF NOTRE-DAME de Paris, is pictured seated, leaning on a table on which lie an ermine cloak and two large, leather-bound volumes. Their titles—*Inventaire du Trésor* et *Brèvièraire de Paris*—refer to the duties of the sitter, who was a member of the cathedral chapter, a group serving as a council to the bishop. His hair powdered white, he is dressed in a robe covered with a ratchet, a sort of short-sleeved alb, with the black bands that distinguish the clergy. He holds a large sheet signed by the architect Germain Soufflot (1713–1780), on which is traced the plan of the sacristy and treasury of Notre-Dame. It was, in fact, in 1756 that Guillot de Montjoye, along with canon Corberon, attended the ceremony at which the cornerstone of this building was laid by the dean of the chapter, Abbé de Saint-Exupéry.

Duplessis was unquestionably one of the most skillful portraitists of the second half of the eighteenth century: The spirited author of numerous paintings depicting some of the outstanding figures of the time, he also painted one of the official portraits of Louis XVI. Here, the artist offers a good-natured and discretely self-important likeness of a man of the church, whose contentment, stature, and portliness symbolize, almost to an extreme, the place and role of the church in France at the end of the ancien régime.

Musée de Picardie Catalogues: 1894, p. 39, no. 142; 1899, p. 213, no. 143; 1911, p. 131, no. 141.
Bibliography: Gueffier 1753, pp. 256–58; Bellemère 1908, p. 43 ; Belleudy 1913, pp. 330, 331, no. 114; Boinet 1928, p. 15; Foucart 1977, p. 43; Lesage 1978, pp. 76–80.
Exhibition: Paris 1947, no. 175.
Related Works: Joseph Siffred Duplessis, *Portrait of Abbé Guillot de Montjoye*, ca. 1756, replica(?), formerly in Paris, "archbishopric of Notre-Dame," before 1830 (destroyed). Copy after Joseph Siffred Duplessis, *Portrait of Abbé Guillot de Montjoye*, Notre-Dame, treasury of the cathedral (in 1954).

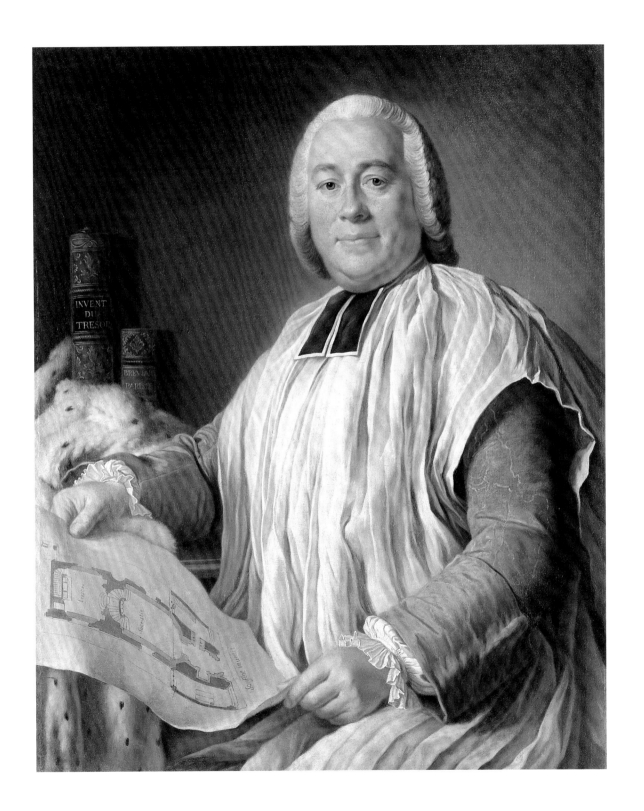

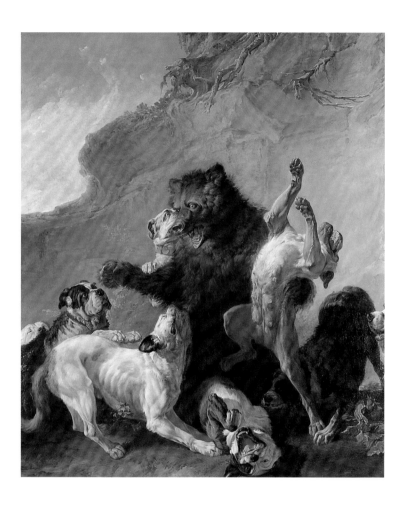

47· JEAN-JACQUES BACHELIER
(Paris 1724–Paris 1806)

A Polish Bear Stopped by Dogs of a Powerful Breed, 1757
Oil on canvas, 108⅝ × 89¾ in. (276 × 228 cm)
Signed, bottom left: *Bachelier*
Musée de Picardie, Amiens; On deposit from the Musée du Louvre,
1864 (M.P.P. 277 A; Louvre 2387)

IN 1757, JEAN-JACQUES BACHELIER WAS COMMISSIONED
to execute six paintings for the small Château de Choisy. This pavilion was built between 1754 and 1756 to provide Louis XV with a place for the private life he could no longer enjoy in the great château of Versailles that had become vast and over-populated. For the drawing room of the king's apartments, Bachelier was to paint four panels, depicting vases in French porcelain, to be mounted above the doors. In addition, there were to be two large canvases for the main dining room, one illustrating "an African lion fought by mastiffs" (fig. 18), and the other "a Polish bear stopped by dogs of a powerful breed." He thus succeeded François Desportes (1661–1743) and Jean-Baptiste Oudry (1686–1755), who, in 1742 and 1743, had been asked by the king to decorate his apartments at Choisy. This connection was pointed out when the canvases were exhibited at the Salon of 1757. Their boldness and warmth captivated the chronicler of *Le Mercure de France,* who exclaimed, "We have lost the famous Oudry, but is Monsieur Bachelier not the equal of his predecessor?" The critic of *L'Année littéraire* was astounded by the swiftness of the artist's progress and noted: "All the boldness of Snijders in the touch, broad, eloquent brushwork, the life and character of everything, the fine effect of harmony: such are the qualities which set him apart; with the very first step, he has reached the peak of the career."

Indeed, Bachelier adopted the formula that had ensured Oudry's success with the king of France and with foreign courts, namely the illustration of a combat, opposing dogs with a single animal, without any human presence. He gave new life to the theme, however, by abandoning wolves and boars in favor of the lion and the bear. He was also unusual in the use of a vertical format, thus focusing on the animals in the center of the composition. A simplified landscape, which is limited to a reed-covered bank and a low skyline or a rocky escarpment rising high in the sky, contributes to the emphasis on the two powerful carnivores and exacerbates the violence of the fighting.

Following the tradition of the animal painters who had preceded him, Bachelier devoted his full attention to the faithful description of the beasts—without, however, achieving results as felicitous as those of Desportes and Oudry. The artist clearly experienced some difficulty in painting his bear: In the preparatory sketch at the Musée des Beaux-Arts in Tours, he tried to conceal its anatomy by placing the mastiffs in the foreground of the composition. Apparently not satisfied with the result, he then sought to gather more information, for on August 23, 1760, when he received payment for the paintings, an additional 600 *livres* were granted, at the request of Marigny, "in consideration of his travel and study expenses." He had probably applied himself to observing a bear and a lion, though without going so far as Poland, the bear's country of origin. The two works thereby gained in verisimilitude, especially the depiction of the bear.

With their monumental dimensions, the two paintings must have created a striking effect in the first dining room of the little Château de Choisy. Once again, they reveal the taste of the sovereign, who liked to surround himself with hunting subjects, giving the room a note of exoticism that was the source of its originality.

—XAVIER SALMON

Provenance: Château de Choisy, dining room, 1757; Paris, Petits Augustins storerooms, 1792(?); Manufacture nationale de la Savonnerie, 1795; Versailles, Musée spécial de l'École française, 1798; Paris, storerooms of the Musée central des Arts, 1802(?); Palais de Rambouillet, 1810–30; Paris, Musée du Louvre, 1832–64.

Musée de Picardie Catalogues: 1865, p. 6, no. 4; 1873, p. 14, no. 5; 1875, p. 15, no. 7; 1878, pp. 24, 25, no. 7; 1899, pp. 3, 4, no. 7; 1911, p. 2, no. 9.

Bibliography: Blanc 1864, vol. 2, pp. 2, 3; Engerand 1901, pp. 6, 7; Bellemère 1908, p. 16; Chamchine 1910, pp. 216–18; Boinet 1928, pp. 14, 40; Mirimonde 1959, pp. 187–90; Faré 1976, p. 262; Lesage 1978, pp. 19–24, no. 3; Cantarel-Besson 1981, vol. 1, pp. 219, 229, 256, 264, 271, vol. 2, pp. 196, 198; Heim, Béraud, and Heim 1989, p. 132; Cantarel-Besson 1992, p. 240; Mouradian 1993, pp. 64–67, no. 28B; Clément-Grandcourt 1994, p. 34.

Exhibitions: Paris 1757, no. 52; Paris 1791, no. 3; Amiens 1989; Amiens and Versailles 1995–96, pp. 170–73, no. 69.

Related Work: Jean-Jacques Bachelier, *A Polish Bear Stopped by Dogs of Powerful Breed*, ca. 1757, oil on canvas, 13⅞ × 10⅝ in. (35.1 × 27 cm), preparatory study, Musée des Beaux-Arts, Tours.

Fig. 18
Jean-Jacques Bachelier
An African Lion Being Attacked by Dogs, 1757
Oil on canvas
108⅞ × 89¼ in. (276 × 228 cm)
Musée de Picardie, Amiens
Photo Marc Jeanneteau

48. Jean-Marc Nattier
(Paris 1685–Paris 1766)

The Triumph of Amphitrite, ca. 1758
Oil on canvas, 16¾ × 26⅞ in. (42.5 × 67.5 cm)
Musée de Picardie, Amiens; Gift of the Lavalard Brothers, 1890
(M.P.Lav. 1894–181)

Celebrated for his talent as a portraitist, Nattier was indeed one of the masters of the genre in the France of Louis XV. Along with straightforward portraits, in which he rendered the features of his models with naturalness and restraint, Nattier also became a specialist in painting his sitters as mythological and allegorical subjects: In these works he gave his models attributes appropriate to their natures and personalities. His innovation of picturing them in the guise of Olympian deities, nymphs, or heroes became a great success, particularly at court.

The present painting obviously does not belong to that repertoire but corresponds instead to the historical vein that Nattier also explored, though with less renown. According to Xavier Salmon, this unusual painting, of which the Louvre has a preliminary sketch signed and dated 1758 (formerly in the Goncourt brothers' collection), is a late work of the artist's.

The subject is one of the themes in the mythological realm most often treated at the time: the triumph of Amphitrite, wife of Neptune, the god of the seas. Like the triumph of Venus, the subject lends itself to a seductive aquatic display, in which Amphitrite, enthroned on her chariot, appears surrounded by tritons, both young and old; naiads; dolphins; seahorses; and putti. In this small painting, despite a certain amount of wear, the painter's fine work as a miniaturist can still be seen. Completing the scene, a steep cliff looms on the horizon, a fleet of ships appears in the distance, and a powerful gust of wind swells the large sail that forms a dais above the goddess. Time, armed with his sickle, contemplates the scene, from the clouds. In this gallantly orchestrated scene, the artist employs a turbulent yet graceful style well suited to the subject.

Provenance: Auguiot (or Anguiot) sales: April 27, 1859, no. 99; December 7, 1859, no. 114; and January 11, 1861, no. 64.
Musée de Picardie Catalogues: 1894, p. 45, no. 181; 1899, p. 224, no. 182; 1911, p. 137, no. 178.
Bibliography: Horsin-Déon 1863, p. 144; Bellemère 1908, p. 41; Boinet 1928, pp. 14, 35 (uncertain attribution to Nattier); Foucart 1977, pp. 18, 22, 44, 49; exhib. cat., Versailles 1999, pp. 284–85, no. 83, fig. 1.
Exhibitions: Paris 1968, no. 67; Tokyo 1982, no. CA.16.
Related Work: Jean-Marc Nattier, *The Triumph of Amphitrite,* 1758, black chalk and ink on paper, 11¼ × 19⅞ in. (28.5 × 50.6 cm), preliminary drawing, Musée du Louvre, Paris.

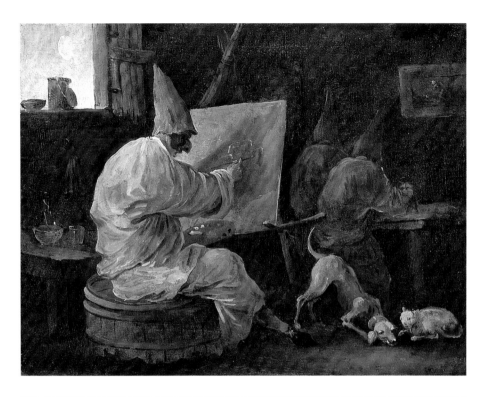

49. HUBERT ROBERT
(Paris 1733–Paris 1808)

The Punchinello Painters, 1760(?)
Oil on wood, 6½ × 8⁹⁄₁₆ in. (16.5 × 21.8 cm)
Musée de Picardie, Amiens; Gift of the Lavalard
Brothers, 1890 (M.P.Lav. 1894–184)

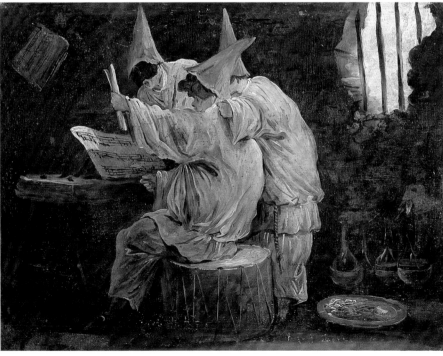

50. HUBERT ROBERT
(Paris 1733–Paris 1808)

The Punchinello Singers, 1760(?)
Oil on wood, 6½ × 8⅝ in. (16.6 × 22 cm)
Musée de Picardie, Amiens; Gift of the Lavalard
Brothers, 1890 (M.P.Lav. 1894–185)

In the commedia dell'arte, the character of Pulcinella or Punchinello symbolizes the Neapolitan bourgeois. According to this Italian tradition, he is invariably dressed in a light linen outfit consisting of baggy pants and a full tunic puffed out by a belt. He wears low black shoes, a pointed wool cap, and a dark mask with a hook nose that conceals the upper part of his face.

Such a picturesque figure could not fail to charm French painters traveling in Italy, and Hubert Robert was no exception. Arriving in Rome in 1754 with the new French ambassador, Count de Stainville (the future duc de Choiseul), Robert was able, due to the support of his patron, to stay at the Académie de France and to benefit from the instruction there.

In 1759, thanks to his diligence and talent, he was granted the status of resident in that institution, which was directed at the time, by Charles-Joseph Natoire (1700–1777), who, along with the director of the *bâtiments du roi*, the marquis de Marigny, encouraged the young painter, the ambassador's protégé.

Robert's abilities developed steadily, and his encounters first with Fragonard, and then with the Abbé Richard de Saint-Non (1727–1791), who arrived in Rome in 1756 and 1759, respectively, and with whom he traveled all over the peninsula, also fostered his creative growth. He remained in Italy until 1765.

The young Robert had ample opportunity to observe the costumes of the commedia dell'arte during Carnival, as the drawings gathered in an album at the Pierpont Morgan Library in New York attest. The residents of the Académie de France took an active part in these festivities, as was noted by the populace of Rome. In addition, the farcical persona of Punchinello, headstrong and stubborn, enabled Robert to exploit a taste for irony that is demonstrated in his works.

In the first panel, an artist Punchinello, seated on a cask and with a palette in hand, sketches a painting placed on an easel. On his left, a bottle of wine and a glass are proof of his taste for drink. Nearby, a dog plays with a cat and, further away, in the shadow of the studio, two other Punchinellos are busy grinding colors. In the second painting, three Punchinellos, one seated on a stool and two standing, sing merrily, following a score placed on a rustic lectern. The presence of four wine bottles on the ground doubtless explains their joviality and musical ardor.

Robert frequently represented painters or draftsmen at work in landscapes, galleries, or studios. The Rotterdam painting, *L'atelier du peintre* (Boymans von Beuningen Museum), which is perhaps a self-portrait of the artist, is the best-known example.

NO. 49
Provenance: Collection of the painter Charles-Joseph Natoire (1700–1777), director of the Académie de France in Rome; sale after decease, December 14, 1778, no. 42; collection of Count d'Houdetot; sale, December 19–20, 1859, no. 122.
Musée de Picardie Catalogues: 1894, p. 46, no. 184; 1899, p. 225, no. 185; 1911, p. 138, no. 181.
Bibliography: Horsin-Déon 1862, p. 145; Bellemère 1908, p. 42; Boinet 1928, p. 15; Vergnet-Ruiz and Laclotte 1962, p. 250; Foucart 1977, pp. 18, 22, 43, 50; Huchard, Lernout, Mahéo, and Couderc 1995, pp. 102, 103.
Exhibitions: Rome 1990–91, pp. 105, 106, no. 54; Amiens 1992, p. 9, no. 10.
Related Work: Gabriel de Saint-Aubin, *The Punchinello Painters, after Hubert Robert*, 1788, drawing, location unknown.

NO. 50
Provenance: Collection of the painter Charles-Joseph Natoire (1700–1777), director of the Académie de France in Rome; sale after decease, December 14, 1778, no. 42; collection of Count d'Houdetot; sale, December 19–20, 1859, no. 122.
Musée de Picardie Catalogues: 1894, p. 46, no. 185; 1899, p. 225, no. 186; 1911, p. 138, no. 182.
Bibliography: Horsin-Déon 1862, p. 145; Bellemère 1908, p. 42; Boinet 1928, p. 15; Vergnet-Ruiz and Laclotte 1962, p. 250; Foucart 1977, pp. 18, 22, 43, 50; exhib. cat., Rome 1990–91, p. 105, fig. a; Huchard, Lernout, Mahéo, and Couderc 1995, pp. 102, 103.
Exhibition: Amiens 1992, p. 9, no. 11.
Related Work: Gabriel de Saint-Aubin (1724–1780), *The Punchinello Singers, after Hubert Robert*, 1778, drawing, location unknown.

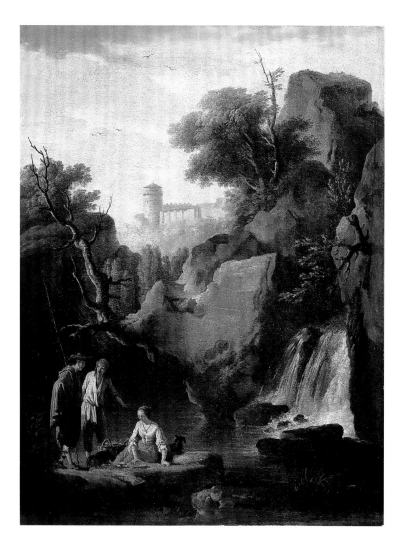

51 · CHARLES-FRANÇOIS GRENIER DE LA CROIX,
CALLED LACROIX DE MARSEILLE
(Paris or Marseilles? 1729?–Berlin 1782)

Landscape with Three Figures in a Gorge, near a Waterfall,
1767

Oil on canvas, 25⅛ × 19⅛ in. (63.9 × 48.7 cm)
Signed and dated, bottom left: *g* [. . .]*?/Rome/1767*
Musée de Picardie, Amiens (M.P.P.200—formerly 216)

52 · CHARLES-FRANÇOIS GRENIER DE LA CROIX,
CALLED LACROIX DE MARSEILLE
(Paris or Marseilles? 1729?–Berlin 1782)

Landscape with Three Figures on the Outskirts of a Town,
ca. 1760

Oil on canvas, 24¾ × 19¼ in. (62.8 × 49 cm)
Musée de Picardie, Amiens (M.P.P.201—formerly 217)

THE WORK AND THE STYLE OF LACROIX DE MARSEILLE have been relatively well defined, based on the existence of numerous paintings signed by the artist. His life and career, however, remain largely unknown. Lacroix de Marseille was apparently the student of Joseph Vernet (1714–1789), and his works preserve the stamp of this early training. The influence of the master of Avignon is evident in the numerous seascapes Lacroix painted, in which he depicted imaginary harbor towns—combining steep reliefs, Mediterranean vegetation, ancient ruins, and picturesque dwellings—dotted with figures occupied with fishing or maritime activities, all bathed in the luminous brightness of a southern climate.

These two matching canvases leave the maritime realm for a more continental clime. With his customary style, Lacroix has created landscapes that are both rugged and peaceful. In the first, a stream fed by a waterfall runs through a gorge that opens onto a fortress; in the other, a hilly landscape is dominated by a town above which rises the rotunda of an ancient temple. In both cases, Lacroix "signs" his compositions with a characteristic detail: a knotty, leafless, dead tree. And in each painting, three figures (peasant women, fishermen, a soldier) enliven the scene.

It is easy to see why such a pleasantly poetic and decorative repertoire met with success. In addition to Lacroix and Vernet, other talents also addressed this repertoire over the course of the eighteenth century, from the "precursor" Adrien Manglard (1695–1760) up to Jean Pillement (1728–1808).

NO. 51
Provenance: Sent by the State as part of preparations for the signing of the Peace of Amiens, 1801.
Musée de Picardie Catalogue: 1820, p. 17, no. 12.
Bibliography: Lesage 1978, pp. 102, 103, no. 23.

NO. 52
Provenance: Sent by the State as part of preparations for the signing of the Peace of Amiens, 1801.
Musée de Picardie Catalogue: 1820, p. 17, no. 13.
Bibliography: Lesage 1978, pp. 100, 101, no. 22.

53. ATTRIBUTED TO JEAN-BAPTISTE GREUZE
(Tournus 1725–Paris 1805)

Young Woman Lifting a Chest, ca. 1760–65
Oil on canvas, 18 × 14 in. (45.6 × 35.7 cm)
Musée de Picardie, Amiens; Gift of the Lavalard Brothers, 1890
(M.P.Lav. 1894–155)

IN A RUSTIC INTERIOR, SUGGESTED BY THE UPRIGHT of a fireplace and a wooden beam, a young woman, barefoot and simply dressed, is lifting a chest or, as Edgar Munhall has proposed, a cage. With its light technique, in transparent brushstrokes, this painting might be viewed as an unfinished sketch that allows us to see the delicate underlying preparatory drawing. At best, this charming piece, which isolates a figure that was perhaps intended to be integrated into a more complex composition, can be assumed to belong to a period when Greuze executed a fair number of moral, sentimental scenes, which are the source of his fame and which feature similar graceful and lively young women. Munhall has astutely compared this canvas with other works carried out at the beginning of the 1760s, featuring the same "allusive" touch and portraying gentle young ladies in works of innocent content: *La Première leçon* (*The First Lesson of Love;* Manchester, New Hampshire, The Currier Gallery of Art) and *La Mère heureuse* (*The Happy Mother;* Rotterdam, Boymans van Beuringen Museum).

Having arrived in Paris in 1750, Greuze was admitted to the Académie five years later. Acclaimed as of his first participation in the Salon the same year, he spent only two years in Italy, impatient to return to the Parisian milieu. The philosopher-critic Denis Diderot (1713–1784) became one of his main admirers, but their relationship eventually soured. In 1769 Greuze suffered a considerable setback with the presentation, first at the Académie, then at the Salon, of his *Septimius Severus and Caracalla* (Paris, Musée du Louvre), which was seriously derided. Humiliated by this disastrous attempt at becoming a history painter, Greuze decided to "fall back and regroup": he did not show at the Salon again until 1800. However, recognized as an excellent portraitist, a skillful draftsman, and, especially, an unequalled painter of genre scenes and figures, he continued to enjoy great popularity, which was further increased by the widespread distribution of engravings of his works. This reputation lasted until the revolutionary period, which had a severe effect on the artist's career.

Musée de Picardie Catalogues: 1894, p. 41, no. 155 (attributed to Jean-Baptiste Greuze); 1899, p. 216, no. 156; 1911, p. 133, no. 153.
Bibliography: Horsin-Déon 1862, p. 145; Bellemère 1908, p. 42; Foucart 1977, pp. 43, 50; Munhall 1977, pp. 6, 11.
Exhibition: Amiens and Dortmund 1960, no. 14.

54· JEAN-BAPTISTE DESHAYS
(Colleville 1729–Paris 1765)

The Deliverance of Saint Peter, ca. 1761

Oil on canvas, 21⅜ × 16⅛ in. (54.3 × 40.9 cm)
Musée de Picardie, Amiens; Gift of the Lavalard Brothers, 1890
(M.P.Lav. 1894–207)

THE EPISODE PORTRAYED IN THIS PAINTING IS TAKEN
from *Acts of the Apostles* (XII: 6–10). King Herod, in his ruthless
fight against the representatives of the church, had Peter arrested,
thrown into prison, and placed under guard. One night, on the eve
of the date chosen for Peter's execution, an angel appeared to him
in his sleep: "[he] raised him up, saying, Arise up quickly. And his
chains fell off from his hands." At the angel's bidding, Peter gath-
ered up his clothes and followed him, "but thought he saw a vision.
When they were past the first and second ward, they came unto
the iron gate that treadeth unto the city; which opened to them of
his own accord . . ."

Deshays chose to depict the moment when Peter, guided by
the angel flying at his side, emerges from the dungeon. Together
they are about to descend a staircase on which five soldiers are
sleeping.

This small painting is one of the known sketches for the large
canvas presented by Deshays at the Salon of 1761 and now hang-
ing in the Cathedral of Saint-Louis at Versailles. The final painting
has more pathos, with a fair number of variations from the prepa-
ratory work.

Despite a very short career—he died at the age of thirty-five—
Deshays was one of the most visible artists of his generation. A
student of Restout, he went on to study with Boucher, whose
daughter he later married. Winner of the Grand Prix in 1751, he
spent three years at the Ecole de Eléves Protégés, under the direc-
tion of Carle Vanloo, then stayed at the Académie de France in
Rome (1754–58). After returning to Paris and being received into
the Académie in 1759, the artist attracted notice at the Salon and
became, according to Diderot's famous remark, "the premier
painter of the nation." Hailed as the only artist capable of renew-
ing history painting in the grand tradition of classical French art,
and possessing a knowledge of Italian painting, Deshays was able
to combine a passionate touch with imagination. This ability to
apply a vibrant style reminiscent of Boucher to a dramatic con-
ception worthy of the Grand Siècle is clear in this sketch, which
was nonetheless considered just an "ordinary piece" by Diderot,
a fervent admirer of the painter's.

Musée de Picardie Catalogues: 1894, p. 50, no. 207 (style of Vanloo); 1899, p. 231,
 no. 207 (school of Vanloo); 1911, p. 141, no. 203 (school of Vanloo).
Bibliography: Estournet 1905 (Noël Hallé); Foucart 1977, p. 45; Sandoz 1977;
 Lesage 1978, pp. 61–66.
Related Works: Jean-Baptiste Deshays, *The Deliverance of Saint Peter,* ca. 1761,
 oil on canvas, 20¼ × 15½ in. (51.5 × 39.5 cm), replica, Musée de Tessé, Le Mans.
 Jean-Baptiste Deshays, *The Deliverance of Saint Peter,* ca. 1761, oil on canvas,
 sketch, Musée Lambinet, Versailles. Jean-Baptiste Deshays, *The Deliverance
 of Saint Peter,* 1761, oil on canvas, definitive painting, Cathedral of Saint-Louis,
 Versailles.

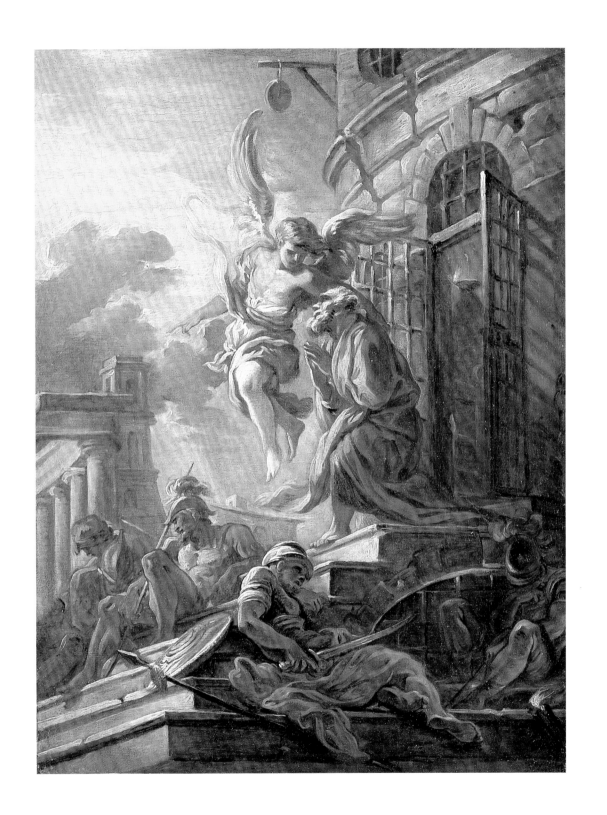

55. JEAN-HONORÉ FRAGONARD
(Grasse 1732–Paris 1806)

The Cradle, ca. 1761–65

Oil on canvas, 18⅛ × 21⅝ in. (46 × 55 cm)
Musée de Picardie, Amiens; Gift of the Lavalard Brothers, 1890
(M.P.Lav. 1894–143)

THE SCENE TAKES PLACE IN A RUSTIC INTERIOR. A young girl lifts the veil of a cradle, where a newborn sleeps soundly. Near her leans a young boy, and a fat cat, perched on a stool on the other side of the bed, contemplates the baby. On the left, behind a hanging sheet, four more people observe the infant: the mother, seated, who is opening a shutter to let the light in; two young children; and another woman. All the spectators look very attentive: Perhaps they are gathered to watch the baby's awakening, under the vigilant and loving supervision of its mother. The viewer, too, is invited into the private life of a family.

Virtually every author who has discussed this famous painting has pointed out that it is obviously inspired by the art of Rembrandt (1606–1669). Specifically, the Dutch master's *Holy Family* was doubtless Fragonard's reference. That painting, today in the Hermitage Museum of Saint Petersburg, was, in the eighteenth century, part of the Crozat Collection in Paris, where Fragonard copied it. Here, he conceived a secular version of the theme, retaining above all Rembrandt's lessons in the handling of light and in brilliant brushwork.

Long considered a fairly late work, this brilliant painting has been resituated by Pierre Rosenberg to an earlier date—just after Fragonard's return to Paris. Fragonard, a student of Chardin and then Boucher, obtained the Grand Prix de Rome in 1752, leaving for Italy four years later and remaining there until 1761. Indeed, this canvas demonstrates the roundness and rapidity of touch, the taste for impasto, the density of colors, and the chiaroscuro work that the painter developed immediately after his stay in Italy. The reds and yellows glow in the half-light, inviting us, with a theme Fragonard was fond of—that of childhood—into an episode of domestic tenderness.

Provenance: Dubois sale, 1860(?); collection of the Lavalard Brothers by 1862.

Musée de Picardie Catalogues: 1894, p. 39, no. 143; 1899, p. 214, no. 144; 1911, p. 132, no. 142.

Bibliography: Horsin-Déon 1862, p. 144; Portalis 1889, p. 272; Nolhac 1906, p. 128; Bellemère 1908, p. 42; Wildenstein 1921, no. 67; Boinet 1928, pp. 15, 52; Brière 1931, p. 199; Réau 1932, p. 102; Réau 1956, p. 164; Wildenstein 1960, no. 457; Vergnet-Ruiz and Laclotte 1962, pp. 97, 236; Thuillier 1967, p. 68; Wildenstein and Mandel 1972, pl. 57, 58, p. 107, no. 481; Foucart 1977, pp. 18, 22, 25, 43, 49; Cuzin 1987, pp. 53, 275, no. 84; Lévêque 1987, p. 177; Rosenberg 1989, p. 82, no. 101; Huchard, Lernout, Mahéo, and Couderc 1995, p. 100; Guillou 1997, p. 71, fig. 18.

Exhibitions: Paris 1883–84, no. 52; Paris 1921, no. 67; Paris 1931, no. 16; Brussels 1953, no. 55, pl. 26; Bordeaux 1956, no. 77; Besançon 1956, no. 21; Brussels 1975, pp. 148, 151, no. 106; Tokyo and Kyoto 1980, no. 72; Lille 1985, pp. 31, 96, 97, no. 52; Paris and New York 1987–88, pp. 253, 254, no. 124; Amiens 1992, p. 6, no. 2.

56. FRANÇOIS BOUCHER

(Paris 1703–Paris 1770)

Saint John the Baptist Preaching in the Wilderness, ca. 1764–67

Oil on cardboard, 15⅛ × 11¾ in. (38.5 × 29.8 cm)
Musée de Picardie, Amiens; Gift of the Lavalard Brothers, 1890
(M.P.Lav. 1894–129)

"IN THOSE DAYS CAME JOHN THE BAPTIST TO PREACH-ing in the wilderness of Judea, / And saying: 'Repent ye: for the kingdom of heaven is at hand'. . . / John had his raiment of camel's hair, and a leathern girdle about his loins, and his meat was locusts and wild honey. / Then went out to him Jerusalem, and all Judea, and all the region round about Jordan, / And were baptized of him in Jordan, confessing their sins." Thus does the evangelist Matthew (III: 1–6) relate the preaching of Saint John the Baptist.

Boucher portrays John the Baptist seated atop a hillock, at the foot of two palm trees. He holds the long cross, on which is wound a phylactery, designating him as the Precursor. His gesture, with the index finger raised, signifies the preacher's eloquence. All around him, a crowd of men, women, children and even animals (a lamb and a dog are seen in the foreground, and the outline of a camel is seen in the background) has gathered, and cherubim flit about in the skies.

It was doubtless about 1764 to 1767 that Boucher created this vigorous grisaille. He had previously painted a *Saint John the Baptist in the Wilderness* (1755; The Minneapolis Institute of Arts), intended to decorate the funeral chapel acquired by Madame de Pompadour for herself and her daughter in the Church of the Capuchins. Later on Boucher realized a *Saint John the Baptist Preaching* for the Church (now Cathedral) of Saint-Louis in Versailles, completed in 1767, according to Alistair Laing. John the Baptist was the object of particular veneration on the part of the marquise de Pompadour, née Jeanne-Antoinette Poisson (1721–1764), the favorite mistress of King Louis XV: The painting, still in Versailles, may have been commissioned by her to be given to the sanctuary. The Amiens painting seems to represent his first thoughts for this work, for which two other studies are known (recently reported again in the art trade). Here, the painter demonstrated a particular brio, well served by the liveliness of the brushwork and the monochromatism. Such ease appears in other works by the painter datable from the same period and also executed in grisaille, such as *The Death of Socrates* (Le Mans, Musée de Tessé) or *The Abduction of Persephone* (Quimper, Musée des Beaux-Arts).

During the last ten years of his life, Boucher occasionally returned to the history painting he had embraced in his youth, executing a few works on religious subjects (including a *Saint Peter Walking on the Water,* also for the church in Versailles). The aging painter still displayed the disconcerting facility that both enchanted and exasperated Diderot: "This master still has . . . the same magic and same defects that mar a rare talent."

Musée de Picardie Catalogues: 1894, p. 36, no. 129; 1899, p. 210, no. 130; 1911, p. 130, no. 128.
Bibliography: Michel, Soullié, and Masson 1906, no. 711; Nolhac and Pannier 1907, p. 107; Boinet 1928, pp. 14, 34; Shoolman 1975, p. 22; Ananoff and Wildenstein 1976, no. 558, fig. 1524; Foucart 1977, pp. 22, 42; Wise and Warner 1996, p. 46, fig. 1, p. 48, no. 16.
Exhibitions: Paris (Cailleux) 1964, no. 18; Amiens 1992, p. 12, no.19.
Related Works: François Boucher, *Saint John the Baptist Preaching in the Wilderness,* ca. 1765, preliminary drawing, location unknown. François Boucher, *Saint John the Baptist Preaching in the Wilderness,* ca. 1765, sketch, private collection, Canada. François Boucher, *Saint John the Baptist Preaching in the Wilderness,* ca. 1765, sketch, location unknown. François Boucher, *Saint John the Baptist Preaching,* 1761, oil on canvas, definitive painting, Cathedral of Saint-Louis, Versailles.

57. **JEAN-SIMÉON CHARDIN**
(Paris 1699–Paris 1779)

Still Life with a Basket of Grapes, 1765

Oil on canvas, 12⅞ × 16 in. (32.7 × 40.5 cm)
Signed and dated, bottom right, on the edge of stone coping:
chardin / 1765
Musée de Picardie, Amiens; Gift of the Lavalard Brothers, 1890
(M.P.Lav. 1894–141)

IN THIS CANVAS, OF WHICH ANOTHER VERSION IS known, Chardin simply arranges several fruits (three small apples and a pear) and two pieces of confectionery around a wicker basket filled with grapes.

In 1748 Chardin abruptly interrupted his work on genre scenes and returned to still life, but in a style much different from that of the beginning of his career. As can be seen in this painting, he henceforth focused on the overall effect rather than the details of individual elements. The scene is shrouded in a spectacular chiaroscuro, full of mystery, and the rendering of the objects is indistinct, as if they are dissolved by a light mist. On the other hand, the reflections on the fruits—every grape—produce a lively brightness.

This painting was probably exhibited at the 1765 Salon, unless that was its "double" in Angers. Concerning the canvases Chardin presented that year, Diderot enthusiastically commented, "You arrive just in time, Chardin, to recreate my eyes/Here you are then, back again, great magician, with your mute compositions! How eloquently they speak to the artist! How much they tell him about the imitation of nature, the science of color and harmony! How the air circulates around these objects!"

Musée de Picardie Catalogues: 1894, p. 38, no. 141; 1899, p. 213, no. 142; 1911, p. 131, no. 140.
Bibliography: Horsin-Déon 1862, p. 145; Bellemère 1908, p. 43; Guiffrey 1908, no. 36; Furst 1911, p. 119; Boinet 1928, p. 15; Wildenstein 1933, no. 866; Wildenstein 1963, p. 210, no. 338, fig. 154; Foucart 1977, pp. 18, 22, 43, 50; exhib. cat., Paris 1979, p. 332; Rosenberg 1983, p. 109; no. 172A; Guillou 1997, p. 77, fig. 12.
Exhibitions: Paris 1765, no. 49(?); Amiens 1931, no. 6; Bordeaux 1958, p. 3, no. 7, pl. 49; Amiens and Dortmund 1960, no. 11; Munster and Baden-Baden 1980, no. 268; Langres 1984, no. 5.
Related Work: Jean-Siméon Chardin, *Still Life with a Basket of Grapes,* 1764, oil on canvas, 12⅝ × 15¾ in. (32 × 40 cm), replica, Musée des Beaux-Arts, Angers.

58. JEAN-BAPTISTE HUET
(Paris 1745–Paris 1811)

Sheep and Doves Pecking on a Basket of Flowers,
ca. 1765–70

Oil on canvas, 28⅛ × 28⅜ in. (74 × 72 cm)
Musée de Picardie, Amiens; Gift of the Lavalard Brothers, 1890
(M.P.Lav. 1894–158)

POISED ON A BASKET OVERFLOWING WITH ROSES, TWO white doves peck at each other while a wooly sheep lies nonchalantly on the side. A soft light bathes the country landscape in slightly acid colors.

Jean-Baptiste Huet was a specialist in these charming pastoral scenes, which were much in vogue with the wealthy French clientele of the eighteenth century. Coming from a dynasty of painters who specialized in animal art, Huet quickly acquired a certain esteem, made official by his admission to the Académie Royale in 1769. At a time when the policy of the *bâtiments du roi* encouraged artists to specialize more in history painting (considered the great genre), Huet remained faithful to his penchant—which was also more lucrative—for charming and graceful rustic scenes in which calm animals sometimes accompany lascivious shepherds. Huet continued in this repertoire until the end of his life. Beginning in the revolutionary period, he supplied designs for the Manufacture Oberkampf, a factory in Jouy-en-Josas that produced printed textiles.

Laure Hug, author of a recent study on this appealing artist, has compared this painting with the décor of the salon Huet executed about 1765–70 for the engraver Gilles Demarteau, which is today partially preserved at the Musée Carnavalet in Paris. The Amiens canvas, which possibly comes from this imposing and original ensemble, has, in any case, the same decorative qualities. It enchantingly illustrates the legacy of Boucher, one of Huet's influences.

Musée de Picardie Catalogues: 1894, p. 41, no. 158; 1899, p. 217, no. 159; 1911, p. 134, no. 156.
Bibliography: Horsin-Déon 1862, p. 145; Gabillot 1892; Foucart 1977, pp. 43, 50; Lesage 1987, pp. 97, 98; Hug 1997, pp. 70–76.
Exhibitions: Munich 1958, p. 68, no. 101; Tourcoing 1963.

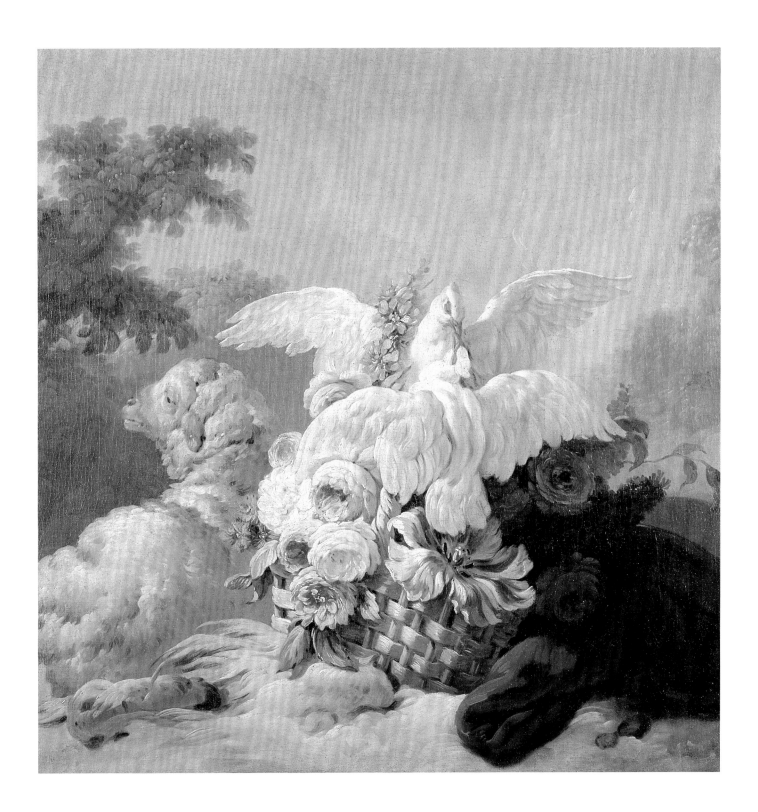

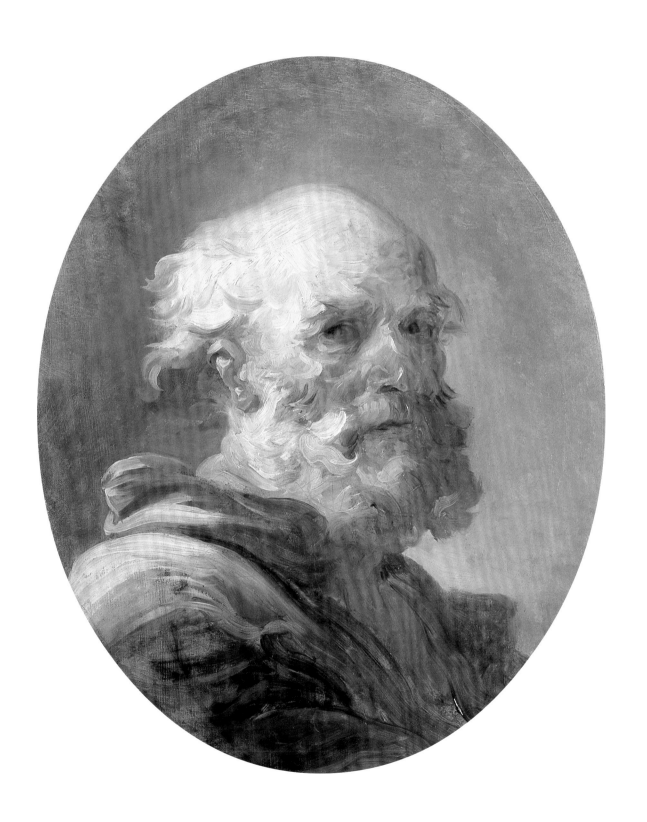

59. Jean-Honoré Fragonard
(Grasse 1732–Paris 1806)

Head of an Old Man, ca. 1766–69
Oil on canvas, 21¼ × 17¾ in. (54 × 45 cm)
Musée de Picardie, Amiens; Gift of the Lavalard Brothers, 1890
(M.P.Lav. 1894–144)

This face of an old man, bald and bearded, is not by any means a portrait but rather a simple head, a pretext for a pictorial study. Although some have claimed to see it as representing Saint Peter, there is no evidence to confirm such a hypothesis. In Fragonard's catalogue, there are a fairly large number of these heads of elderly people, which seem to be spread over several years, between 1761, the date of his return from Italy, and the beginning of the likely period of the famous series of *portraits de fantaisie* (1766–72). In contrast to those, Fragonard's old people do not form a homogenous cycle but are instead sporadic experiments. For example, Pierre Rosenberg has pointed out the differences between a bust from the Musée Jacquemart-André in Paris, executed in a style reminiscent of Giambattista Tiepolo (1696–1770) and seemingly close to Fragonard's Venetian trip of 1761, and the heads from Nice (Musée Chéret), Hamburg (Kunsthalle), and Amiens, which he has dated closer to 1766.

Of course, in this magnificent painting, Fragonard once again shows his admiration for Rembrandt (1606–1669), and the influence of the Dutch master is apparent in the theme, the decisiveness of the brushwork, and the play of light. Although Rembrandt's philosophical dimension does not find its equivalent here—Fragonard seeking first and foremost to demonstrate his extraordinary pictorial ease, his dexterity in handling a brush, and his joy of painting—this old man's searching gaze, both severe and melancholy, nonetheless does not lack a sense of reflection or emotion. In addition, Fragonard reveals his awareness of the work of certain Italian painters of the seventeenth century, such as Guido Reni (1575–1642) and Guercino (1591–1666).

The most striking aspect of such a painting, however, is its incredible technique, about which Rosenberg, on the subject of this series, has said, "this beautiful impasto handled with such assurance . . . this vitality of the brush which bends the model to the artist's requirements . . . this life given to the pictorial matter." He adds that its "ascendancy over the subject is pushed to its extreme limits." According to Jean-Pierre Cuzin, "these casual quick sketches in fact constitute a dazzling synthesis of all the visual culture of the painters of the time: in their timeless accoutrements, these figures on the borderline of life reach a paradise of painting where Bologna, Venice, and Amsterdam become joyously reconciled."

When he painted this canvas, Fragonard had just been admitted into the Académie (1765) with *Corésus et Callirhoé* (Paris, Musée du Louvre), which was a huge success (and in which, as a matter of fact, several old people appear). But the artist soon turned his back on an official career, which he cared little about, preferring to devote himself to his art and to a selected clientele of enlightened art lovers.

Provenance: Anonymous sale, Paris, April 29, 1782, no. 35; collection of the Lavalard Brothers by 1862.

Musée de Picardie Catalogues: 1894, p. 39, no. 144; 1899, p. 214, no. 145; 1911, p. 132, no. 143.

Bibliography: Horsin-Déon 1862, p. 144, no. 26; Boinet 1928, p. 15; Wildenstein 1921, no. 26; Réau 1956, pp. 182, 183, 235; Wildenstein 1960, no. 204, fig. 103; Wildenstein and Mandel 1972, p. 95, no. 215; Foucart 1977, pp. 22, 43, 49; Cuzin 1987, pp. 131, 290, no. 165; Lévêque 1987, p. 168; Rosenberg 1989, p. 91, no. 187; Huchard, Lernout, Mahéo, and Couderc 1995, p. 100.

Exhibitions: Paris 1921, no. 26; Besançon 1956, no. 17; Bordeaux 1956, no. 75, pl. 29; Charleroi 1957, no. 17; Paris and New York 1987–88, pp. 203, 208, no. 102; Amiens 1992, p. 7, no. 3.

60. ATTRIBUTED TO FRANÇOIS-ANDRÉ VINCENT
(Paris 1746–Paris 1816)

Musical Quartet, ca. 1769–70

Oil on canvas, 13¾ × 15¾ in. (35 × 40 cm)
Musée de Picardie, Amiens; Gift of the Lavalard Brothers, 1890
(M.P.Lav. 1894–197)

ON THE BACK OF A MINIATURE BY PIERRE-ANTOINE Baudouin (Louvre), which either reproduces or inspired *Musical Quartet*, is a handwritten note, which conveniently gives the likely identities of the four figures in this scene. On the left, leaning nonchalantly on the back of an armchair, is the marquis Jean-Benjamin de Laborde (1734–1794), a *fermier-général*, first manservant to Louis XV, and occasional composer who holds a kit, a small fiddle used by dancing masters. In the center, Marie-Madeleine Guimard (1743–1816), a famous dancer at the Opéra, plucks the strings of a harp. Standing on the right, the Abbé and future Cardinal Louis de Rohan (1734–1803), who later won renown in the famous affair of the queen's necklace, plays the flute, and seated in front of him, Charles de Rohan (1715–1787), Prince de Soubise and marshal of France, plays the horn.

With a charming intimacy, the painting invites the viewer to enter, on the occasion of this small chamber music concert in which Mademoiselle Guimard is surrounded by her protectors, the private life of Parisian society toward the end of the reign of Louis XV. Previously attributed in turn to Jean-François de Troy (1679–1752) and then Jean-Honoré Fragonard, the canvas has now been attributed to Vincent, with some hesitation, by Jean-Pierre Cuzin.

Musée de Picardie Catalogues: 1894, p. 48, no. 197 (Jean-François de Troy); 1899, p. 228, no. 199 (de Troy); 1911, p. 140, no. 195 (de Troy).
Bibliography: Gonse 1900 (Fragonard); Lemoine 1904, p. 287; Boinet 1928, p. 15, pl. 43 ("mistakenly attributed" to de Troy); Mirimonde 1968, p. 128; Wildenstein and Mandel 1972, p. 112, no. 578 (attributed to Fragonard); exhib. cat., Paris 1974, p. 171; Foucart 1977, p. 44; Cuzin 1983, p. 123, no. 51; Cuzin 1986; exhib. cat., Bordeaux, Geneva, Paris 1995–96, p. 282.
Exhibitions: Paris 1883–84, no. 89; Brussels 1953, no. 56; Tokyo 1986, no. 36; Paris 1991–92, pp. 40, 129; Amiens 1992, p. 10, no. 14.
Related Work: Pierre-Antoine Baudouin (1723–1769), *Chamber Concert*, ca. 1769, gouache on vellum, diam.: 2.2 in. (6.3 cm), Musée du Louvre, Paris.

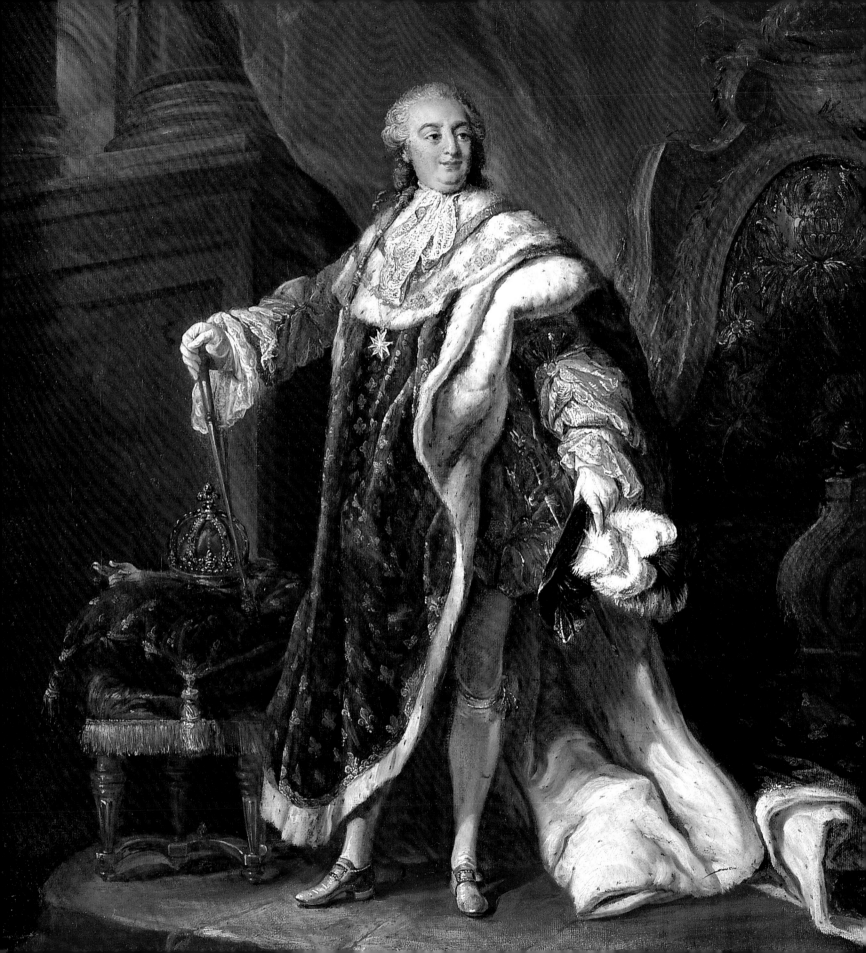

The Reign of Louis XVI

1774–1792

LOUIS XVI'S ASCENSION TO THE FRENCH THRONE IN 1774, AND HIS subsequent appointment of the comte d'Angiviller to the position of director of the *bâtiments du roi*, marked a period of transition in art that had begun with the emergence of Neoclassicism in the final years of Louis XV's reign. The triumph of this new aesthetic (see fig. 19), which was characterized by a return to the forms and motifs of ancient art, occurred at the Salon of 1781, where Jacques-Louis David exhibited his critically acclaimed *Belisarius*.

Official art policy was marked predominantly by an effort to reinvigorate morally edifying, didactic history painting. Funds were allocated to this end, and Angiviller instituted a series of royal commissions, among which was the order in 1775 of four large works depicting episodes of French history from several artists, including Joseph-Benoît Suvée and François-André Vincent. This emphasis on the revival of history painting, however, did little to diminish the widespread popularity of the lesser genres, which the king himself personally favored.

The late 1770s and '80s witnessed a move away from depicting contemporary events and toward illustrating classical antiquity. To this end, Angiviller strengthened the Académie de France in Rome, which he felt was the proper training ground for young artists. Under his auspices, the Prix de Rome took on a new luster, sending French artists to the eternal city so that they could come into contact with the monuments of ancient Rome and the work of modern Italian masters.

Despite the upheaval during the French Revolution, the Salon opened in 1789 after the fall of the Bastille. Surprisingly, the demand for works of art did not decrease during this time of intense turmoil. By the end of the century, private patronage rivaled royal commissions in determining aesthetic standards.

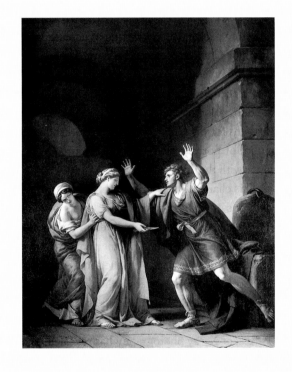

Fig. 19
Francois-André Vincent
Arie and Poetus, 1785
Oil on canvas
12⅝ × 10⅛ in. (32.2 × 25.7 cm)
Musée de Picardie, Amiens
Photo Marc Jeanneteau

61. ATTRIBUTED TO NICOLAS-BERNARD LÉPICIÉ
(Paris 1735–Paris 1784)

Six Children's Heads and Flowers, ca. 1770(?)
Oil on canvas, 28¹⁵⁄₁₆ × 35⅞ in. (73.5 × 91 cm)
Musée de Picardie, Amiens; Gift of the Lavalard Brothers, 1890
(M.P.Lav. 1894–170)

A DISCREET AND DEVOUT PERSONALITY, LÉPICIÉ
turned to painting after working as an engraver with his father, a
friend of Chardin. Trained by Carle Vanloo, he was accepted into
the Académie in 1769 as a history painter. The *bâtiments du roi*
then placed several orders with him, and he also participated in
the decoration of the Petit Trianon at Versailles and executed
cartoons for the Gobelins tapestry workshops. But it was as the
author of portraits and, especially, genre scenes, that he found
favor with the public.

This charming yet curious canvas of studies brings together
six heads of young boys on a single support. These portraits may
represent the same model in different poses: full face, profile, eyes
lowered, eyes raised, smiling, melancholy or pensive, hair rumpled
or curled, wearing a cap. On the same canvas can be seen the
practiced rendering flowers, which are scattered over the whole
surface. The work thus functions as a page of sketches, to be used
by the painter as a sort of notebook or catalogue.

Recent X-ray photography has revealed, under the paint layer,
an underdrawing representing a man holding a plow drawn by
oxen. Could it be a sketch for an historical or genre scene by an
artist familiar with both spheres?

Several portraits of children, adolescents, and young people
by Lépicié are known. The most famous are those of the three
children of his friend the painter Joseph Vernet (1714–1789):
Emilie (1760–1794), aged nine (1769; Paris, Musée du Petit
Palais); Louis-Livio (1747–1820), at the age of twenty-four (1771;
sold in Paris in 1997); and Carle (1758–1836), shown drawing at
the age of fourteen (1772; Paris, Musée du Louvre). Also worth
noting is the delightful *Young Draftsman* at the Mauritshuis in
The Hague. In these works, Lépicié shows himself to be highly
sensitive to youthful personalities, whose feelings and poses he
captures with spirit.

Pierre Rosenberg, skeptical of the painting's attribution to
Lépicié, believes the children and flowers were painted by
different artists.

Provenance: M.G. sale, Paris, January 17, 1866, no. 59.
Musée de Picardie Catalogues: 1894, p. 44, no. 170; 1899, p. 221, no. 171; 1911,
 p. 136, no. 168.
Bibliography: Bellemère 1908, p. 41; Gaston-Dreyfus 1922, pp. 184, 185, no. 9;
 Gaston-Dreyfus 1923, pp. 56, 57; Boinet 1928, p. 15; Foucart 1977, pp. 19, 25, 29,
 44; Lesage 1978, pp. 125, 126; Huchard, Lernout, Mahéo, and Couderc 1995,
 pp. 103, 105.
Exhibitions: Paris 1874, no. 312; Paris 1883–84, no. 89; Paris 1931, no. 36; Amiens
 and Dortmund 1960, no. 8; Copenhagen 1960, no. 33.

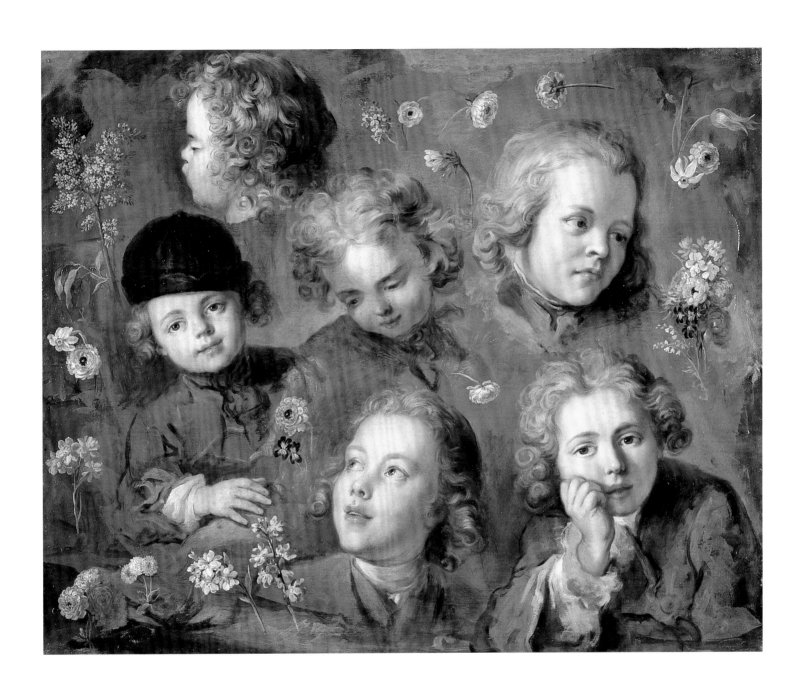

62. Noël Hallé

(Paris 1711–Paris 1781)

The Game of Blind Man's Buff, 1770–80

Oil on canvas, 68½ × 47⅞ in. (174 × 121.5 cm)

Musée de Picardie, Amiens; Gift of the Lavalard Brothers, 1890

(M.P. 1894–206)

THE SCENE TAKES PLACE IN THE GARDENS OF AN Italian villa, in front of the large door of a barn overflowing with hay. The top of the building is a terrace, next to which rises the graceful silhouette of an umbrella pine. In the background, a summer house and two ancient columns contribute to the Italian atmosphere. There has been a picnic, the remains of which are spread out in the foreground: a pretty still life of water pitchers, bottles, a basket, and glasses. A group of men and women are playing blind man's buff: In the center, a blindfolded man attempts to identify his companions. In front of him, two players call out to him, one holding out a rod; and, behind him, a woman has snatched his wig and is spinning it on a cane. Further away, three elegant women with elaborate hairstyles dash excitedly toward their "victim." On either side, seated or standing, spectators nonchalantly observe the game. A gardener, with a shovel on his shoulder, closes the composition on the right. In the foreground, a little dog dragging a ribbon leaps about, and a mastiff prepares to chase it. On the terrace, three people are leaning over the balustrade.

Blind man's buff, which appeared in the sixteenth century, was very popular in eighteenth-century France. The game consists of blindfolding one of the participants who must, by feeling his way, catch another player and identify him or her by touch. That player then takes his place and must do the same, and so forth. Scenes of blind man's buff are frequent in eighteenth-century painting and tapestry, attesting to the popularity of this diversion. It was also a metaphor for the game of love, and the poet Dancourt (1661–1725) wittily remarked on the connection in 1701: "In the game of love, as in Blind Man's Buff, / Everything depends on luck."

Previously attributed to Hubert Robert, but rightfully restored to Hallé by Pierre Rosenberg in 1971, the canvas probably belonged originally to a decorative set that was integrated into wood paneling, just another work of equivalent size belonging to the Louvre and featuring a picturesque landscape in the Italian style with an old bridge.

Hallé, descended from a long line of painters, was trained in the workshop of his brother-in-law, Jean Restout. A winner of the Prix de Rome in 1736, he was in Italy from 1737 to 1744. Upon returning to Paris, he was accepted into the Académie in 1748, and he continued to obtain marks of esteem and honors until his death. Author of a varied œuvre, he was above all a history painter, and his works, widely exhibited at the Salon, attest to his fame. He produced works for the Choisy château as well as for the Trianon; he executed cartoons for the Gobelins tapestry workshops; and he even painted portraits and genre scenes for individuals.

Treated with a free and lively touch, in light, pale colors close to watercolor, this surprising canvas is emblematic of the spirit of an era and depicts, in a veiled and caricatured manner, the mores of the frivolous and libertine society so brilliantly explored by the novelist Pierre Choderlos de Laclos (1741–1803).

Provenance: Eugène Tondu sale, Paris, April 10–15, 1865, no. 209.

Musée de Picardie Catalogues: 1894, p. 50, no. 206 (style of Hubert Robert?); 1899, pp. 226, 227, no. 192 (Robert); 1911, p. 139, no. 188 (Robert).

Bibliography: Gonse 1900, p. 14 (Robert); Gonse 1904, p. 60, no. 82; Bellemère 1908, p. 43 (Robert); Nolhac 1910, p. 128, pl. 131 (Robert); Boinet 1928, pp. 15, 55 ("mistakenly attributed" to Robert); Lentenac 1929, pl. 52; Foucart 1977, pp. 27, 43; Lesage 1978, pp. 92, 93; Lomax 1983, pp. 108, 109; Willk-Brocard 1994, pp. 74–78; Willk-Brocard 1995, pp. 183, 439, 440, no. 127.

Exhibitions: Paris 1931, p. 60, no. 82 (French school of the second half of the eighteenth century); London 1949–50, p. 33, no. 115; Amsterdam 1951, no. 2; Toledo, Chicago, and Ottawa 1975–76, no. 46, pl. 94; Tokyo 1982, no. c13; Biot 1989, pp. 60, 61; Cologne, Zurich, and Vienna 1996–97, pp. 273–75, no. 99.

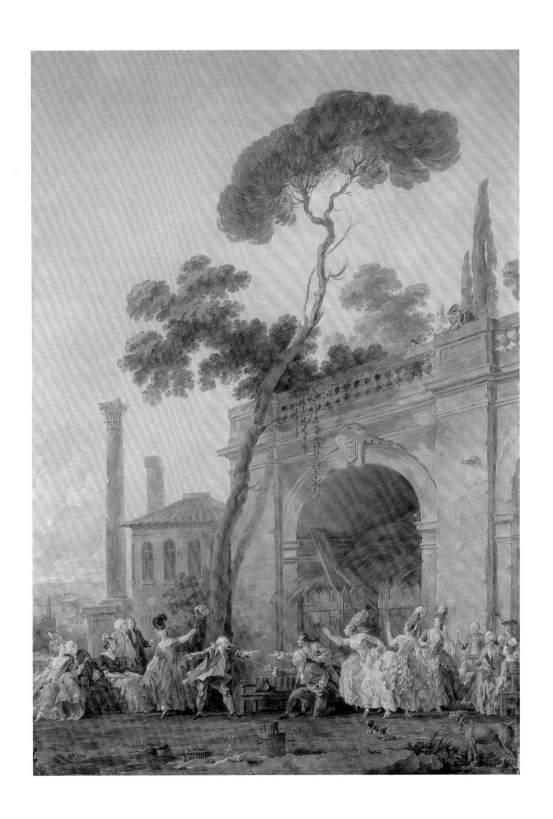

63. UNKNOWN FRENCH ARTIST
18th century

A Vendor of Potions(?), ca. 1770–80
Oil on canvas, 12½ × 16 in. (31.9 × 40.7 cm)
Musée de Picardie, Amiens; Gift of the Lavalard Brothers, 1890
(M.P.Lav. 1894–192)

FORMERLY ATTRIBUTED TO SUBLEYRAS, THIS CHARMing little picture was compared some ten years ago by Jean-Pierre Cuzin to the work of Jacques Dumont called *Le Romain* (1701–1781). That attribution has been neither confirmed nor contradicted by other suggestions; however, we might cautiously advance here the name of Jean-Baptiste-Marie Pierre (1714–1789), whose style does not seem foreign to this work.

The subject remains equally mysterious: The scene, in which two young people watch a woman pouring the contents of a jug into an earthenware jar, earned it the traditional title that, lacking anything better, is retained here. In fact, the décor of the room, cluttered with vases, suggests the lair of some magician, and the female figure seated on the bench might be preparing a particular potion. On the right, a drapery seems to conceal a figure hiding in its folds. Some detail will perhaps enable us one day to identify the subject.

Whatever the exact subject, the work, with its subdued colors, lively brushwork, and singular atmosphere, is representative of those paintings of tantalizingly strange atmospheres that appealed to certain personalities curious about the unusual.

Musée de Picardie Catalogues: 1894, p. 47, no. 192 (Pierre Subleyras); 1899, p. 228, no. 197 (Subleyras); 1911, p. 139, no. 193 (Subleyras).
Bibliography: Boinet 1928, p. 13; Foucart 1977, p. 44 (Subleyras); Lesage 1973, pp. 156, 157, no. 41.
Exhibition: Hamburg and Munich 1952, no. 61.

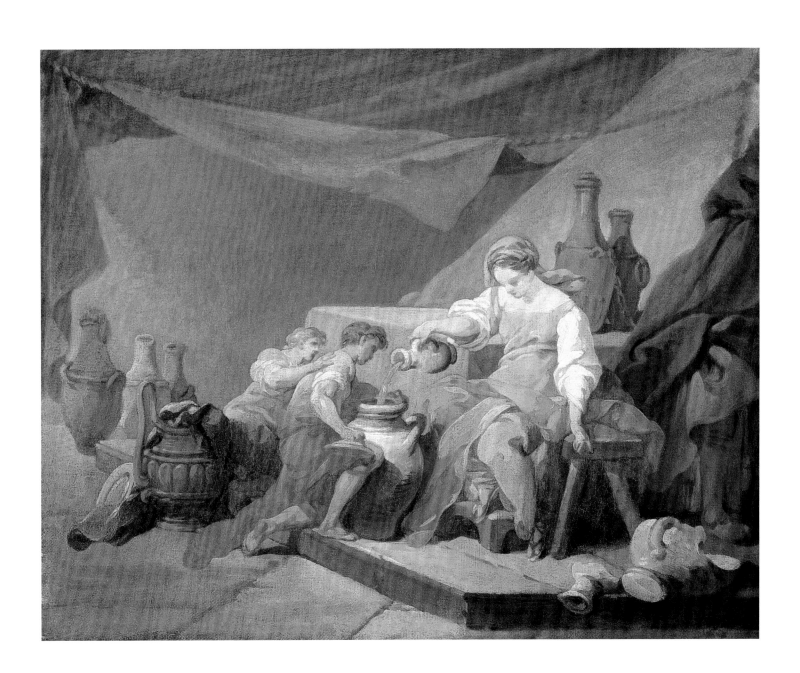

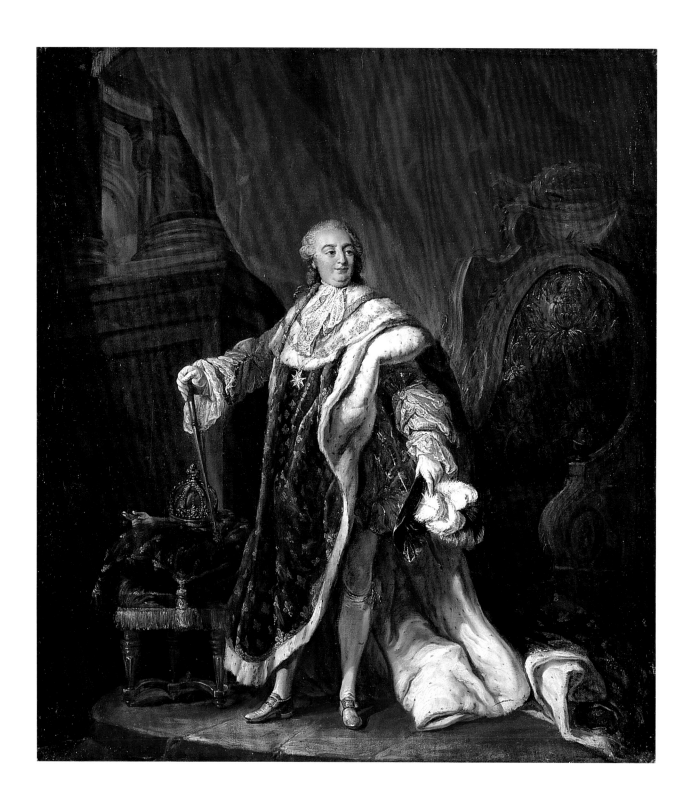

64.
UNKNOWN FRENCH ARTIST,
AFTER LOUIS-MICHEL VANLOO
(Toulon 1707–Paris 1771)

Portrait of Louis XVI in Coronation Dress, 1774(?)

Oil on canvas, 24 × 20⅛ in. (61 × 51 cm)
Musée des Beaux-Arts, Orléans (101)

THIS CANVAS COULD BE BY ANY OF A NUMBER OF painters who worked for the *bâtiments du roi* at Versailles and whose duty was to paint official portraits of the sovereign and his family.

The composition is borrowed from the famous full-length portrait of Louis XV painted in 1759 by Louis-Michel Vanloo. In 1761, Vanloo made a small-size replica of this painting to serve as a model for the *bâtiments* copyists. It is probably that small version that was used as the basis for the present canvas. Only the sovereign's face has been changed, replaced by a portrait of Louis XVI. It is quite likely that this small-scale portrait was done shortly after the king ascended to the throne in 1774, and before Joseph-Siffred Duplessis and Antoine-François Callet (1741–1823) executed the official portraits of the sovereign in 1778–79, those later being widely disseminated by copies and engravings.

Grandson of Louis XV, Louis XVI (1754–1793) ruled from 1774 to 1792. In 1770 he was married to Marie-Antoinette, daughter of Francis I, emperor of Austria. A virtuous, basically peaceful man, who loved the hunt, nothing disposed him to rule France; the successive deaths of his elder brothers made him the unfortunate heir to the throne. He was unable to resist the often deleterious influence of the queen and her entourage, who opposed all reform of a state that was suffering a serious financial crisis despite the favorable economic environment.

By 1788, the convocation of the Estates-General had become unavoidable; however, the sovereign was unable to capitalize on the profound surge of monarchical sympathy among the French people. The proclamation of the Rights of Man and the abolition of the feudal regime put an end to the absolutism of royal power, but the new constitutional monarchy did not last long. The suspension of the king, the proclamation of a national convention, and his sentence for treason led the last sovereign of the ancien régime to the guillotine on January 21, 1793.

This portrait in ceremonial dress, painted shortly after his coronation, continues a tradition instituted by Louis XIV of showing the sovereign in the Throne Room, dressed as for the coronation ceremony. All the kingly insignia are shown: He wears the heavy coronation mantle and the chains of the Order of the Holy Ghost and the Golden Fleece, and he holds the sword of Charlemagne and the scepter, sign of his authority. Near him, on a cushion decorated with fleurs-de-lys, are the golden crown and the hand of Saint Louis, symbol of judicial power.

—ERIC MOINET

Provenance: Collection of the Château de Mesmière, near Neufchatel in Normandy; collection of Paul Fourché (1840–1922) in Bordeaux; donated by Paul Fourché in 1907; exhibited in the Paul Fourché Museum in Orléans (plundered, then destroyed in the bombings of June 1940) from 1907 to 1939.
Bibliography: *Annexe* 1908, p. 38, no. 313; O'Neill 1981, p. 144, no. 190.

65. FRANÇOIS-ANDRÉ VINCENT
(Paris 1746–Paris 1816)

Erminia with the Shepherds, ca. 1774
Oil on canvas, 28 × 35⅛ in. (71 × 89.3 cm)
Musée de Picardie, Amiens; Gift of the Lavalard Brothers, 1890
(M.P.Lav. 1894–149)

THE FAMOUS EPIC POEM *JERUSALEM DELIVERED* BY Torquato Tasso (1544–1595) inspired paintings by numerous artists from the Renaissance on (see no. 67). The present canvas illustrates Erminia's stay with the shepherds (Canto VII).

Among the various tales interwoven in this heroic epic, set at the time of the First Crusade, is the story of the thwarted love of the beautiful Saracen princess Erminia for the young Christian knight Tancred. One night, going out in search of the man she loves, Erminia takes refuge with a peasant family. They extol the sweetness of a simple, peaceful life and urge the young woman to throw down her arms.

Vincent faithfully portrays the scene, conceiving a picturesque, rustic setting. A palm tree planted in front of a humble dwelling suggests the exotic location. Peaceful flocks graze nearby; an amusing cow's head can be seen on the right. Welcomed by an old, bearded shepherd wearing a turban, by his wife who brandishes a shepherd's crook, and by their children, Erminia, dismounting, has just removed her helmet.

The subject of Erminia with the shepherds had a certain success in eighteenth-century France. Its obvious moral message—war vanquished—combined with sentimental heroism in an Oriental setting could not fail to please. In fact, the subject was addressed by Carle Vanloo, Jean-Jacques Lagrenée (1739–1821) and—in a composition fairly similar to this one, exhibited at the Salon of 1795—Guillaume Lethière (1760–1832). Vincent himself

may be the author of an illustration of another episode showing *Tancred Cared for by Erminia* (location unknown).

This painting entered the museum with an attribution to Fragonard. Jean-Pierre Cuzin restored it to Vincent and dated it from his Roman period. A student of Joseph-Marie Vien (1716–1809) and Alexandre Roslin (1718–1793), Vincent obtained the Grand Prix de Rome in 1768. He was in Italy between 1771 and 1775 and often visited Fragonard, who was there as of December 1773. After brilliant beginnings that earned him membership in the Académie in 1782, Vincent, who was seen as David's rival, was eclipsed during the revolutionary period. His reputation is only recently being recovered, thanks to the work of Cuzin. Vincent has benefited from this research, which has reattributed to him works that previously had been thought to be by Géricault (1791–1824), Delacroix (1798–1863), and Fragonard.

It is true that this vigorously treated canvas suggests the name of Fragonard; it could have been executed at a time when the two artists were living and working in close proximity to each other.

Musée de Picardie Catalogues: 1894, p. 40, no. 149 (Fragonard); 1899, p. 215, no. 150 (Fragonard); 1911, p. 132, no. 147 (Fragonard).
Bibliography: Horsin-Déon 1862, p. 144 (Fragonard); Gonse 1900, p. 15; Boinet 1928, p. 15 ("mistakenly attributed" to Fragonard); Wildenstein and Mandel 1972, p. 112, no. 579 (attributed to Fragonard); Foucart 1977, pp. 43, 49 (Fragonard); Cuzin 1983, pp. 114, 115, 123, n. 51.
Exhibition: Amiens 1992, p. 10, no. 13.

66. JEAN-HONORÉ FRAGONARD
(Grasse 1732–Paris 1806)

Education of the Virgin, ca. 1775
Oil on canvas, 36¼ × 28¾ in. (92 × 73 cm)
Musée de Picardie, Amiens; Purchased with the help of the Regional
Acquisition Funds for the Museums of Picardie and the National
Heritage Funds, 1992 (M.P.P. 1992.5.1)

THE APOCRYPHAL GOSPELS GIVE THE VIRGIN MARY a mother named Anne who, in her old age, supposedly conceived without sin and gave birth to a daughter who, in turn, brought Christ into the world. Beginning in the medieval era, one of the traditional representations of Saint Anne shows her teaching the young Virgin. Here Fragonard shows the aged Saint Anne seated, with her very young daughter standing, leaning against her mother's legs. The child raises her gaze to her mother's face and places a hand on a large open book before her. Cherubim are concealed in the half-light that suffuses the scene.

All of Fragonard's biographers have wondered about the dating of this work. Rosenberg suggests placing it just after the second Italian journey (1773–74), during which the artist accompanied a wealthy financier, Bergeret de Grancourt.

Three versions of this composition are known. The one in San Francisco featuring a more labored technique, could date from just before the trip to Italy. Fragonard would thus have taken up the same design again a few years later, but with a thoroughly different style, in the examples of Amiens and Los Angeles. In any event, the similarity is evident between this composition and one by Giambattista Tiepolo (1696–1770) on the same subject in the Church of Santa Maria della Fava, which Fragonard would have been able to see, in the course of his two visits to Venice.

This spectacular painting has occasionally been called unfinished, but it was certainly conceived as it is by the artist, who sought to propose a vision, a revelation, with this misty, mysterious, almost ghostly touch. Here Fragonard wanted the viewer to admire his technique, his allusive brush, his delicate substances formed by a monochromatic palette, which plays on the whole range of shades from light ochre to dark brown, thanks to a con-

trasted, feverish light that blurs shapes. Once again, Rembrandt is the origin of this inspiration. Fragonard apparently had the opportunity to study the Dutch master in the course of a brief trip to Holland in 1775–76. But Fragonard's work also invites one to meditate on this silent conversation between a woman and her small daughter, heralding so much suffering and hope.

The dreamlike power of the painting, very strange and serene, along with its rigor and relative Classicism already foreshadow the final works of an artist who, despite certain Neoclassical temptations, surmounted the obstacles of the revolutionary years, though not without difficulties.

Provenance: Possibly the Aubert sale, Paris, April 17–18, 1806, no. 13; Walferdin sale, Paris, Hôtel Drouot, April 12–16, 1880, no. 66; Baron de Beurnonville sale, Paris, rue Chaptal, May 9–16, 1881, no. 73; Grimelius Collection(?); Baron A. de Turckheim Collection; Countess de Pourtalès Collection; Marquise de Loys-Chandieu Collection, Paris; Madame Maurice Bérard Collection, by 1935.
Bibliography: Portalis 1880, p. 302; Portalis 1889, pp. 276, 302; Mauclair 1904, p. 56; Wildenstein 1921, no. 27; Brion-Guerry 1952; Réau 1956, p. 141; Wildenstein 1960, no. 17; Wildenstein and Mandel 1972, p. 86, no. 19; exhib. cat., Paris and New York, 1987–88, p. 474, fig. 1; Rosenberg and Stewart 1987, p. 166; Cuzin 1987, pp. 175, 312, no. 274; Rosenberg 1989, p. 114, no. 378; Cuzin 1992, pp. 8, 9; *Gazette des Beaux-Arts* 1993, p. 12, no. 49; Huchard, Lernout, Mahéo, and Couderc 1995, p. 100, 101; *D'un musée l'autre en Picardie* 1996, pp. 41, 190.
Exhibitions: Paris 1921, no. 27; Paris 1954; Grasse 1957, pp. 23, 24, no. 9; Amiens 1992, p. 6, no. 1
Related Works: Jean-Honoré Fragonard, *Education of the Virgin*, ca. 1755, oil on wood, 11⅞ × 9⅝ in. (30.3 × 24.4 cm), The Armand Hammer Foundation, Los Angeles. Jean-Honoré Fragonard, *Education of the Virgin*, ca. 1755, oil on canvas, The Fine Arts Museums, San Francisco. Jean-Honoré Fragonard, *Education of the Virgin*, ca. 1755, black chalk and bistre wash on paper, 15½ × 11⅝ in. (39.5 × 29.4 cm), The Saint Louis Art Museum. Jean-Honoré Fragonard, *Education of the Virgin*, ca. 1755, black chalk and brown and black wash on paper, 21⅝ × 17½ in. (54.8 × 44.5 cm), art trade, London (in 1995).

67. JOSEPH-BENOÎT SUVÉE
(Bruges 1743–Rome 1807)

The Wounded Tancred Recognizes Clorinda Whom He Has Just Fought, ca. 1776–78

Oil on canvas, 56⅞ × 77⅜ in. (144.5 × 196.5 cm)
Musée de Picardie, Amiens; On deposit from the Musée du Louvre, 1864 (M.P.P. 340; Louvre 8077)

THE PAINTING ILLUSTRATES AN EPISODE (CANTO XIII) from *Jerusalem Delivered*, the famous epic poem of Torquato Tasso (1544–1595) that inspired so many artists in the seventeenth and eighteenth centuries (see also no. 65). The epic takes place during the First Crusade led by Godefroy de Bouillon at the end of the eleventh century and recounts the exploits and relationships of several protagonists, sometimes touching upon the fantastic. Favorites among the heroes are the two figures shown in this painting: the valiant, young Christian knight Tancred and the beautiful and intrepid woman warrior with whom he has fallen in love, the Saracen Clorinda.

Several episodes narrate the encounters between these two, separated by religion yet united by affection. Finally, in the shadows of night, Tancred, thinking he is pitting himself against a resolute adversary, fatally wounds Clorinda. Suvée invites us to share the dying woman's last moments in the presence of her supposed enemy Tancred, who is distraught at having cut short the life of the woman he loves. Two soldiers support the young man, also weak and wounded; before the tent where he has lain the young woman stand two unwelcoming old people. Above, on the right, Clorinda's soul is already ascending to heaven.

Of Flemish origin, Suvée received the Grand Prix in 1771, permitting him to stay at the Académie de France in Rome until 1778. Upon returning to Paris, he pursued a career that was notably marked by several royal commissions. In 1801 he was appointed director of the Académie de France in Rome, presiding over its installation at the Villa Médicis, which remains its home to this day.

This canvas seems to date from the artist's first Roman period and perhaps belonged to a cycle conceived around *Jerusalem Delivered* that originally linked it to two other paintings: *Tancred Aided by Erminia* (Nantes, Musée des Beaux-Arts), of nearly identical dimensions, and *Erminia with the Shepherds* (Ghent, Musée des Beaux-Arts), a more monumental work that, however, might have constituted the main element of the décor. Whether they come from the same ensemble or not, the three paintings could well belong to the same creative period, immediately prior to the painter's return to France in 1778.

A composition whose dramatic eloquence is served by a vast, clear construction, Suvée's canvas responds to the official artistic policy of the day, which sought to promote history painting, the pinnacle of the hierarchy of genres. With its stylistic simplification, edifying message, and references to antiquity, the work, though still marked by the elegance of the Rococo style, already belongs to the beginnings of Neoclassicism.

Musée de Picardie Catalogues: 1865, p. 28, no. 84; 1873, p. 45, no. 105; 1875, p. 59, no. 137; 1878, p. 103, no. 137; 1899, p. 112, no. 272; 1911, p. 77, no. 337.
Bibliography: Bellemère 1908, p. 21; Lesage 1978, pp. 160–62, no. 42; Coekelberghs 1993, p. 50.

68. Louis-Roland Trinquesse
(Paris? ca. 1745–Paris? ca. 1800)

Portrait of a Young Boy, 1777

Oil on canvas, 21 × 17⅛ in. (53.2 × 43.5 cm)
Signed and dated, middle right: *L.A.R. Trinquesse en 1777*
Musée de Picardie, Amiens; Gift of the Lavalard brothers, 1890
(M.P.Lav. 1894–196)

Curiously, the life and career of Trinquesse remain very obscure: It is not even known with certainty where and when he was born and died. This state of affairs is puzzling given that the artist's work is fairly widespread. A talented draftsman, Trinquesse left a great number of drawings, most often done in red chalk and picturing young women. These drawings—of which the Musée de Picardie possesses a fine example—show elegant women in dresses with attractive pleated effects rendered by energetic strokes. The charming nature of these representations, so emblematic of the spirit of the eighteenth century, has always aroused the interest of connoisseurs.

In addition to being a genre painter, Trinquesse was also a portraitist. Here he presents the image of a child casually dressed in a brilliant satin jacket and lace-collared shirt. The boy stares at the viewer with a lively, impish look; his somewhat mussed hair and pink cheeks add to his vivacity. With this informal view alluding to the model's private life, the painter depicts a familiar figure almost transformed, by his pose and allure, into a sort of child rake. It has been conjectured that the present portrait represents the artist's son. The inscription, which seems to be a signature, could in fact designate the young model's given name: It does not seem that the letter *A*, appearing in the given name, indicates the painter, as he usually used only the initials *L.R.*

Musée de Picardie Catalogues: 1894, p. 48, no. 196; 1899, p. 228, no. 198; 1911, p. 139, no. 194.
Bibliography: Bellemère 1908, p. 41; Boinet 1928, p. 15, pl. p. 48; Nicolle 1931, pp. 98, 99, 126; Wilhelm 1974, p. 56, pl. 3; Foucart 1977, p. 23, n. 38, p. 44; Lesage 1978, pp. 169–71.
Exhibitions: Paris 1883–84, no. 134; Paris 1931, no. 73; Amiens and Dortmund 1960, no. 10; Dijon 1969, no. 56, pl. 16.

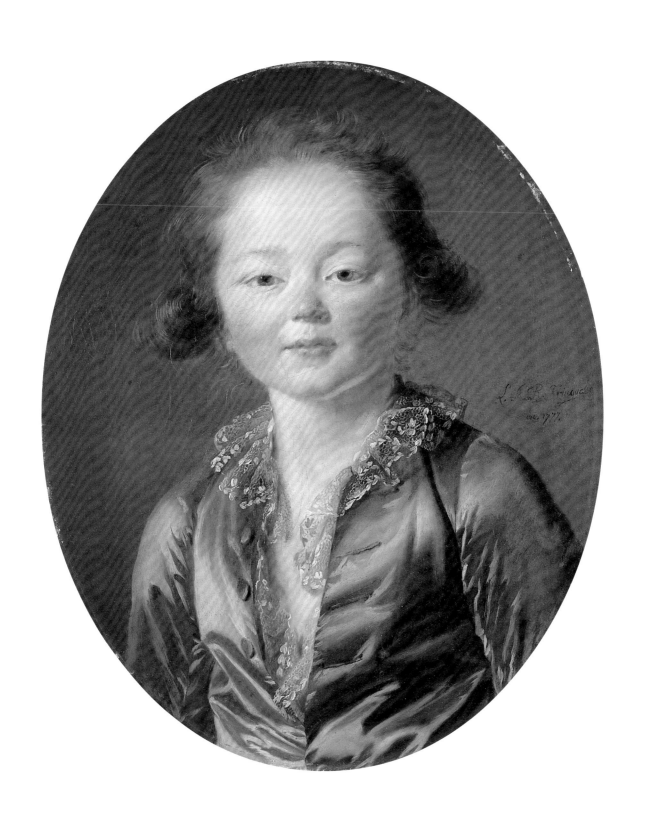

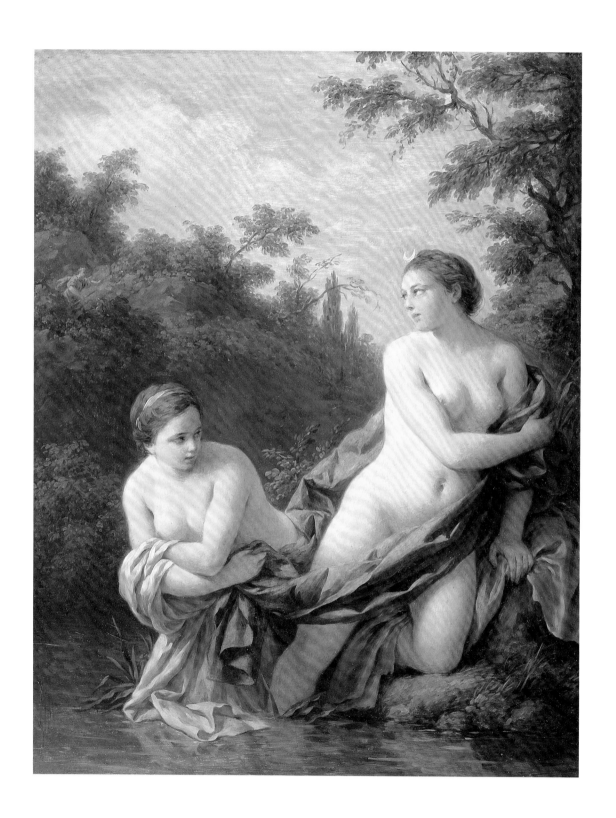

69. LOUIS JEAN-FRANÇOIS LAGRENÉE, CALLED
LAGRENÉE *L'AÎNÉ*
(Paris 1725–Paris 1805)

Diana at Her Bath, Surprised by Acteon, 1778
Oil on wood, 16½ × 12¾ in. (42 × 32.5 cm)
Musée de Picardie, Amiens; Gift of M. Dupont, 1891 (M.P.P. 418)

THIS SMALL PANEL ENTERED THE MUSÉE DE PICARDIE in 1891, along with a pendant representing *Venus and Cupid* (fig. 20). That work, signed and dated *Lagrenée 1778*, confirms the attribution of the present painting and also provides a date.

The well-known story pictured in this work is from the *Metamorphoses* of Ovid (III, 138–251): Acteon, having gone hunting, arrives by chance at the sacred spring where Diana is bathing with her nymphs. The chaste goddess preferred to avoid human company. Not tolerating being disturbed by a mere mortal, she casts a spell upon the young man, transforming him into a stag to punish him for having dared see her "unveiled." Thus metamorphosed, Acteon is pursued and finally torn to pieces by his own hounds. The painting depicts the precise moment when Diana, recognizable by the crescent decorating her brow, sees, emerging from the bushes to the above left, the unfortunate Acteon who is already being transformed with sprouting antlers.

Louis Lagrenée, who is not to be confused with his brother, the painter Jean-Jacques Lagrenée (1739–1821)—Lagrenée *le jeune*—had a particularly successful career: Winner of the Prix de Rome in 1749, he entered the Académie in 1755 and climbed the rungs of that venerable institution's hierarchical ladder. He received the favors of the king, his entourage, and the court, and at the request of Elizabeth, the empress of Russia, he became director of the Academy of Fine Arts in Saint Petersburg from 1760 to 1762. As a history painter, he was much in demand, and his output was abundant. A superb limner of pleasant and courtly mythological tales, the artist was at his best in these small formats. In these he could be particularly attentive to the porcelainlike rendering suitable for depicting sensuality. Diderot himself praised this technique in a review of the 1771 Salon: "It is flesh, to be taken, to be touched, to be kissed."

Musée de Picardie Catalogues: 1899, p. 66, no. 165 (Jean-Jacques Lagrenée *le jeune*); 1911, p. 48, no. 205 (Lagrenée *le jeune*).
Bibliography: Bellemère 1908, p. 26; Boinet 1928, p. 14; Vergnet-Ruiz and Laclotte 1962, p. 241 (Lagrenée *le jeune*); Lesage 1978, pp. 104–08, no. 25; Sandoz 1983, p. 261, no. 326.
Exhibition: Paris 1779, no. 12.

Fig. 20
Louis Jean-François Lagrenée, called Lagrenée *l'aîné*
Venus and Cupid, 1778
Oil on wood
16⅛ × 12¾ in. (41 × 32.5 cm)
Musée de Picardie, Amiens
Photo Marc Jeanneteau

70. ATTRIBUTED TO JEAN-BAPTISTE
LALLEMAND
(Dijon 1716–Paris 1803)

*Ruins of an Ancient Portico with a Statue of
a River God*, ca. 1780

Oil on canvas, 24⅜ × 28⅞ in. (61.8 × 73.3 cm)
Musée de Picardie, Amiens; Bequest of Edmond Soyer,
1914–18 (M.P. 2072–679)

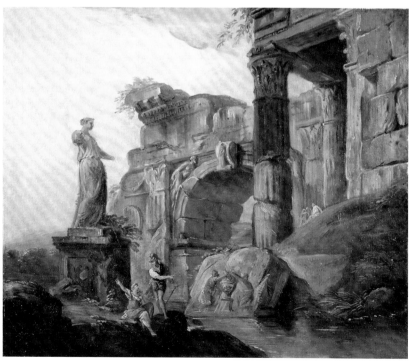

71. ATTRIBUTED TO JEAN-BAPTISTE
LALLEMAND
(Dijon 1716–Paris 1803)

Ruins of an Ancient Arch with a Female Statue,
ca. 1780

Oil on canvas, 24⅜ × 28¼ in. (61.8 × 73 cm)
Musée de Picardie, Amiens; Bequest of Edmond Soyer,
1914–18 (M.P. 2072–678)

UPON ENTERING THE MUSEUM, THESE TWO CANVASES were attributed to Giovanni Paolo Pannini (1691–1765), a prolific Italian artist of architectural follies. They must now be brought back into the French school, and the name of Jean-Baptiste Lallemand has been suggested. This Burgundian artist painted numerous views of his native city of Dijon and its environs, as well as genre scenes illustrating provincial daily life at the end of the ancien régime. Admired as a landscapist, Lallemand finished his career in Paris, enjoying a certain fame.

Thanks to a prolonged stay in Italy—he spent nearly fifteen years in Rome (1747–61)—Lallemand acquired a marked interest in these fantastic scenes. With their explorations of imaginary sites of antiquity in which columns, statues, entablatures, and sculpted blocks are entangled against backgrounds of toppled monumental buildings, these views were much appreciated in the eighteenth century. This language, evoking the grandeur of Greco-Roman antiquity, is humanized by the presence of figures that, while providing scale, also confer a picturesque side to these spectacular landscapes. Lallemand perfectly mastered this vocabulary, which manages to appeal to the eye in search of the grandiose, while also encouraging reflection on the vanity of material splendors, the colossal architectural masterpieces bequeathed by a glorious past not having withstood the test of time. A fairly large body of works by Lallemand treating this theme is known, and it is possible, nonetheless with a slight reserve, to propose the attribution of these two canvases to this "little master" of a genre that was powerfully exploited with witty inventiveness by Hubert Robert.

72 . HUBERT ROBERT
(Paris 1733–Paris 1808)

Portico with Dancers and Musicians in a Park, 1780–85
Oil on canvas, 20⅛ × 20⅛ in. (51 × 51 cm)
Musée de Picardie, Amiens; Gift of the Lavalard Brothers, 1890
(M.P.Lav. 1894–186)

IN A PARK, SIX MUSICIANS HAVE TAKEN THEIR PLACES beneath the arcade of an antique-style portico inspired by the Villa Médicis, the high frieze of which is decorated with bas-reliefs. In front of the colonnade, on a rostrum covered with a carpet, two elderly people are seated. In front of the stage, a couple is dancing, the woman wearing a white dress and a large hat, the man a black cape and a beret. In the distance, the perspective grants a view of a vast courtyard surrounded by a portico; within it stands a circular temple rising above a high flight of steps.

One aspect of Robert's art is epitomized by this painting: A prolific artist, he enjoyed creating imaginary landscapes in which classical architecture, more or less ravaged by time, is integrated into a natural setting of vegetation. Figures give his compositions the necessary scale, while conferring a picturesque note and often adding humor or even irony. These various ingredients enable the painter, with his elegance and sense of measure, to contrast vestiges of grandiose architecture with the human beings who inhabit them, engendering a somewhat melancholy, but above all, poetic reflection on the passage of time. Nonetheless, Robert's work, marked by his extraordinary inventiveness, always remains classical and ordered, thanks to the balance of his compositions and his systematic recourse to antiquity. This ability to combine fantasy and restraint enabled him to move smoothly from the Rococo period, with its taste for pleasantly dreamlike and light, lyrical scenes, to the Neoclassical age, which, in contrast, favored the rigor of the antique. Robert was one of the rare painters to succeed in combining this double requirement in his work, and this painting is a perfect example of an art that was able to respond to a radical evolution of taste. A comparison of this canvas and its festive subject with paintings of similar subjects by Fragonard accentuates the fundamental difference between the work of these two friends: one is imbued with a sort of reserve, and the other is still characterized by the excesses of the Baroque.

Musée de Picardie Catalogues: 1894, p. 46, no. 186; 1899, p. 225, no. 187; 1911, p. 138, no. 183.
Bibliography: Bellemère 1908, p. 43; Boinet 1928, pp. 15, 53; Réau 1938, p. 147; Vergnet-Ruiz and Laclotte 1962, p. 100; Foucart 1977, pp. 22, 43; Cayeux 1987, pp. 141–43, no. 114.
Exhibitions: Paris 1883–84, no. 123; Paris 1931, no. 62; London 1949–50, p. 33, no. 114; Besançon 1957, p. 35, no. 81; Paris (Cailleux) 1957, p. 41, pl. 4; Vienna 1966, p. 97, no. 62, pl. 46; Bordeaux 1969, p. 56, no. 99; Biot 1989, pp. 62, 63; Aix-en-Provence 1991, pp. 110, 111, no. 96; Amiens 1992, p. 8, no. 9.

73. ATTRIBUTED TO JEAN-FRANÇOIS DONVÉ
(Saint-Amand 1736–Lille 1799)

Wedding Procession Passing Through the Place Périgord in Amiens, ca. 1785

Oil on wood, 21⅝ × 26⅛ in. (55 × 66.5 cm)
Musée de Picardie, Amiens; Gift of the Association des Amis des Musées d'Amiens, with the participation of the Regional Acquisition Funds for the Museums of Picardie, 1998 (M.P.P. 1998.7.1)

PREVIOUSLY ATTRIBUTED TO GABRIEL DE SAINT-AUBIN (1724–1780), this painting should, in the opinion of Emile Dacier, be removed from that artist's catalogue and attributed to Jean-François Donvé, a student of Louis Watteau (1731–1798), called Watteau of Lille.

The scene illustrated on this panel was described in the catalogue of the Delbergue-Cormont sale, which already suggested an attribution to Donvé: "The procession enters from the main street and crosses the Place de Périgord, in Amiens. Relatives and guests follow the newlyweds who are preceded by musicians, pastry chefs, cooks bearing meats suspended from a pole, and a child driving a little cart full of fowl and drawn by a dog. Lords and ladies in elegant dress stroll around a fountain crowned by the group of the Three Graces."

The Place Périgord was named in honor of the governor of the province, Gabriel de Talleyrand-Périgord. Unfortunately, this square has completely vanished, following the destruction caused by World War I, but it is known to us from drawings (Musée de Picardie, Duthoit Collection) and old photographs. According to the 1780 plan by Jacques-Pierre Rousseau (1731–1801), architect of the city of Amiens as of 1771, the Place Périgord was to consist of six buildings identical to the one seen in the painting, around an oval *place*. In the end, only one of the six was actually constructed; similarly, there seems to be no trace of the fountain decorated with the group of the *Three Graces* depicted here. In 1782 Rousseau proposed erecting a monumental obelisk there with fountains around the base, but the project was never carried out. This painting thus gives us an idealized view of a square as it should have been completed. Nonetheless, it remains an exceptional example of the urban-planning projects of Amiens in the eighteenth century. Additionally, it elucidates certain local traditions: For example, the dogcart was a means of transportation frequently used in Picardie during the ancien régime. Above all, the painting is a lovely evocation of a provincial French city on the eve of the 1789 Revolution.

Provenance: Delbergue-Cormont Collection; sale, Paris, May 31, 1882, no. 6; Marius Paulme Collection; sale, Paris, November 22, 1923, no. 88 (attributed to Gabriel Saint-Aubin).
Bibliography: Dacier 1931, p. 109, no. 618; Pinette 1999, p. 85.

74 · **HUBERT ROBERT**
(Paris 1733–Paris 1808)

*Landscape with a Woman Thrown by Her Mount at the
Foot of a Statue of Venus,* ca. 1790–1800

Oil on canvas, 11⅞ × 6¾ in. (30.2 × 17.2 cm)

Musée de Picardie, Amiens; Gift of the Lavalard Brothers, 1890

(M.P.Lav. 1894–189)

75 · **HUBERT ROBERT**
(Paris 1733–Paris 1808)

*Landscape with a Man Lifting a Block of Stone at the Foot
of a Statue of Hercules,* ca. 1790–1800

Oil on canvas, 11⅞ × 6⅞ in. (30.2 × 17.4 cm)

Musée de Picardie, Amiens; Gift of the Lavalard Brothers, 1890

(M.P.Lav. 1894–190)

THESE TWO SMALL PAINTINGS ACT AS PENDANTS. In the first, a tortuous landscape with steep, rocky reliefs is topped by the silhouette of an ancient round structure, derived from the Temple of the Sibyl at Tivoli. In the foreground, a mule has just thrown its rider into the basin of a fountain decorated with a statue of Venus, provoking astonishment among the witnesses who gesticulate nearby. The second painting proposes a more open site in which a temple with colonnade and pediment arises. Ancient stone ruins—steles, an altar, a cornice with modillions, a sarcophagus—surround a statue of Hercules, and a man accompanied by two women and a child lifts a heavy block of stone.

In these two canvases are found the usual ingredients of Hubert Robert's pictorial vocabulary and, first and foremost, his predilection for antiquity. This proclivity is seen in the architectural monuments and, of course, the two statues, which are among the most famous types of Hellenistic sculpture, frequently copied during the Roman era. The Hercules, in particular, corresponds to the Farnese Hercules, the famous version that belonged to the Farnese family of Rome.

With their combinations of figures and ruins in vegetation, Robert's landscapes are intentionally picturesque. Robert also deliberately gives his works a humorous turn: In the first canvas, the goddess of love and beauty, standing on a pedestal, lifts her garment at the back, allowing her charms to be admired. She turns as if to contemplate the unfortunate fallen rider, who, with her skirt in disarray, inadvertently reveals an all-too-human anatomy! In the second picture, a muscular but relaxed Hercules, calmly leaning on his heavy club, seems to observe from the height of his pedestal his earthly emulator who laboriously tries to lift a thick stone slab. This latter painting could be an early version of the *Landscape with the Farnese Hercules* (Paris, Musée du Petit Palais), which follows the outline of the Amiens canvas but includes distinct variations. This large-scale work, which comes from the Beaumarchais Mansion in Paris, dates from 1790. Finally the same Farnese Hercules and the same sarcophagus are found in the *Roman Ruins with the Coliseum* (Paris, Musée du Louvre), painted, it would seem, in 1798.

Returning to France in 1765, Robert was elected to the Académie the following year. In 1777, along with the sculptor Augustin Pajou (1730–1809) and the painter Jean-Baptiste-Marie Pierre (1714–1789), he was appointed to organize the Royal Museum of the Louvre. Though harassed and imprisoned in 1793–94, Robert survived the Revolution, and met up again with Fragonard in the new commission in charge of the Museum. In the course of this long period following his return from Italy, Robert executed numerous landscapes still imbued with memories of his stay on the peninsula. In particular, he painted a certain number of grand settings: These two paintings are perhaps sketches for such groups.

NO. 74
Musée de Picardie Catalogues: 1894, p. 47, no. 189; 1899, p. 226, no. 190; 1911, p. 138, no. 186.
Bibliography: Bellemère 1908, p. 43; Foucart 1977, pp. 22, 43.

NO. 75
Musée de Picardie Catalogues: 1894, p. 47, no. 190; 1899, p. 226, no. 191; 1911, p. 138, no. 187.
Bibliography: Bellemère 1908, p. 43; Foucart 1977, pp. 22, 43; Rosenberg and Changeux 1994, p. 60; Bluche 1995, p. 58 (reproduced backwards).
Related Work: Hubert Robert, *Landscape with the Farnese Hercules*, ca. 1750, oil on canvas, 111 × 52 in. (281 × 132 cm), Musée du Petit Palais, Paris.

76. CONSTANCE CHARPENTIER
(Paris 1767–Paris 1849)

Melancholy, 1801

Oil on canvas, 51⅛ × 65 in. (130 × 165 cm)
Signed, bottom right: *CA. M. Blondelu./fe Charpentier*
Musée de Picardie, Amiens; On deposit from the Musée du Louvre,
1864 (M.P.P. 289; Louvre 3213)

BEGINNING IN THE MIDDLE OF THE EIGHTEENTH century, the phenomenon of female painters began to spread throughout France. Gradually, women, whose place in the world of painting heretofore had been relatively limited, began to assert themselves. Anne Valleyer-Coster (1744–1818), Adélaïde Labille-Guiard (1749–1803), and Elisabeth Vigée-Le Brun (1755–1842) are certainly the best-known examples of this noticeable evolution in a realm that had previously been largely male-dominated. After the end of the ancien régime, this trend was continued during the revolutionary decades and concurrent with the success of women's workshops, new talents emerged, among whom personalities such as Marguerite Gérard (1761–1837) and Constance Mayer (1778–1821) stand out.

It is in such a context that we must place the fine painting by Constance Blondelu-Charpentier, a portraitist and painter of genre scenes who is not as yet well known. The canvas is perfectly revelatory of its author's training: A student of Jacques-Louis David (1748–1825), Charpentier here shows herself to be a faithful emulator of her master. It is notable that the figure of *Melancholy* constitutes a sort of isolated echo of that of Camille in the famous *Oath of the Horatii* (1784). The present work is altogether Neoclassical in its reference to antiquity as well as in its irreproachable technique and moral scope, Charpentier adopted a theme that was already well tested in England in the second half of the eighteenth century and which witnessed a strong development in French painting at that time: Louis Lagrenée in about 1785 and especially François-André Vincent in 1801 both proposed versions of the same subject.

The image disclosed here is so immediately eloquent that it hardly requires any commentary. The painting's title obviously encourages us to observe the melancholy reverie of a young woman whose languid, indolent bearing and fixed gaze speak for themselves. To extend the moody atmosphere, the painter chose to place her heroine in a landscape in keeping with her feelings: the weeping willow, the brook, and the crepuscular light all reflect the figure's sadness.

A masterly work by virtue of the effectiveness of its message as well as the quality of its execution and the simplicity of its composition, Constance Charpentier's *Melancholy* is representative of the Neoclassical aesthetic. Yet it also foreshadows the Romantic spirit, with its fascination for the connection between of Nature and Man and its taste for exploring the depths and contradiction of human feelings. The appeal of such a pensive mood is proclaimed in a poem published on the occasion of the work's appearance at the 1801 Salon: "In the shadow of a weeping willow,/ On the edge of a limpid body of water/ This woman portrays her heart for us/ In a sweet, shy look,/ One takes pleasure in dreaming/ Near such a pretty woman/ And this painting lets us discover/ Charm in melancholy."

Provenance: Acquired by the State as a Prix d'encouragement, 1801.
Musée de Picardie Catalogues: 1865, p. 28, no. 81; 1873, p. 20, no. 24; 1875, p. 23, no. 33; 1878, pp. 39, 40, no. 33; 1899, p. 27, no. 66; 1911, p. 19, no. 83.
Bibliography: Benoit 1897, p. 339; Sterling 1951, pp. 129, 130; Sterling 1952, p. 127; Foucart 1970, p. 76; Fields-Denton 1996, pp. 109, 110; *Catalogue sommaire illustré des peintures du Musée du Louvre et du Musée d'Orsay. Ecole française*, vol. 5, Paris, 1986, p. 222; *Dictionary of Women Artists*, vol. 1, 1997, pp. 381, 382.
Exhibitions: Paris 1801, no. 58; Amiens 1969, no. 8; Paris 1973; Paris, Detroit, and New York 1974–75, pp. 346, 347, no. 19, pl. 101; Los Angeles, Austin, Pittsburgh, and Brooklyn 1976–77, p. 207, no. 69, pl. 69 p. 208.

Exhibitions Cited

Aix-en-Provence 1991
La passion selon Don Juan, Musée Granet

Amiens 1860
Exposition provinciale. Notices des tableaux et objets d'art, d'antiquité et de curiosité exposés dans les salles de l'Hôtel de ville d'Amiens, Hôtel de Ville, Société des Antiquaires de Picardie

Amiens 1931
Chefs-d'oeuvres des Musées de Picardie, Musée de Picardie

Amiens 1951
Fénelon et son temps, Musée de Picardie

Amiens 1952
Noël célébré par les artistes et les enfants, Musée de Picardie

Amiens and Dortmund 1960
Cinq siècles de peinture française, Musée de Picardie and Musée des Beaux-Arts

Amiens 1969
Napoléon I^er, 1769–1821, Musée de Picardie

Amiens 1989
Histoire de chasse, histoire de France, Chapelle des Visitandines

Amiens 1992
Autour de Fragonard, Musée de Picardie

Amiens and Versailles 1995–96
Versailles: Les Chasses exotiques de Louis XV, Musée de Picardie and Musée national des châteaux de Versailles et de Trianon

Amsterdam 1951
Het Franse Landschap van Poussin tot Cézanne, Rijksmuseum

Berlin 1973
China und Europa. Chinaverständnis und chinamode im 17 und 18 jahrfundert, Schloss Charlottenburg

Besançon 1956
J. H. Fragonard. Peintures et dessins, Musée des Beaux-Arts et d'Archéologie

Besançon 1957
Concerts et Musiciensu, Musée de Beaux-Arts et d'Archéologie

Biot 1989
Images des Loisirs, Musée national Fernand Léger

Bordeaux 1956
De Tiepolo à Goya, Galerie des Beaux-Arts

Bordeaux 1958
Paris et les ateliers provinciaux au XVIIIe s., Musée des Beaux-Arts

Bordeaux 1969
L'art et la musique, Musée des Beaux-Arts

Bordeaux 1980
Les arts du théâtre, de Watteau à Fragonard, Musée des Beaux-Arts

Bordeaux, Geneva, and Paris 1995–96
L'âge d'or du petit portrait, Musée des Arts décoratifs, Musée de l'Horlogerie, and Musée du Louvre

Brussels 1953
La femme dans l'art français, Palais des Beaux-Arts

Brussels 1975
De Watteau à David: Peintures et Dessins des musées de province français, Palais des Beaux-Arts

Caen 1993
 Les figures d'Elstir: Proust et les peintres, Musée des Beaux-Arts

Charleroi 1957
 Fragonard—David—Navez, Palais des Beaux-Arts

Cologne, Zurich, and Vienna 1997
 Das Cappricio als Kunstprinzip—Zur Vorgeschichte der Moderne von Arcimboldo und Callot bis Tiepolo und Goya Malerei—Zeichnung—Graphik, Wallraf-Richartz Museum, Kunsthaus, and Kunsthistorisches Museum (Palais Harrach)

Copenhagen 1935
 L'Art français au XVIIIème siècle, Palais de Charlottenbourg

Copenhagen 1960
 Portraits français de Largillierre à Manet, Ny Carlsberg Glyptothèque

Dijon 1969
 Colson—Vestier—Trinquesse, Musée des Beaux-Arts

Dijon 1982–83
 La peinture dans la peinture, Musée des Beaux-Arts

Geneva 1949
 Trois siècles de peinture française. XVI-XVIIIe siècles. Choix d'œuvres des Musées de France, Musée Rath

Grasse 1957
 Fragonard, Musée Fragonard

Hamburg and Munich 1952
 Chefs-d'oeuvres des maîtres français, de Poussin à Ingres, Alten Pinakothek and Kunsthalle

Karlsruhe 1999
 Jean Siméon Chardin, 1699-1779. Werk. Herkunst. Wirkung, Staatliche Kunsthalle

Langres 1984
 Diderot et la critique des Salons, Musée Langres

Lille 1968
 Au temps du Roi Soleil, les peintres de Louis XIV, Palais des Beaux-Arts

Lille 1985
 Au temps de Watteau, Fragonard et Chardin. Les Pays-Bas et les peintres français du XVIIIe siècle, Musée des Beaux-Arts

London 1949–50
 Landscape in French Art, Royal Academy of Arts

London 1954–55
 European Masters of the Eighteenth Century, Royal Academy of Arts

London 1958
 The Age of Louis XIV, Royal Academy of Arts

Los Angeles, Austin, Pittsburgh, and Brooklyn 1976–77
 Women Artists 1550–1950, Los Angeles County Museum; University Art Museum, University of Texas; Museum of Art, Carnegie Institute; and Brooklyn Museum of Art

Marcq-en-Baroeul 1996
 La représentation du cheval dans l'art, Fondation Prouvost

Mondaye 1956
 Les Restout, Abbaye de Mondaye

Montreal, Quebec, Ottawa, and Toronto 1961–62
Héritage de France. French paintings, 1610–1760,
Montreal Museum of Fine Arts, Musée de
Quebec, National Gallery of Canada, and Art
Gallery of Ontario

Montreal 1981
Largillierre, portraitiste du XVIIIe siècle,
Montreal Museum of Fine Arts

Moscow and Leningrad 1978
*De Watteau à David: Tableaux français du
XVIIIe siècle des musées français,* Pushkin
Museum and Hermitage Museum

Munich 1958
Le siècle du Rococo, Residenz

Munster and Baden-Baden 1980
Stilleben in Europa, Westfälisches Landes-
museum für Kunst und Kulturgeschichte and
Staatliche Kunsthalle

Nancy 1960
La Forêt dans la peinture ancienne, Musée des
Beaux-Arts

Nantes and Toulouse 1997–98
*Visages du grand siècle. Le portrait français sous
le règne de Louis XIV, 1666–1715,* Musée des
Beaux-Arts and Musée des Augustins

New York, Detroit, and Paris 1986–87
François Boucher, 1703–1770, The Metropolitan
Museum of Art, The Detroit Institute of Arts,
and Grand Palais

New York and Fort Worth 1991–92
Nicolas Lancret, 1690–1743, The Frick Collec-
tion and Kimbell Art Museum

Nice, Clermont-Ferrand, and Nancy 1977
Carle Van Loo, Musée Chéret, Musée Bargoin,
and Musée des Beaux-Arts

Paris 1742
Salon de 1742

Paris 1745
Salon de 1745

Paris 1747
Salon de 1747

Paris 1757
Salon de 1757

Paris 1765
Salon de 1765

Paris 1779
Salon de 1779

Paris 1791
Salon de 1791

Paris 1801
Salon de 1801 (An IX)

Paris 1874
Exposition pour les Alsaciens-Lorrains, Palais
de la Présidence du corps législatif (Palais
Bourbon)

Paris 1883–84
L'art du XVIIIe siècle, Galerie Georges Petit

Paris 1921
Exposition d'oeuvres de Jean-Honoré Fragonard,
Musée des Arts Décoratifs

Paris 1925
Le paysage français de Poussin à Corot, Petit
Palais

Paris 1928
Nicolas de Largillierre, Petit Palais

Paris 1929
Le théâtre à Paris, Musée Carnavalet

Paris 1931
Chefs-d'oeuvre des musées de Province, Musée de
l'Orangerie

Paris 1932
François Boucher, Fondation Foch, hôtel de
M. Jean Charpentier

Paris 1933
Chefs-d'oeuvre des musées de province, Musée Carnavalet

Paris 1947
Les grandes heures de Notre-Dame de Paris, Chapelle de la Sorbonne

Paris 1951
Salon de la chasse et de la vénerie

Paris 1954
Chefs-d'oeuvre des collections parisiennes, Musée Carnavalet

Paris 1957
L'Art du XVIIIe siècle, Galerie Cailleux

Paris 1957
Le Portrait français de Watteau à David, Musée de l'Orangerie

Paris 1958
Le XVIIe siècle français. Chefs-d'oeuvre des musées de province, Petit Palais

Paris 1959
Hommage à Chardin, Galerie Heim

Paris 1960
Le Paysage en Orient et en Occident, Musée du Louvre

Paris 1964
François Boucher, Galerie Cailleux

Paris 1964
La société française du XVIIe et du XVIIIe siècle, traveled

Paris 1965–66
Chefs-d'oeuvre de la peinture française dans les musées de Leningrad et de Moscow, Musée du Louvre

Paris 1966
Beaumarchais, Bibliothèque Nationale

Paris 1968
Watteau et sa génération, Galerie Cailleux

Paris 1973
Equivoques, Musée des Arts Décoratifs

Paris 1974
Louis XV. Un moment de perfection de l'art français, Hôtel de la Monnaie

Paris 1975
L'Hôtel de Ville de Paris et la place de Grève, Musée Carnavalet

Paris 1979
Chardin—1699–1779, Grand Palais

Paris 1980
Soufflot et son temps, Hôtel de Sully

Paris 1991–92
Mozart à Paris, Musée Carnavalet

Paris 1999–2000
Marcel Proust, l'écriture et les arts, Bibliothèque Nationale de France

Paris, Detroit, and New York 1974–75
De David à Delacroix, La peinture française de 1774 à 1830, Grand Palais, The Detroit Institute of Arts, and The Metropolitan Museum of Art

Paris and Rome 1987
Subleyras 1699–1749, Musée du Luxembourg and Villa Médicis

Paris and New York 1987–88
Fragonard, Grand Palais and The Metropolitan Museum of Art

Paris, Dusseldorf, London, and New York 1999–2000
Chardin, Grand Palais, Kunstmuseum am Ehrenhaf, Royal Academy of Art, and The Metropolitan Museum of Art

Rome 1990–91
J.-H. Fragonard e H. Robert a Roma, Villa Médicis

Rotterdam and Braunschweig 1983
Schilderkunst uit de eerste hand Olieverfschetsen van Tintoretto tot Goya (Malerei aus erster Hand: Ölskizzen von Tintorreto bis Goya), Musée Boymans van Beunigen and Musée Herzog Anton Ulrich

Rouen 1970
Jean Restout (1692–1768), Musée des Beaux-Arts

San Francisco 1949
Rococo: Masterpieces of Eighteenth Century French Art from the Museums of France, California Palace of the Legion of Honor

Sarrebrück and Rouen 1954
Chefs-d'oeuvres oubliés ou peu connus, Musée des Beaux-Arts

Sceaux 1937
Environs de Paris autrefois, Musée de l'Ile de France

Sceaux 1962
Ile-de-France-Brabant, Musée de l'Ile de France

Tokyo 1966
Le Grand siècle dans les collections françaises, National Museum

Tokyo 1982
Quatre femmes à la cour de France

Tokyo 1986
La vie familière et la vie princière en France au 18e siècle, Fuji Museum

Tokyo and Kyoto 1980
Fragonard, National Museum of Western Art and Kyoto Municipal Museum of Art

Toledo, Ohio, Chicago, and Ottawa 1975–76
The Age of Louis XV, The Toledo Museum of Art, The Art Institute of Chicago, and The National Gallery of Canada

Tourcoing 1963
Tableaux de fleurs du XVIIIème siècle au XIXème siècle, Musée des Beaux-Arts

Versailles 1999
Nattier, Musée National du Château

Vienna 1966
L'Art et la Pensée Française au 18ème siècle, Oberes Belvedere

Washington, D.C., Toledo, Ohio, and New York 1960–61
The Splendid Century, The National Gallery of Art, The Toledo Museum of Art, and The Metropolitan Museum of Art

CATALOGUES OF THE MUSÉE DE PICARDIE

1820

Notice des tableaux qui décorent les salles de la Mairie, à Amiens

1865

Musée Napoléon à Amiens: Catalogue des peintures et sculptures exposées dans ce monument

1873

Catalogue des ouvrages de peinture et sculpture exposés dans le Musée communal d'Amiens

1875

Catalogue des ouvrages de peinture et sculpture exposés dans le Musée de Picardie

1878

Catalogue raisonné et descriptif des ouvrages de peinture et de sculpture exposés dans le Musée de Picardie

1894

Catalogue des tableaux composant la collection Lavalard Frères de Roye au Musée de Picardie

1899

Catalogue descriptif des tableaux et sculptures du Musée de Picardie 1911

Catalogue des Tableaux et Sculptures du Musée de Picardie

OTHER SOURCES

Ananoff, Alexandre, and Daniel Wildenstein. *François Boucher*. 2 vols. Lausanne and Paris, 1976.

Ananoff, Alexandre, and Daniel Wildenstein. *L'opera completa di Boucher*. Milan, 1980.

Annexe du musée de peinture (collection P. Fourché). Catalogue sommarie des oeuvres et objects exposés. Orléans, 1908.

Babeau, A. "L'Hôtel de Ville de Paris et l'inventaire de son mobilier en 1740," *Mémoires de la Société historique de Paris* 26 (1899).

Bailey, Colin. *The Loves of the Gods: Mythological Painting from Watteau to David*. New York, 1992.

Bailey, Colin B., ed. *The First Painters of the King: French Royal Taste from Louis XIV to the Revolution*. New York, 1985.

Baratte, François. "A propos de la Chasse au léopard de François Boucher à Amiens. Souvenirs antiques ou rêveries poétiques?" *Revue du Louvre et des Musées de France* 2 (1990).

Bardon, Henri. "Les peintures à sujets antiques au XVIIIè siècle d'après les livrets de Salons," *Gazette des Beaux-Arts* 61 (1963), pp. 217–50.

Barthélemy, S. *Catalogue des peintures de Jean-Baptiste Pater conservées au Louvre*. Typed training session report, Ecole du Patrimoine, Paris, 1990.

Bataille, Marie-Louise. "Lajoue." In Dimier Louis, ed., *Les peintres français du XVIIIe siècle*. Vol. 2. Paris and Brussels, 1930, pp. 347–61.

Baxandall, Michael. *Patterns of Intention: On the Historical Explanation of Pictures*. New Haven and London, 1985.

Bazin, Germain. *Baroque and Rococo Art*. New York, 1964.

Beauvalot-Gouzi, Christine. *Restout* (forthcoming).

Bellemère, J. *Le Musée d'Amiens*. Amiens, 1908.

Belleudy, Jules. *Joseph Siffrein Duplessis, peintre du roi*. Châtres, 1913.

Benoît, François. *L'art français sous la Révolution et l'Empire. Les doctrines, les idées, les genres*. Paris, 1897.

Beurnonville, Baron de. *Catalogue des tableaux anciens de toutes les écoles composant la très importante collection de M. le baron de Beurnonville*. Paris, 1881.

Blanc, Charles. *Histoire des peintres—Ecole française*. Vol. 2. 1864.

Bluche, François. *De la Renaissance au règne de Louis XVI*. Paris, 1995.

Blunt, Anthony. *Art and Architecture in France, 1500–1700*. London, 1953.

Bocher, E. *Jean-Baptiste Siméon Chardin, Les gravures françaises du XVIIIe s*. Vol. 3. Paris, 1876.

Boinet, Amédée. "Une exposition d'art ancien à Fontainebleau," *Gazette des Beaux-Arts* (April 1921), pp. 255–60.

———. *Le musée d'Amiens, Musée de Picardie*. Paris, 1928.

Boyer, Guy, and Jean-Louis Champion, eds. *Mille peintures des musées de France*. Paris, 1993.

Brême, Dominique. "Largilliere, un géant retrouvé," *Dossier de l'art* 50 (1998).

———. "Un petit Versailles en Auvergne, le château de Parentignat," *L'Objet d'art* 304 (1996).

Brière, Gaston. "Notes sur les tableaux de Largilliere commandés par la ville de Paris," *Bulletin de la Société de l'Histoire de l'Art Français* (1918–19), pp. 215–38.

———. "L'exposition des chefs-d'oeuvres des musées de province," *Bulletin de la Société de l'Histoire de l'Art Français* (1931), pp. 189–217.

Brière, Gaston, M. Dumoulin, and P. Jarry. *Les tableaux de l'Hôtel de Ville de Paris*. Paris, 1937.

Brion-Guerry, L. *Fragonard*. Milan, 1952.

Brunot, Ferdinand. "Naissance et développement de la langue de la critique d'art en France. La peinture," *Revue de l'art ancien et moderne*, 1931.

Cailleux, Jean. "Personnages de Watteau dans l'oeuvre de Lajoue," *Bulletin de la Société de l'Histoire de l'Art Français* (1957), pp. 101–111.

Cantarel-Besson, Y. *La naissance du Musée du Louvre*. Coll. Notes et Documents. 2 vols. Paris, 1981.

———. *Musée du Louvre (janvier 1797–juin 1798): procès-verbaux du conseil d'administration du "Musée central des Arts."* Coll. Notes et Documents, Paris, 1992.

Catalogue sommaire illustré des peintures du musée du Louvre et du musée d'Orsay, Ecole française. Vols. 3–5. Paris, 1986.

Cayeux, Jean de. "Les artistes français du XVIIIe siècle et Rembrandt," *Etudes d'art français offertes à Charles Sterling*, 1975, pp. 287–305.

Cayeux, Jean de. *Hubert Robert et les jardins*. Paris, 1987.

Chamchine, B. *Le château de Choisy*. Paris, 1910.

Champeaux, Alfred de. *L'Art décoratif dans le vieux Paris*. Paris, 1898.

Chastel, André. *French Art: The Ancien Régime, 1620–1775*. Paris, 1995.

Chefs-d'oeuvres de l'art. Grands peintres. Chardin. 1978.

Chennevières, H. de. *Notice des tableaux appartenant à la collection du Louvre exposés dans les collections du palais de Fontainebleau*. Paris, 1881.

Clément-Grandcourt, B. "Jean-Jacques Bachelier, peintre de fleurs et d'animaux," *L'Estampille—L'Objet d'Art* 277 (February 1994), pp. 30–43.

Coekelberghs, Denis. *Tableaux de maîtres anciens du XVIe au XIXe siècle*. Galerie d'Arenberg, Brussels, 1993.

Conisbee, Philip. *Painting in Eighteenth-Century France*. London, 1981.

Coural, Nathalie. *Pierre Patel (1605–1676) et ses fils* (forthcoming).

Courthion, P. "Les peintres et la table," *L'Art Vivant* 166 (November 1932).

Craske, Matthew. *Art in Europe, 1700–1830: A History of the Visual Arts in an Era of Unprecedented Urban Economic Growth*. Oxford, 1997.

Crow, Thomas. *Painters and Public Life in Eighteenth-Century Paris*. New Haven and London, 1985.

Cuzin, Jean-Pierre. "De Fragonard à Vincent," *Bulletin de la Société de l'Histoire de l'Art Français* (1983), pp. 103–24.

————. "Vincent reconstitué," *Connaissance des Arts* (1986).

————. *Jean-Honoré Fragonard. Vie et oeuvre. Catalogue complet des peintures*. Fribourg and Paris, 1987.

————. "L'Education de la Vierge de Fragonard au Musée de Picardie à Amiens," *La Revue du Louvre* 4 (October 1992), pp. 8–9.

Dacier, Emile, and Louis Hourticq. *Le Paysage français de Poussin à Corot*. Paris, 1926.

Dacier, Emile. *Gabriel de Saint-Aubin, peintre, dessinateur et graveur (1724–1780)—II: catalogue raisonné*. Paris and Brussels, 1931.

Darcel, Alfred. "Expositions d'art et d'archéologie," *Gazette des Beaux-Arts* 7 (1860).

Darton, Robert. *The Forbidden Best-Sellers of Pre-Revolutionary France*. New York, 1995.

Dayot, A., and J. Guiffrey. *J.B.S. Chardin*. Paris, 1907.

Demadières-Miron, Paul Horace. *Explication des tableaux, dessins, sculptures, antiquités et curiosités exposés au musée d'Orléans*. Orléans, 1843.

————. *Musée d'Orléans, explication des tableaux, dessins, sculptures, antiquités et curiosites qui y sont exposés*. Orléans, 1851.

Demont, L. "Notes sur les collections de l'Académie Royale de Peinture," *Bulletin de la Société de l'Histoire de l'Art Français* (1913), pp. 79–84.

Denvir, B. *Chardin*. Paris, 1950.

Dezallier d'Argenville, A.J. *Abrégé de la vie des plus fameux peintres*, Second edition. Paris, 1762.

Dezallier d'Argenville, A.N. *Voyage pittoresque des environs de Paris ou description des maisons royales, châteaux et autres lieux de plaisance, situés à quinze lieues aux environs de cette ville, Paris*, 1779 (4th ed.).

Dictionary of Women Artists, vol 1. London and Chicago, 1997.

Dimier, Louis, ed. *Les peintres français du XVIIIe siècle. Histoire des vies et catalogue des oeuvres*, vol. 2. Paris and Brussels, 1930.

Dorbec, P. "Louis Tocqué," *Gazette des Beaux-Arts* 2 (1909), pp. 441–68.

Doria, comte Arnauld. "Quelques oeuvres de Tocqué identifiées," *Bulletin de la Société de l'Histoire de l'Art Français* (1927).

————. *L'Art et les artistes* 91 (1928).

————. *Louis Tocqué*. Paris, 1929.

D'un musée l'autre en Picardie. Paris, 1996.

Engerand, Fernand. "Les commandes officielles de tableaux au XVIIIe siècle: Charles Coypel," *La Chronique des Arts et de la Curiosité* 31 (1896).

———. *Inventaire des tableaux commandés et achetés par la Direction des Bâtiments du Roi (1709–1792)*. Paris, 1901.

Estournet, Abbé M.O. "La Famille des Hallé," *Réunion des Sociétés des Beaux-Arts des Départements* (1905), pp. 71–236.

Faré, Michel. *La nature morte en France.* 2 vols. Geneva, 1962.

Faré, M. and F. *La vie silencieuse en France, la nature morte au XVIIIème siècle.* Fribourg and Paris, 1976.

Fernandez, Agnès. "Les chasses exotiques de Louis XV," *Muséart* (December 1995).

Field, Dentons Margaret. "Antoine-Jean Gros' *Portrait de Christine Boyer* et Jean-Frédéric Schall's *Pensée sur la brièveté de la vie:* Private Grief and Public Rhetoric in Post-revolutionary French Painting," *Gazette des Beaux-Arts,* 28 (1996), pp. 103–120.

Florisoone, Michel. *La Peinture française: le dix-huitième siècle.* Paris, 1948.

Foucart, Jacques. "Critique de l'exposition Napoléon Ier, Amiens, Musée de Picardie," *Revue de l'Art* 8 (1970).

———. *Les Lavalard.* Amiens, 1977.

Fried, Michael. *Absorption and Theatricality: Painting and Beholder in the Age of Diderot.* Chicago and London, 1980.

Furst, H. *Chardin.* London, 1911.

Gabillot, G. *Les Huet.* 1892.

Gabillot, C. *Les peintres des fêtes galantes. Antoine Watteau, Jean-Baptiste Pater, Nicolas Lancret.* Paris, 1907.

Gaehtgens, Thomas W. "J. M. Vien et les peintures de la légende de sainte Marthe à Tarascon," *La Revue de l'Art* (1974).

Gaehtgens, Thomas W., and Jacques Lugand. *Joseph-Marie Vien, Peintre du Roi (1716–1809).* Paris, 1988.

Gaillemin, J.L. "La galerie des chasses exotiques de Versailles," *Connaissance des Arts* (March 1996).

Galerie Françoise ou Portraits des hommes et des femmes célèbres qui ont paru en France . . . , avec un abrégé de leur vie par une société de gens de lettres. Paris, 1772.

Gaston-Dreyfus, Philippe. "Catalogue raisonné de l'oeuvre de N.B. Lépicié," *Bulletin de la Société de l'Histoire de l'Art Français* 1 (1922), pp. 134–271.

———. *Catalogue raisonné de l'oeuvre de N.B. Lépicié.* Paris, 1923.

Gazette des Beaux-Arts (March 1993).

Gilles-Mouton, Colette. *Jean-Baptiste Van Loo.* Master's thesis, Université de Paris IV–Sorbonne, 1970.

Goncourt, Edmond and Jules de. *L'Art du XVIIIe siècle.* Paris, 1880.

———. *Notules.* Vol. 12. Paris, 1909.

———. *French Painters of the Eighteenth Century.* Ithaca, New York, 1981.

Gonse, Louis. *Les chefs-d'oeuvre des Musées de France. La Peinture.* Paris, 1900.

———. *Les chefs-d'oeuvre des Musées de France. Peintures.* Paris, 1904.

Goodman, John, and Thomas Crow. *Diderot on Art.* 2 vols. New Haven and London, 1995.

Grate, Pontus. "Largillierre et les natures mortes de Grenoble," *La Revue du Louvre* 1 (1961), pp. 23–30.

————. "Boucher in Stockholm," *Florilegium in honoren Carl Nordenfalk Octogerarii Contextum, Nationalmuseum Skriftserie, N.S.9., Stockholm.* Stockholm, 1987.

————. *French Paintings II. Eighteenth Century. Swedish National Art Museums.* Stockholm, 1994.

Gronkowski, C. "L'exposition Nicolas de Largillière au Petit Palais," *Gazette des Beaux-Arts* (June 1928), pp. 321–38.

Gueffier. *Description historique des curiosités de l'église de Paris.* 1753.

Guiffrey, J.J. *Eloge de Lancret peintre du roi par Ballot de Sovot accompagné de diverses notes sur Lancret, de pièces inédites et du catalogue de ses tableaux et de ses estampes.* Paris, 1874.

————. *Jean-Baptiste Siméon Chardin. Catalogue complet de l'oeuvre du maître.* Paris, 1908.

————. *Histoire de l'Académie de Saint-Luc,* Archives de l'art français. Vol. 9. Paris, 1915.

Guillou, Jean-François. *La peinture en 1000 photos de Giotto à Gauguin.* Paris, 1997.

Hazlehurst, F.H. "The Wild Beasts Pursued: The Petite Galerie of Louis XV at Versailles," *The Art Bulletin* 66 (June 2, 1984).

Heim, Jean-François, Claire Béraud, and Philippe Heim. *Les salons de peinture de la Révolution Française, 1789–1799.* Paris, 1989.

Holmes, Mary Tavener. "Lancret, décorateur des 'petits cabinets' de Louis XV à Versailles," *L'Oeil* (March 1985), pp. 25–30.

Horsin-Déon, S. "Les cabinets d'amateurs à Paris. Cabinets de MM. Lavalard et Eudoxe Marcille," *Annuaire des artistes et des amateurs* (1862), pp. 137–38, 143–48.

Huchard, Viviane, Françoise Lernout, Noël Mahéo, and Sylvie Couderc. *Le Musée de Picardie, Amiens.* Paris, 1995.

Hug, Laure. *Catalogue de l'oeuvre peint de Jean-Baptiste Huët (1745–1811).* DEA thesis, Université de Paris IV–Sorbonne, 1997.

Ingersoll-Smouse, Florence. *Pater.* Paris, 1928.

Kahn, Gustave. *François Boucher.* Paris, 1905.

Kimball, Fiske. *The Creation of the Rococo.* Philadelphia, 1943.

Lastic, Georges de. "Nicolas de Largilliere, peintre de natures mortes," *La Revue du Louvre* 4–5 (1968), pp. 233–40.

————. "Rigaud, Largilliere et le tableau du prévôt et des échevins de la ville de Paris de 1689," *Bulletin de la Société de l'Histoire de l'Art Français, Paris, 1975* (1976), pp. 147–56.

————. "Nouvelle attribution," *Bulletin des Musées d'Amiens* 2 (1983).

Leblanc, Abbé. *Lettre sur l'exposition des ouvrages de peinture, sculpture, etc. de l'année 1747. Et en général sur l'utilité de ces sortes d'Expositions. A Monsieur R.D.R.* (Deloyne, vol. 2, 26), 1747.

Lehnen, Peter. "Expensae circa processum beatificationis et canonizationis Sancti Camilli de Lelli," *Analecta ordinis CC.RR. Ministrantium infirmis.* Vol. 10. 1964.

Lécuyer, R. "Regards sur les Musées de Province, Amiens," *L'Illustration* (January 2, 1932).

Lemagny, Jean-Claude. "Lajoue," *Kindlers Malerei Lexikon.* Vol. 4. Zurich, 1967.

Lemoine, H. "Notes sur le peintre Vincent," *Gazette des Beaux-Arts* 2 (1904).

Lentenac, P. *Hubert Robert.* Paris, 1929.

Lesage, Jean-Claude. *Oeuvres méconnues de peintres français du XVIIIème s. au Musée de Picardie—Amiens.* Master's thesis, Université de Lille III, 1978.

Lévêque, Jean-Jacques. *La vie et l'oeuvre de Jean-Honoré Fragonard.* Paris, 1987.

————. "Quand l'exotisme entrait à Versailles," *Le quotidien du médecin* (November 17), 1995.

Levey, Michael. *Painting and Sculpture in France, 1700–1789.* New Haven and London, 1993.

Locquin, Jean. *La peinture d'histoire en France de 1747 à 1785.* Paris, 1912.

Lomax, David. "The Early Career of Noël Hallé," *Apollo* (February 1983).

Lossky, Boris. "L'Apollon et Issé dans l'oeuvre de François Boucher," *Gazette des Beaux-Arts* (1954).

Magnin, Jeanne. *Le paysage français des enlumineurs à Corot.* Paris, 1928.

Mantz, Paul. *François Boucher, Lemoyne, Natoire.* Paris, 1880.

Marcel, Pierre. "Les peintures et le public en France au XVIIIe siècle," *Mélanges Bertaux. Recueil de travaux dédiés à la mémoire d'Emile Bertaux.* Paris, 1924, pp. 205–13.

Marcille, Eudoxe-François. *Catalogue des tableaux statues et dessins exposes au musée d'Orléans.* Orléans, 1876.

————. *Histoire et description du musée d'Orleans* (taken from *L'inventaire général des richesses d'art de la France*). Paris, 1878.

Marcus, Claude-Gérard. "Un petit Maître mal connu: Jean-Baptiste Benard—Ecole française XVIIIe siècle," *Art et Curiosité* (May–June 1965), pp. 4–8.

Mauclair, Camille. *Les grands artistes. Fragonard.* Paris, 1904.

Maumené, Ch., and L. d'Harcourt. *Iconographie des rois de France, Seconde partie: Louis XIV, Louis XV, Louis XVI.* Paris, 1932.

Messelet, Jean. "Jean Restout (1692–1768)," *Archives de l'Art français,* 19 (1938).

Michel, André. *Boucher.* Paris, 1889.

————. *François Boucher.* Paris, 1904.

Michel, André, L. Soullié, and Ch. Masson. *François Boucher.* Paris, 1906.

Mirimonde, Albert Pomme de. "Deux esquisses retrouvées de Bachelier et de Brenet," *La Revue des Arts* 4–5 (1959), pp. 187–92.

————. "Scènes de genre musicales de l'Ecole française au XVIIIème siècle dans les collections publiques," *La Revue du Louvre et des Musées de France* 3 (1968).

Mouradian, H. *Jean-Jacques Bachelier (1724–1806).* Master's thesis, Université de Paris IV, Institut d'Art et d'Archéologie, 1993.

Munhall, Edgar. *Jean-Baptiste Greuze, 1725–1805.* Hartford, 1976.

Nicolle, Marcel. "Chefs-d'oeuvre des musées de province," *Gazette des Beaux-Arts* (1931), pp. 98–127.

Nolhac, Pierre de. *J.-H. Fragonard, 1732–1806.* Paris, 1906.

————. *Hubert Robert.* Paris, 1910.

————. *Nattier, peintre de la cour de Louis XV.* Paris, 1925.

Nolhac, Pierre de, and Georges Pannier. *François Boucher.* Paris, 1907.

O'Neill, Mary. *Les peintures de l'Ecole Française des XVIIe et XVIIIe siècles, Musée des Beaux-Arts d'Orléans.* Orléans, 1981.

Parker, Karl T. *Catalogue of the Collection of Drawings in the Ashmolean Museum.* Oxford, 1938.

Pascal, Georges. *Largilliere.* Paris, 1928.

Pigler, A. *Barockthenen.* 3 vols. Budapest, 1956.

Pinette, Matthieu. "Acquisitions. Amiens, Musée de Picardie," *Revue du Louvre* 1 (1999), p. 85.

Portalis, Baron Roger. "La collection Walferdin et ses Fragonard," *Gazette des Beaux-Arts* (1880), p. 302.

———. *Honoré Fragonard, sa vie, son oeuvre.* Paris, 1889.

Racinais, H. *Un Versailles inconnu, les petits appartements des rois Louis XV et Louis XVI.* 2 vols. 1950.

Réau, Louis. "Les influences flamandes et hollandaises dans l'oeuvre de Fragonard," *Revue Belge d'Archéologie et d'Histoire de l'Art* 2 (April 2, 1932), pp. 97–104.

———. *L'art au XVIIIe siècle.* 1938.

———. *Fragonard, sa vie et son oeuvre.* Brussels, 1956.

Ridder, A. de. *J.-B. S. Chardin.* Paris, 1932.

Rocheblave, S. *Charles-Nicolas Cochin.* 1927.

Roland Michel, Marianne. "French Eighteenth Century Drawings in the Rijksprentenkabinet," *Apollo* (June 1983), pp. 469–75.

———. "Représentations de l'exotisme dans la peinture en France dans la première moitié du XVIIIe siècle," *Studies on Voltaire and the Eighteenth Century* 151–55 (1975).

———. *Lajoue et l'art rocaille.* Neuilly-sur-Seine, 1984.

———. *Chardin.* Paris, 1994.

Rosenberg, Pierre. *Chardin.* Geneva, 1963.

———. *Tout l'oeuvre peint de Chardin.* Paris, 1983.

———. *Tout l'oeuvre peint de Fragonard.* Paris, 1989.

———. *Chardin.* Geneva, 1991.

Rosenberg, Pierre, and Jean-Pierre Changeux. *1500–1825. The Fine Arts Museum of San Francisco.* San Francisco, 1987.

Rosenblum, Robert. *Transformations in Late Eighteenth-Century Art.* Princeton, 1967.

Rosenfeld, Myra Nan. "Largilliere: Problèmes de méthodologie," *Revue de l'Art* 66 (1984), pp. 69–74.

Roudier, Jean-Michel. *Ver-Vert, étude d'un phénomène littéraire et artistique.* Musées de la Nièvre, 1998.

Salmon, Xavier. "Versailles, les chasses exotiques de Louis XV," *L'Estampille, L'Objet d'Art* 297 (December 1995), pp. 35–45.

———. "La Chasse chinoise de Jean-Baptiste Pater demeura-t-elle après 1739 dans la Galerie des Chasses en pays étrangers au château de Versailles?" *Gazette des Beaux-Arts* (February 1997), pp. 101–108.

———. *Jean-Marc Nattier, 1685–1766.* Paris, 1999.

Sandoz, Marc. *Jean-Baptiste Deshays—1729–1765.* Paris, 1977.

———. *Les Lagrenée.* Vol. I. Paris, 1983.

Schama, Simon. *Citizens: A Chronicle of the French Revolution.* London, 1989.

Schönberger, Arno, and Halldor Soehner. *The Rococo Age: Art and Civilization of the 18th Century.* New York, 1960.

Schuman, J.C. *Charles Parrocel (1688–1752).* Dissertation, University of Washington, 1979.

Scott, Barbara. "The Art of *la chasse*: Barbara Scott on Louis XV's Exotic Hunt Paintings at Versailles," *Country Life* (March 7, 1996).

Shoolman, Regina. "François Boucher: St. John the Baptist, a Study in Religious Imagery," *Minneapolis Institute of Arts Bulletin* 62 (1975), pp. 17–20.

Smith, Joan van Renssalaer. *Nicolas de Largilliere: A Painter of the Régence.* Doctoral dissertation, University of Minnesota, 1964.

Sterling, Charles. "Sur un prétendu chef-d'oeuvre de David," *Bulletin de la Société de l'Histoire de l'Art Français* (1951).

Sterling, Charles. "A 'Fine' David Reattributed," *The Metropolitan Museum of Art Bulletin* 9: 5 (1951), pp. 121–32.

Thuillier, Jacques. *Fragonard*. Geneva, 1967.

Tintelnot, H. *Barock Theater und barock Kunst*. Berlin, 1939.

Valcanover, F. *Jean-Siméon Chardin*. Milan, 1966.

Vergnet-Ruiz, Jean, and Michel Laclotte. *Petits et grands musées de France. Peinture française des primitifs à nos jours*. Paris, 1962.

Verlet, P. *Versailles*. Paris, 1926.

Vieville, Dominique. "Le musée et son décor: Amiens, le Musée de Picardie," *Revue du Louvre* 2 (1995), pp. 51–69.

Vilain, Jacques. "Une nativité de Carle Van Loo au Musée des Beaux-Arts de Brest," *La Revue du Louvre* (1970), pp. 371–76.

Wildenstein, Daniel, and Gabriele Mandel. *L'opera completa di Fragonard*. Milan, 1972.

Wildenstein, Georges. "L'exposition Fragonard au pavillon de Marsan," *Revue de l'Art Français* 7 (July 1921), pp. 356–63.

———. *Lancret*. Paris, 1924.

———. *Chardin*. Paris, 1933.

———. *The Paintings of Fragonard*. Aylesbury, 1960.

———. "De l'utilisation des sources dans la rédaction des catalogues d'exposition," *Chronique des Arts et de la Curiosité* 1096 (May 1960), pp. 1–2.

———. *Chardin*. Zurich, 1963.

Wilhelm, Jacques. "Les portraits masculins dans l'oeuvre de L.R. Trinquesse," *Revue de l'Art* 25 (1974), pp. 55–65.

Willk-Brocard, Nicole. "Noël Hallé (1711–1781) décorateur. *Paysage avec architecture et figures*," *Revue du Louvre* 5–6 (1994), pp. 74–78.

———. *Une dynastie Les Hallé—Daniel (1614–1675), Claude-Guy (1652–1736), Noël (1711–1781)*. Paris, 1995.

Wintermute, Alan. *Watteau and His World*. New York, 1999.

Wise, Susan, and Malcolm Warner. *French and British Paintings from 1600 to 1800 in The Art Institute of Chicago (A Catalogue of the Collection)*. Chicago, 1996.

The numbers provided are catalogue numbers.

Aubert, Louis 25

Aubry 33

Bachelier, Jean-Jacques 47

Bénard, Jean-Baptiste (attributed to) 39

Boucher, François 14, 16, 38, 56

Chardin, Jean-Siméon 13, 15, 37, 57

Charles-André, called Carle Vanloo 21, 36, 42, 45

Charles-André, called Carle Vanloo (attributed to) 41

Charpentier, Constance 76

De Bar, Bonaventure (attributed to) 8, 9

Deshays, Jean-Baptiste 54

Donvé, Jean-François (attributed to) 73

Duplessis, Joseph Siffred (or Siffrein) 46

Fragonard, Jean-Honoré 55, 59, 66

Grenier de La Croix, Charles-François, called
 Lacroix de Marseille 51, 52

Greuze, Jean-Baptiste (attributed to) 53

Grimou, Alexis 7

Hallé, Noël 62

Huet, Jean-Baptiste 58

Lagrenée, Louis Jean-François, called Lagrenée
 l'aîné 34, 69

Lajoue, Jacques de 22

Lallemand, Jean-Baptiste (attributed to) 70, 71

Lancret, Nicolas 17

Largilliere, Nicolas de 2, 5, 6

Le Moyne, François (attributed to) 12

Lépicié, Nicolas-Bernard (attributed to) 61

Loir, Marianne (attributed to) 44

Nattier, Jean-Marc 27, 48

Parrocel, Charles 10, 19, 20

Patel, Pierre-Antoine, called Patel *le fils* 3

Pater, Jean-Baptiste 18

Restout, Jean 23, 32

Rigau y Rós, Hyacinthe, called Rigaud 1

Rigau y Rós, Hyacinthe, called Rigaud (studio of) 4

Robert, Hubert 49, 50, 72, 74, 75

Subleyras, Pierre 24, 26, 28, 31

Suvée, Joseph-Benoît 67

Tocqué, Louis 30

Trinquesse, Louis-Roland 68

Vanloo, Jean-Baptiste (attributed to) 11

Vincent, François-André (attributed to) 60

Vincent, François-André 65

Unknown French Artists 29, 35, 40, 43, 63, 64

American Federation of Arts